AMERICANA PORTRAIT SESSIONS

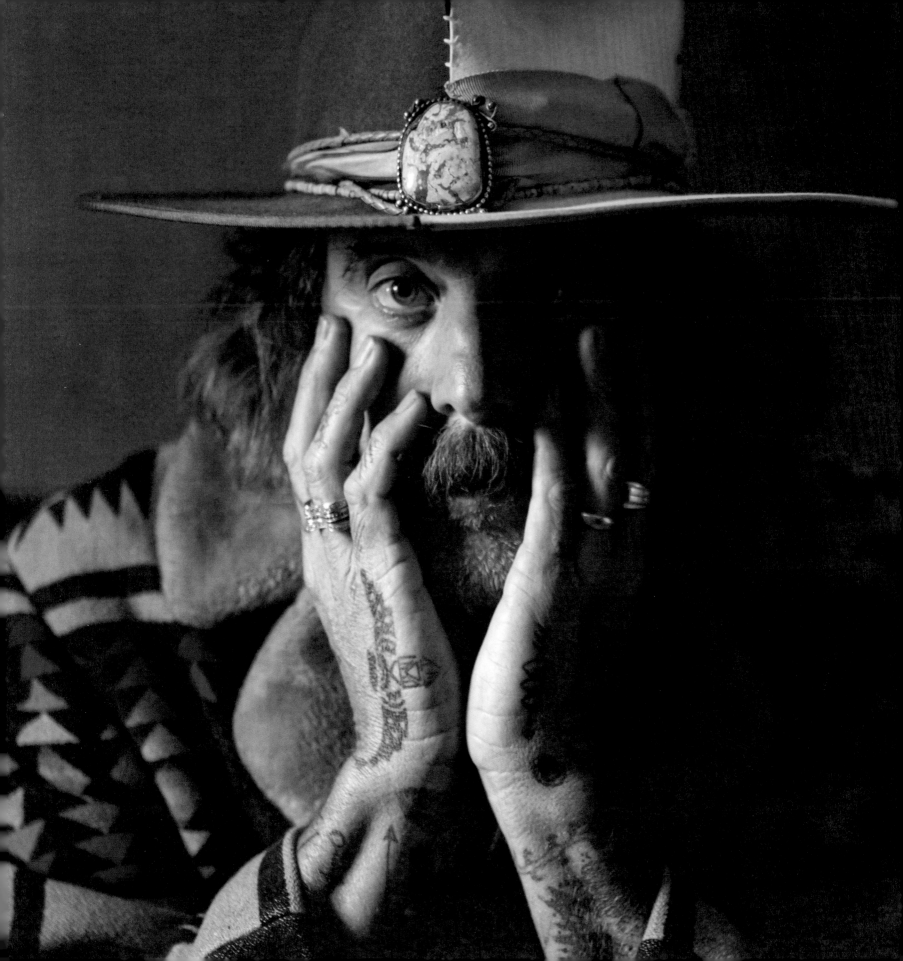

AMERICANA
PORTRAIT SESSIONS

JEFF FASANO

Foreword by Mary Gauthier
Introduction by Edd Hurt

VANDERBILT UNIVERSITY PRESS | NASHVILLE, TENNESSEE

Copyright © 2023 by Jeffry Fasano

Published 2023 by Vanderbilt University Press

All rights reserved

First printing 2023

Library of Congress Cataloging-in-Publication Data on file

LCCN 2023002352

ISBN 978-0-8265-0582-8 (hardcover)

ISBN 978-0-8265-0583-5 (epub)

ISBN 978-0-8265-0584-2 (web PDF)

Printed and bound in Canada by Friesens.

To Mario Cabrera, my mentor, teacher, and friend.
Without your guidance, your support, and your demand
for integrity, and constantly telling me to learn your craft,
this book would never have been possible.

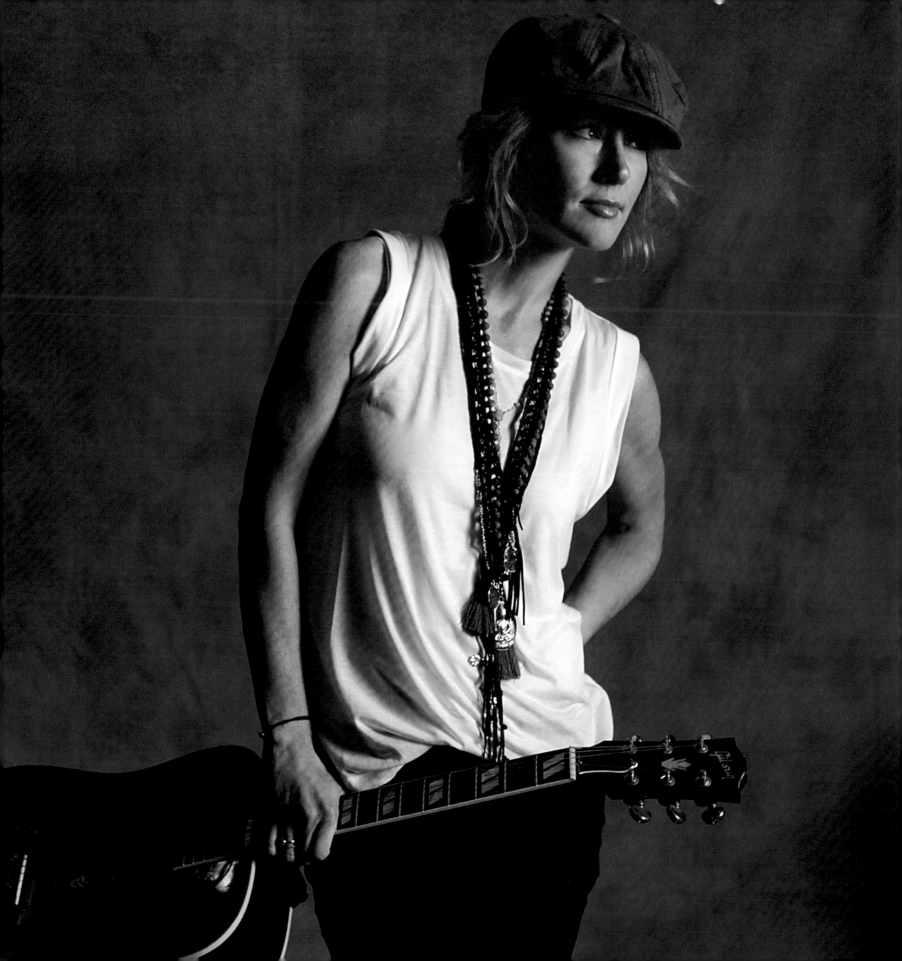

CONTENTS

FOREWORD

Mary Gauthier

A good photo is a beautiful image. A great photo captures the subject's essence. Capturing an artist's essence? You have to have empathy.

A few years ago, Jeff and I caught a matinee showing of *Bohemian Rhapsody* at Regal Green Hills Cinema. As we sat in the theater and the movie unfolded, we were blasted backward in time to the days when we were young, Queen was our favorite band, and it was us and them against the world.

"We're four misfits, four people who don't belong," Freddie Mercury tells music manager John Reid at a rooftop restaurant. "And we're playing for other misfits. The outcasts, we see them there, in the back of every room, they don't belong either. We are their band. We belong to them."

Freddie was talking about me. The queer kid from a small southern town, awkwardly trying to navigate my identity, who loved this band back when it really, really mattered to have a band, my band, that understood.

When the movie ended, Jeff and I walked out of the theater stunned, silent. I looked over, and saw that like me, he had tears in his eyes. Turns out, he too was one of those outcasts in the back of the room when he was a kid, one of the ones that didn't belong. Queen was his band, too.

When you grow up as an outsider, you become an observer. Jeff and I are both observers. Him with his camera, me with my songs. We document and chronicle what we see.

Behind the soundboard, on the side of the stage, in the back of the room, Jeff seems to be everywhere in Nashville, all the time. The Bluebird, City Winery, Third and Lindsley, the Family Wash, the Station Inn, Exit Inn, AmericanaFest—the list goes on and on. Camera ready, eyes darting around, looking for the shot. The one that reveals a truth.

Jeff's photos are a reflection of the heart of the man who cried after the Queen movie, and the kid who loved the outsider band, who saw himself among the different, the curious, and the weird.

Empathy comes from being a skilled observer.

The magic in Fasano's photos?

Empathy.

PREFACE

My Story

Every person can find their deepest passion and express that in their lives.

One night when I was leaving my corporate job in New York City, sitting on the 1 train heading uptown, it hit me like a slap across the face. I realized that I was not enjoying my life. It was time to grow up and change it. So I went home, took off my suit and tie, got comfortable, found one of those yellow legal pads and a pen, sat down, and wrote at the top of the page, "What do I want to be when I grow up?"

I began making a list by writing down what I liked doing and all the things I could do. Photography was in the mix. I kept at it, adding more to the list for an hour or two, and then put it down. I took a break, ate some dinner, and then picked it up again. It was at that moment that PHOTOGRAHY leapt off the page—hit me in my heart and made me realize how much I loved taking pictures. I found my passion. I knew it deep in my soul. It was then that I made the choice to dedicate every waking moment in my life to the craft of photography. I was thirty-three years old.

I wanted to quit my job right then and there, but my father convinced me that the journey toward that end was just begin-ning. He said, "You will quit your job, but not yet." He was right. I then begrudgingly made a plan for the journey ahead and committed myself to it. I built a darkroom, purchased lights (thanks, Dad!), and practiced, practiced, and practiced some more. When I was not at my nine-to-five job, I ate, drank, and slept photography. It was etched into my soul, and the joy it brought me was something I really had never felt before—other than playing baseball, my first passion. There really wasn't

anything else I did during that time. The journey led me on a path of discovering the artist in me and developing a body of work I could bring to the world when I did quit my job. I car-ried my camera everywhere I went.

Then one day, when I was wandering around lower Manhattan on my lunch break looking for someone or some-thing interesting to photograph, it hit me—I was done. I went back to my office in World Trade Center One, sat at my desk and typed out my resignation letter. I was forty years old.

A few months later, I left that corporate job and a world that no longer resonated for me. My intention was to create a new life that was fulfilling and enjoyable. You see, I didn't leave a job, I just came to the end of a part of my life and was ready to move into the next part. I made a commitment to myself to do this. And by following through on this commitment, I not only created this life, I am now living it. It sure has been quite a journey and I am doing things I never dreamed of. One of those unbelievable things on my wish list is this book.

On my path, I have had so many amazing people support me in creating my dream—too many to name here, and this proved to be so important—as they encouraged me to maintain my focus on my commitment.

My father was my rock who knew it when I did, and held that vision with me. Mario Cabrera, my mentor, teacher, and friend, was with me every step of the way, holding me to a stan-dard of integrity that I have carried with me—and I maintain it to this day.

It has been a long road filled with peaks and valleys; times of great unknowing that led me to learn how to trust myself

and the process. And to stay open in my heart to anything and everything that came along on the path. I just said Yes!

Along this path, I have had the great fortune to meet, photograph, and build relationships with notable artists from around the world, many of whom you can see in this book. Through the love of my craft, doors opened, and as I walked through them, I connected with so many interesting people who are creating their life, their creative expression, and expressing it to the world. I get the chance with my talents and gifts, as a photographer, to support them in doing this. For me, that's what it is all about—supporting each other on our path through life. I am grateful for those who have helped me.

I live in my heart and it is all about connection. And when that connection happens, we can create everything together. The essence of the person is what I intend to capture, and through my images reveal that essence to the world. What lies beneath the surface is the beauty and elegance of the soul and the heart, it is real and authentic—and that is what I convey in my work.

Photography has been a doorway to so much in my life.

Folks, I share this story because it is my intention to inspire others to shift and change their life as I did. I undertook this project, creating this book, to bring my art to the world, yes, but also to show everyone that you too can live your dream.

I listened to my heart, when it asked me to. I found my passion. I found a vehicle for my self-expression and a deep love for creating it. And thus I have been able to receive what has appeared on my path, because I made a commitment to my dream and to myself. I am living that dream—still committed to it—and you can too. I now understand that I am truly blessed!

Peace, Jeff

INTRODUCTION

Edd Hurt

Even more than the well-established genres from which it draws inspiration, Americana music contains multitudes. Americana has been around in its most fully realized form for about twenty-five years, but its roots lie in various forms of music that flourished in the 1960s and '70s. That's just part of the story, or taxonomy, of a genre that really isn't a genre and that is as voracious, expansive, and, of course, hard to define as rock 'n' roll and folk music. In Americana as it exists now, you'll hear folk performers who accompany themselves with only a guitar or piano, soul singers who evoke the sounds of the great Memphis record company Stax Records in the 1960s, rock 'n' rollers who seek to combine the approaches of Hank Williams and Lou Reed, political artists who bring Bob Dylan and Phil Ochs to mind, and Beatles-esque, power-pop bands that pick up where another Memphis group of noncon-formists who influenced Americana, Big Star, left off in 1975. In other words, there is no real stylistic handbook you can trot out like a vade mecum for fans who want to travel the byways of Americana.

What Jeff Fasano—a New York–born photographer who made the move to Nashville because he fell in love with the city's rich music and wanted to explore the personalities of its practitioners—does in his portraits of Americana artists is document what is commonly called diversity. This diversity is another part of Americana's definition complex. Because Fasano has chosen to photograph artists as personalities—he prefers to catch them up close, in a studio or a dressing room or a recording studio—the portraits in this book offer a look into the way Elizabeth Cook, or James McMurtry, or Allison Russell

and Chris Smither, appear as human beings who also happen to be stars and artists. In his work, every face tells its story or declines to be closely read, as is the prerogative of any person working in front of audiences who tend to associate the personality of an artist with the work an artist produces. You can read his photos as his attempt to unlock the mysteries of the human condition as they manifest themselves on the eternal road musicians travel.

The photos presented here serve as a reminder of Americana's broad reach and stylistic diversity. In Jeff Fasano's work, pop stars from the sixties and seventies mingle with young singers, and instrumentalists draw upon old-time practices and pay tribute to the storied past. Since Americana is partly a marketing term—and marketing, like genre itself, is an inescapable and even useful part of how we think about music—the first thing to ask yourself, if you're interested in getting to the bottom of a music that now competes with mainstream country as a major part of the output of Nashville, Tennessee, is where and when Americana starts.

Looking at Jeff's work, you see photographs of revered sixties figures like David Crosby and Stephen Stills; lesser known but influential post-folk singers like the aforementioned Chris Smither; British Invasion–influenced producers and singers like Freedy Johnston, Nick Lowe and Chris Stamey; and avatars of the Texas school of literate, down-home songwriting like Hayes Carll and James McMurtry. J. D. Souther, who is portrayed in communion with his guitar, one leg up on a chair in what looks like a backstage dressing room, represents the most commercial side of Americana. Associated with the Eagles—themselves

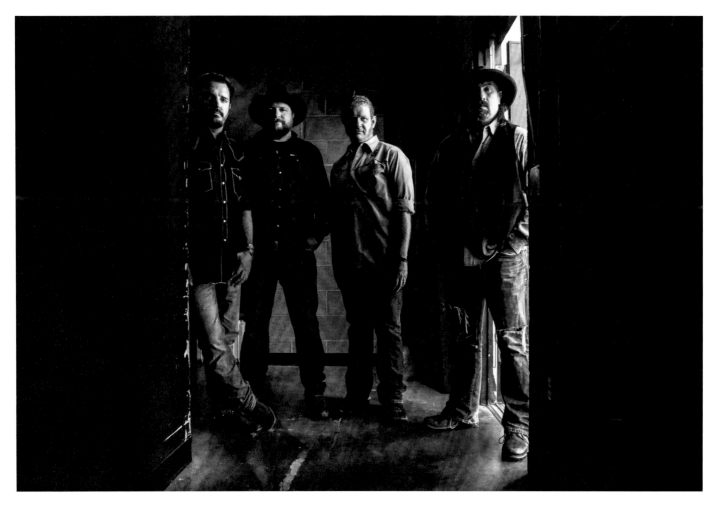

Reckless Kelly by Jeff Fasano

one of the biggest-selling acts of all time, and hardly shrinking violets of committed non-commercialism—Souther belongs in a book about Americana for many reasons, not least because the Eagles set the template for country-rock in the seventies. Similarly, Joan Osborne—her presence seems reassuringly unaffected in Fasano's lens as she lounges, with very cool rock 'n' roll shoes, in the front seat of a car—may initially strike you as an outlier. But she's not. She's a pop artist, certainly a fine songwriter, but not a folkie or a country singer.

So, where does Americana begin, and what intricate combination of sensibilities does it represent, at a remove of twenty years from when it took its present form? How did the folkies, rockers, soul musicians, and pop singers of the sixties and seventies—those cosmic cowboys, freaky bluegrass groups, syncretic amalgamations of the so-called folk tradition (I'll say something more about the contradictions of folk music in a minute)—become the big-ticket, sometimes cult-level artists of Americana music? Did Jim Lauderdale, for example, a Nashville fixture for

years who has dabbled in straight country, Grateful Dead–style ruminations, and much more, set out to become an Americana artist? How does an English bluesman, John Mayall, fit into the picture of a music supposedly based on roots traditions that North American blues musicians like Robert Johnson, Howlin' Wolf, and Skip James invented in the wilds of Mississippi in the 1920s and '30s? And another question: how does the idea of being commercial, of reaching as many people as possible, fit into this particular scheme of twenty-first-century music?

If you grew up in the sixties and seventies, and you were born around 1960, you received a big dose of what we now call classic rock. The progression goes something like this. First, there were the folk groups of the pre-Beatles world, like the Kingston Trio, and the foundational folkies who believed in the power of populist music to change the world, like Pete Seeger. Tied to the notion of radical politics, the folk movement proved invaluable to the development of popular music in the sixties. In that decisive decade, when long-held ideas of song form and performance values got turned on their ears, song collectors and record freaks discovered Skip James, Robert Johnson, and literally thousands of other artists who had previously been known only to a few dedicated record collectors. Alongside folk, there was country music itself, which was based on English-Appalachian folk tunes but was also a pure product of commercial Nashville. As a center of recording, songwriting, and star-making, Nashville paired singers with appropriate songs, applied production techniques designed for maximum appeal, and even produced instant folk tunes. For example, "The Long Black Veil"—a spooky tune most memorably rendered by The Band on their Americana-anticipating 1968 album *Music from Big Pink*—quickly became a "folk" standard in the hands of singers like Joan Baez.

"The Long Black Veil" was written in 1959 by Danny Dill and Marijohn Wilkin, and a country singer, Lefty Frizzell, was the first to record its satisfying and moralistic lines. Similarly, Jack Clement—the Memphis-born record producer, songwriter, singer, and all-around gadfly of sixties Nashville who made

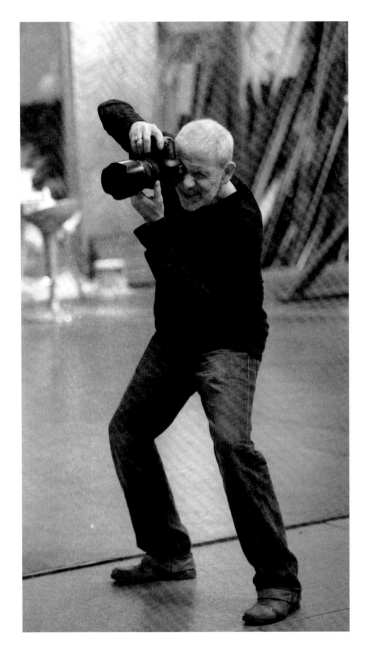

From *Skin on Skin* (2016). Photo by Timothy Vechik

history by producing and writing songs for the pioneering Black country singer Charley Pride—turned out a song titled "Miller's Cave." First cut in 1960 by singer Tommy Tucker (and released on Memphis's Hi Records label), "Miller's Cave" is another instant folk classic, and it became a standard in the songbag of many a singer-songwriter. I remember one afternoon in Nashville in 2013, talking to Guy Clark, the great Texas-born songwriter, about his early career as a traveling folk singer, and he told me "Miller's Cave" was one of the sure-fire tunes he carried around.

Country was, in fact, a more populist music than the folk of the sixties. Like rock 'n' roll, it was perceived as counter-revolutionary by a significant part of an audience that looked to the past, as if the past was completely untainted by the desire for popularity or the need to make a living. In an even more extreme example of this dichotomy, rock 'n' roll was considered beyond the pale, partly because of its instrumentation. More to the point, rock musicians took from the avant-garde in that term's well-established sense of trying out new sounds, modes, and textures. By 1965, rock 'n' roll had become rock, which meant that the Beatles, the Rolling Stones, the Kinks, the Byrds and many others applied high-art principles to songs with a big beat.

If the Byrds are one of the foundational groups of Americana, it's because of their ability to fuse bluegrass and folk with rock and Bob Dylan, not because of their brilliantly modernist jazz-folk excursions into outer space: "Eight Miles High," "So You Want to Be a Rock 'n' Roll Star," and "Dolphins Smile." Their career, which divides neatly between 1965 to 1967 and 1968 to 1971, contains another clue to the mystery of Americana. Their pre-1968 work fits into the scheme of the High Sixties. Their 1968 country-rock album *Sweetheart of the Rodeo*, recorded partly in Nashville with Gram Parsons and the great pedal-steel player Lloyd Green, is commonly cited as another harbinger of Americana, just like *Music from Big Pink*, the Flying Burrito Brothers' 1969 album *The Gilded Palace of Sin*, and Bob Dylan's 1966 *Blonde on Blonde*.

That list of proto-Americana would likely include records by Fairport Convention, an English band led by singer Sandy Denny and guitarist Richard Thompson. In fact, Thompson has for years been squarely in the Americana camp, having written the song "1952 Vincent Black Lightning" in 1991. It became a favorite of Americana artists and has been covered by the Mammals, Del McCoury, Reckless Kelly, and Bob Dylan himself. Another British band, Brinsley Schwarz—they were led by the very Robbie Robertson–influenced guitarist of the same name, and in fact sounded very much like a tongue-in-cheek version of the Byrds and the Band on their best album, 1972's *Nervous on the Road*—were Americana before there was a name for it. Nick Lowe, who was the group's main singer and most talented member, went from quasi-pop on his 1978 album *Pure Pop for Now People* to roots-inflected tunes in the eighties. Fasano's photo of Lowe portrays a slightly sardonic rogue who is going to enjoy the glass of wine he holds in his left hand.

In the eighties, after the advent of punk, Americana inches closer to its modern form. It was the generation of writers, performers, and tastemakers who were born around 1960 that created the idea of Americana. (It's a music invented by the baby-boom generation, and it has continued to beguile musicians who weren't born when Nirvana released their first record.) After all, if you grew up in the incredibly fertile era of all of that pioneering classic rock, and suddenly punk upends the eternal verities for a few years, one way to reconcile punk and everything else is to apply punk to country music, blues, and "roots" music in general. So say hello to John Cale, Lou Reed, the Mekons, and the Blasters, and also howdy to Dwight Yoakam, Lucinda Williams, Alejandro Escovedo, and many others you would find in the pages of *No Depression* magazine—the most ideologically consistent publication of early Americana.

That meant that the Clash's *London Calling* (released in 1979, but a definitive eighties record) was, essentially, an Americana album, complete with nods to soul, R&B, and rockabilly. A few years later, Elvis Costello—already a star for his fusion of Randy Newman, the Rolling Stones, and Great American

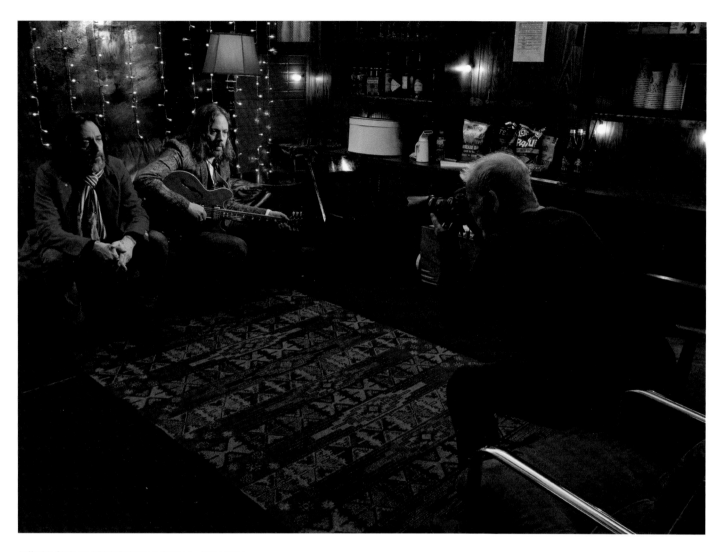

Jeff with Chris and Rich Robinson. Photo by Dan Heller

Songbook–derived songwriting on albums like *This Year's Model* and *Trust*–recorded an album titled *King of America*. Released in 1986, *King of America* features Costello alongside American musicians like former Elvis Presley bassist Jerry Scheff and James Burton. Also appearing on the album is T Bone Burnett, now a major figure in Americana music and, in the late seventies a member of the Alpha Band, another group whose Dylan-meets-New Wave-in-Texas music would sound at home in the Nashville or Austin of 2022.

King of America and the Mekons' 1985 *Fear and Whiskey* provided the template that future Americana artists would follow. Originally an anarchist punk band, the Mekons integrated fiddles and steel guitar into their sound on *Fear and Whiskey*, and the album closes with a cover of country singer songwriter

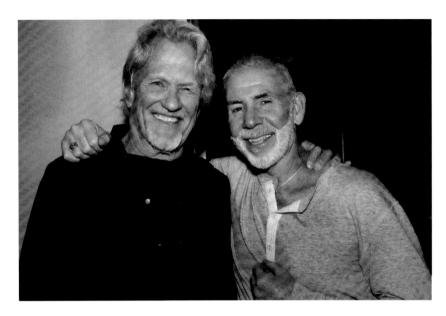

Jeff Fasano with Kris Kristofferson, Los Angeles, California

Leon Payne's "Lost Highway." As punk, rock 'n' roll and country became intertwined in the eighties, there were countless neo-rockabilly bands, so-called "cowpunk" groups, and all manner of genre exploration from musicians like Dave Alvin, Alex Chilton, Tony Joe White, and Bettye LaVette, herself already a music-business veteran by the mid- eighties. LaVette's career path—from Detroit soul singer to all purpose interpreter of material by Elton John, Bob Dylan, and whomever she deemed appropriate for her skills—encapsulates one important aspect of Americana. Her eclecticism and taste in material would lead her in the nineties to record with Drive-By Truckers, the Alabama band who modernized Southern rock by combining it with punk.

Jeff Fasano perfectly captures LaVette, who takes command of the situation while poised in two red chairs. This, clearly, is a woman who is out to do what she wants, and no questions asked. Having seen her several times over the last decade, I can attest to her intensity and her immense skill as an unsentimental, even caustic singer.

The formative years of Americana come to an end in the late nineties, which was the heyday of *No Depression* magazine, a publication that served—and still does—as a kind of barometer for what is, what isn't, and what might be Americana music. By 1999 the idea of Americana had begun to include quasi-country rock bands like Old 97's, whose leader, Rhett Miller, is caught here in a relaxed pose, as if he were simply another musician and not a star. Lucinda Williams' critically acclaimed 1999 *Car Wheels on a Gravel Road* received praise from hard-to-please rock critics like Robert Christgau, and the record's mix of studio craft and spontaneity—what is craft on this densely layered album, and what is spontaneous?—remains one mode of Americana that artists seek to use to this day.

By the time the early aughts roll around, an artist like Elizabeth Cook—a Florida native raised in an intense country-music environment, an ambitious songwriter and record-maker who joined the *Grand Ole Opry* but never made inroads in traditional country—could release an album called

Balls that includes a cover of the Velvet Underground's "Sunday Morning." Produced by Rodney Crowell, *Balls* is a landmark in the history of Americana. Cook's subsequent work was marvelously syncretic, as on her 2020 release *Aftermath*—a pop statement informed by her deep understanding of the pressures and pleasures of working-class life.

Of course, Cook is also a star, and Jeff Fasano photographs her on the steps on a tour bus. By the second decade of the twenty-first century, Americana audiences and tastemakers had taken as their own a British Invasion–style rocker like Nashville's Aaron Lee Tasjan. His 2018 album *Karma for Cheap* sounds like Tasjan channeling Tom Petty and the Beatles and Jeff Lynne, to great effect. From its origins as a kind of pop-folk music that owed a debt to the hippie country of the seventies—not to mention bluegrass, a major component of Americana Jeff Fasano documents in photos of Del McCoury, Ricky Skaggs, and Sierra Hull—Americana became an all-purpose form of classic rock that was also, in its way, roots music.

Many big stars appear in this book, including Kris Kristofferson and David Crosby—both inventors of the genre, in their own ways—as do many performers who mostly remain known to connoisseurs and adepts of studio craft and songwriting. In so many ways, these artists are the core of the genre, which isn't to discount the appeal and artistry of the big stars. Jeff Fasano opens up a window into the personalities of Freedy Johnston, a superb songwriter who continues to make literate records for an audience that really should be larger, and Whitney Rose, a rising star whose intelligent country-rock contains a hint of glamour and danger.

What is the future of Americana, and how does the popularity of its newest stars—many of whom defy long-standing roles of gender, race, and genre—speak to the changes it has undergone in the last twenty-five years? Certainly Allison Russell, whose 2021 debut album *Outside Child* tells the story of her quest for authenticity in a male-dominated world, might serve as a shining example of how this music has evolved. *Outside Child* incorporates a little jazz, a little rock, and some soul, but the core of her art is storytelling—the essential element of Americana. The multi-faceted genre encompasses a vast array of musical strands, but in the end, what matters is the individual voice, no matter how those elements are used in the service of Americana's quest for authenticity.

AMERICANA PORTRAITS

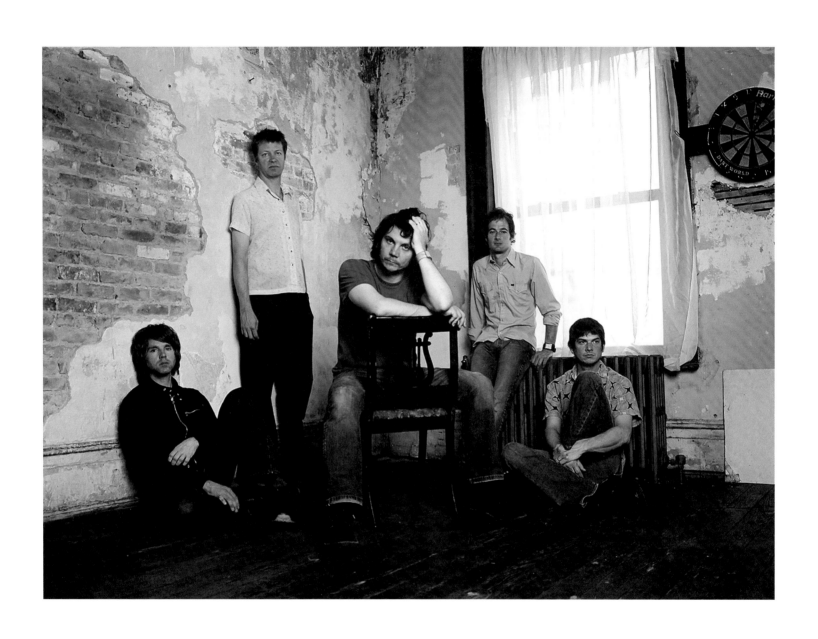

WILCO
New York, New York

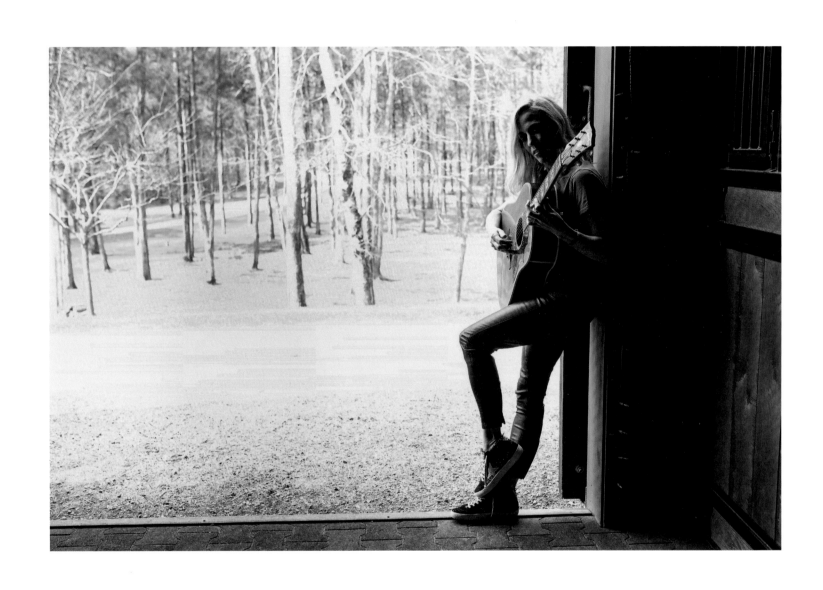

SHERYL CROW

Nashville, Tennessee

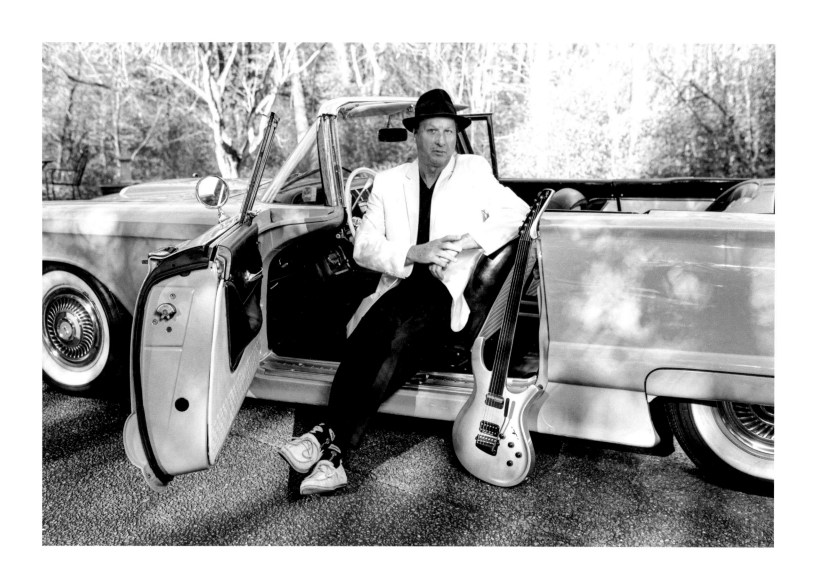

ADRIAN BELEW

Nashville, Tennessee

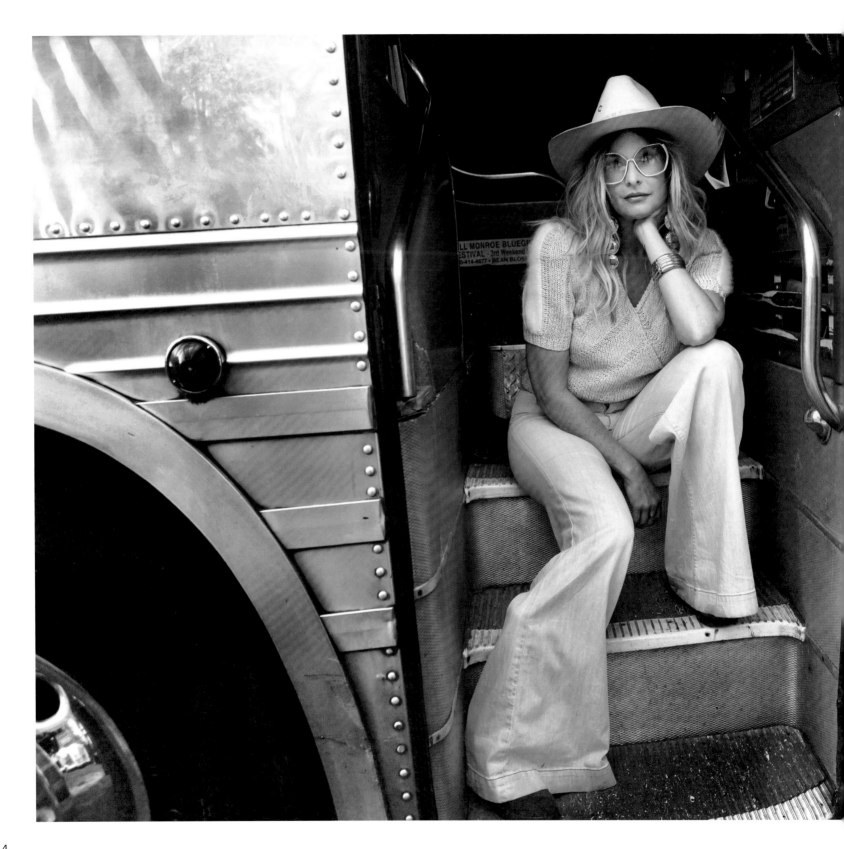

14

ELIZABETH COOK
Black Mountain, North Carolina

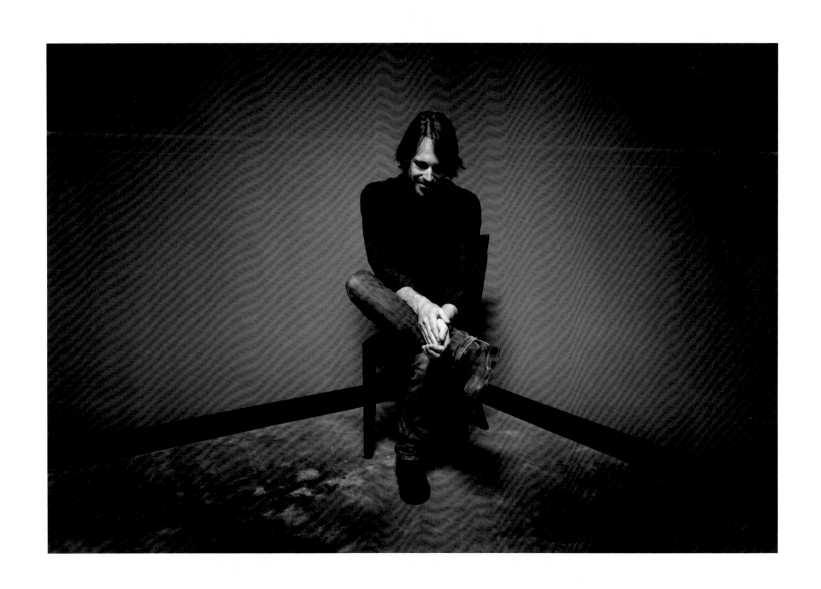

GLEN PHILLIPS

Nashville, Tennessee

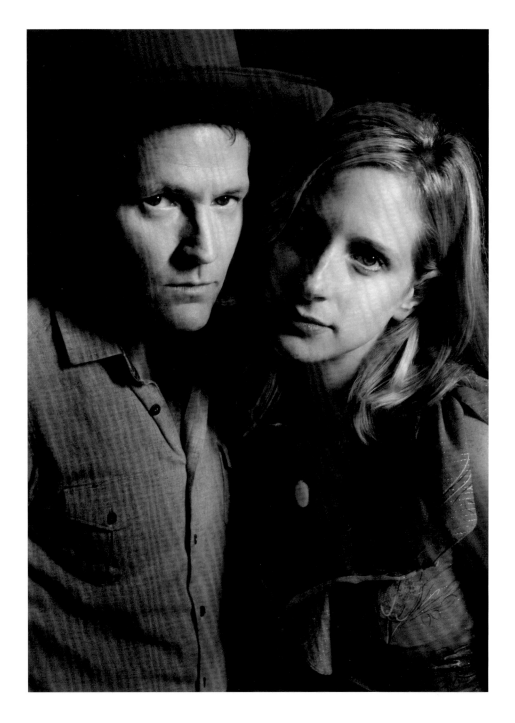

WHITEHORSE
Nashville, Tennessee

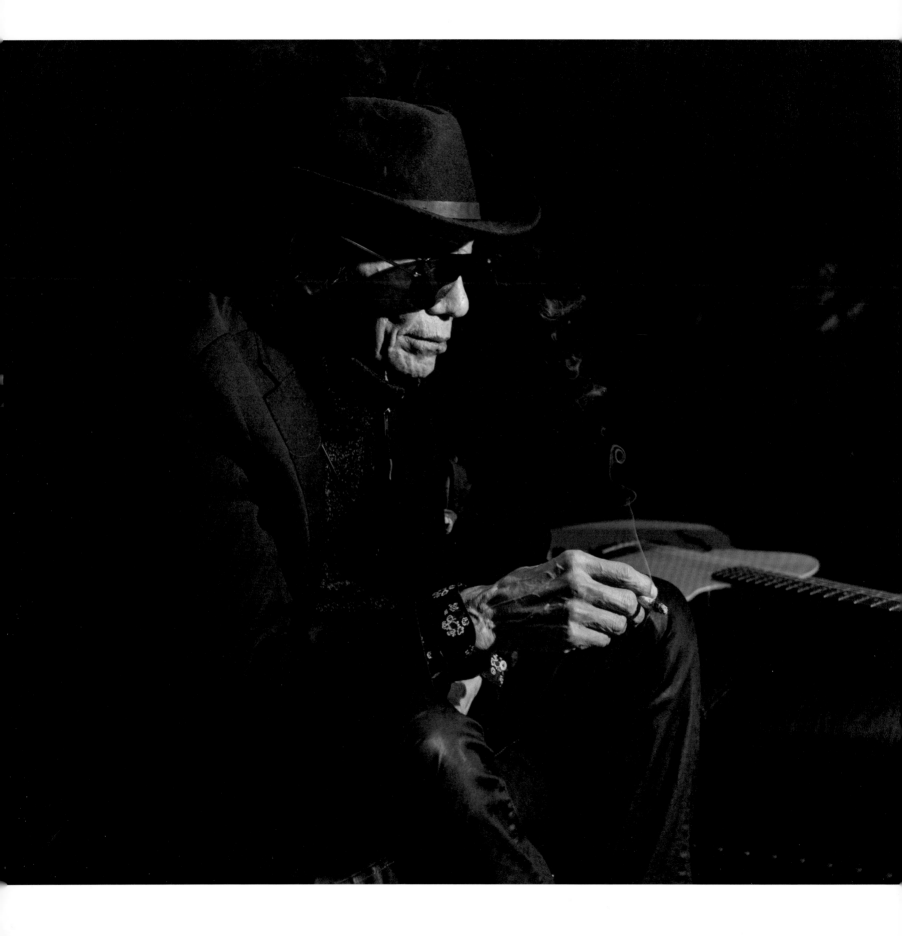

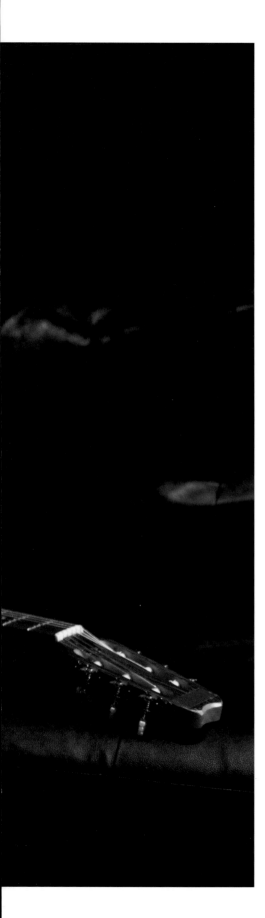

RODRIGUEZ
Nashville, Tennessee

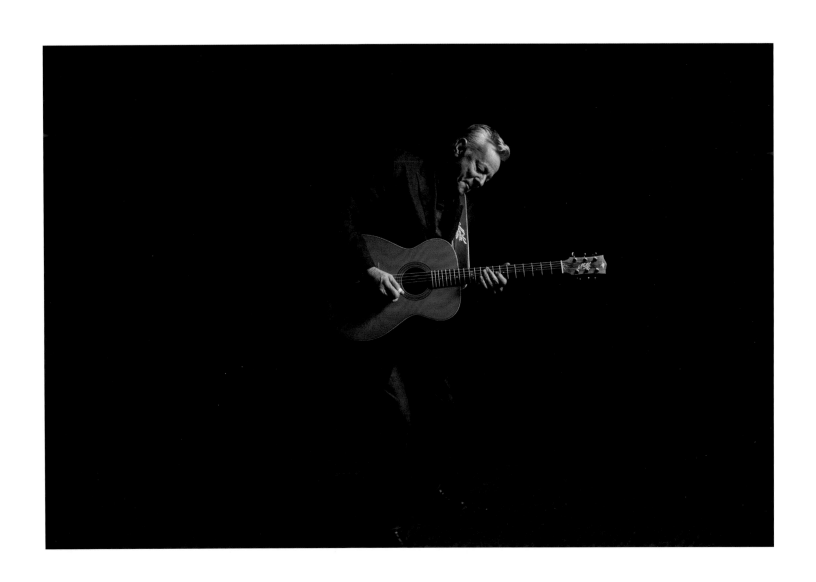

TOMMY EMMANUEL

Nashville, Tennessee

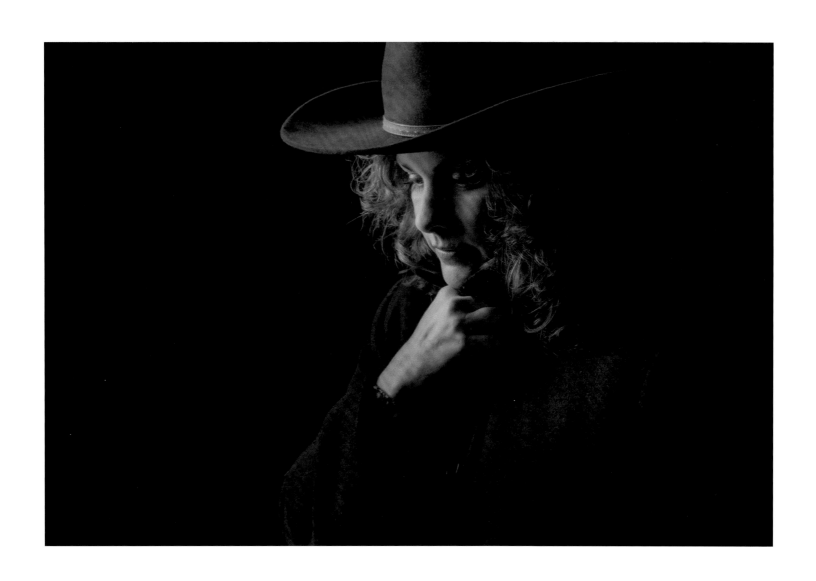

AMY LAVERE
New Orleans, Louisiana

DEL MCCOURY
Raleigh, North Carolina

23

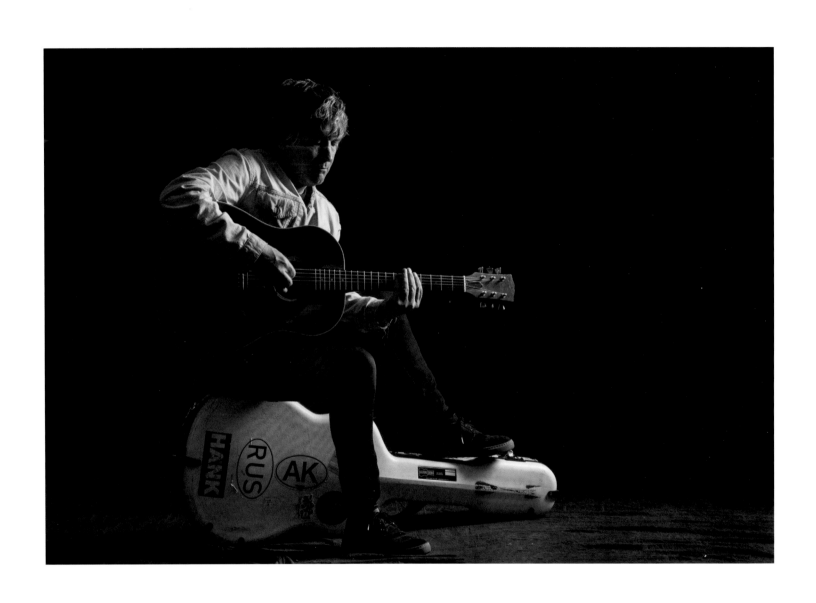

TIM EASTON
New Orleans, Louisiana

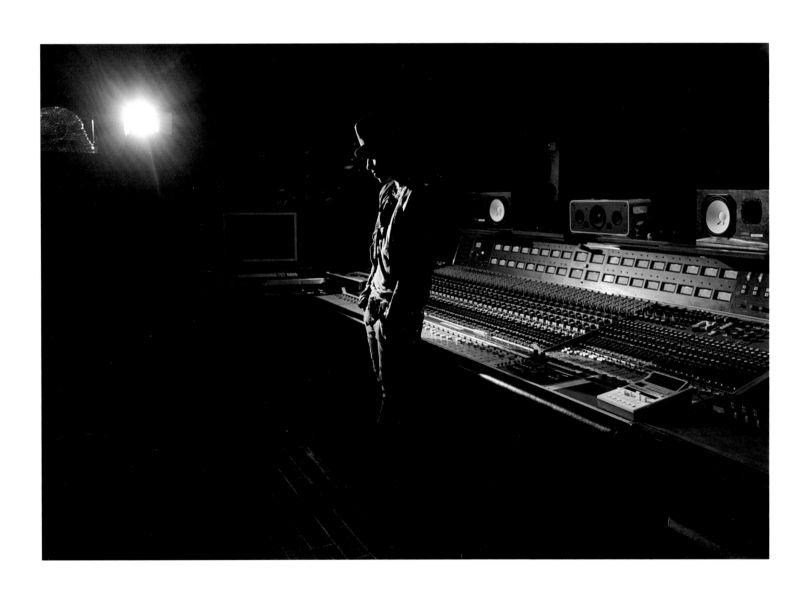

LINDA PERRY

Los Angeles, California

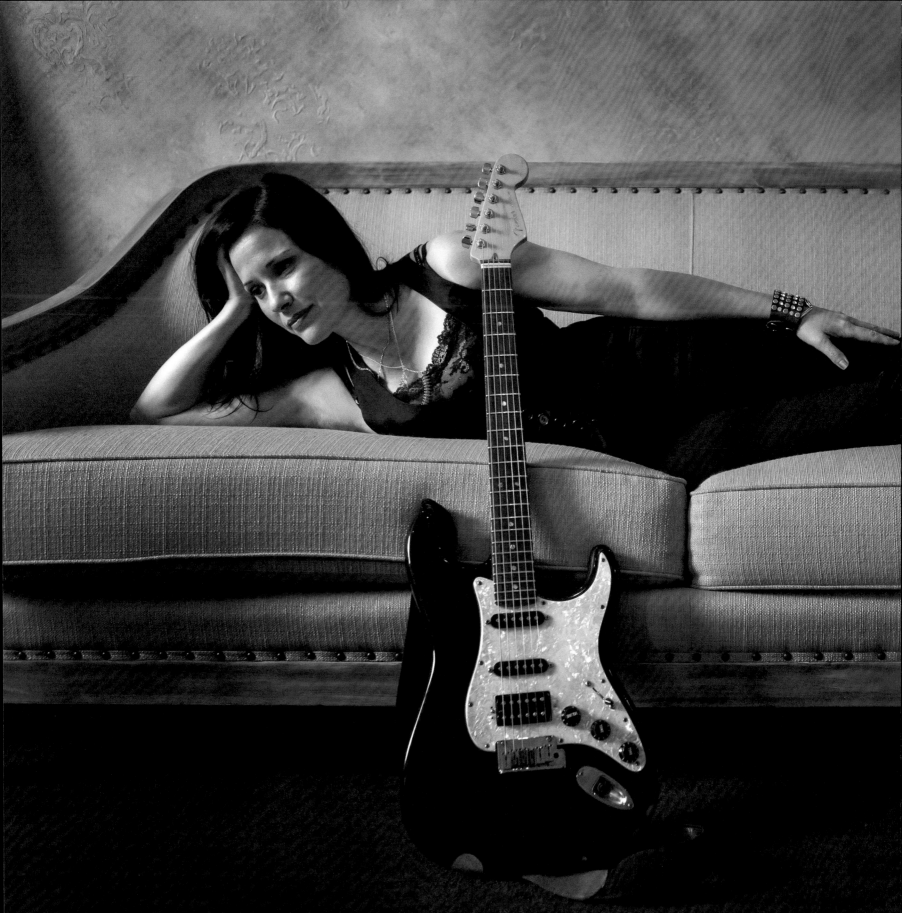

SHANNON MCNALLY
Nashville, Tennessee

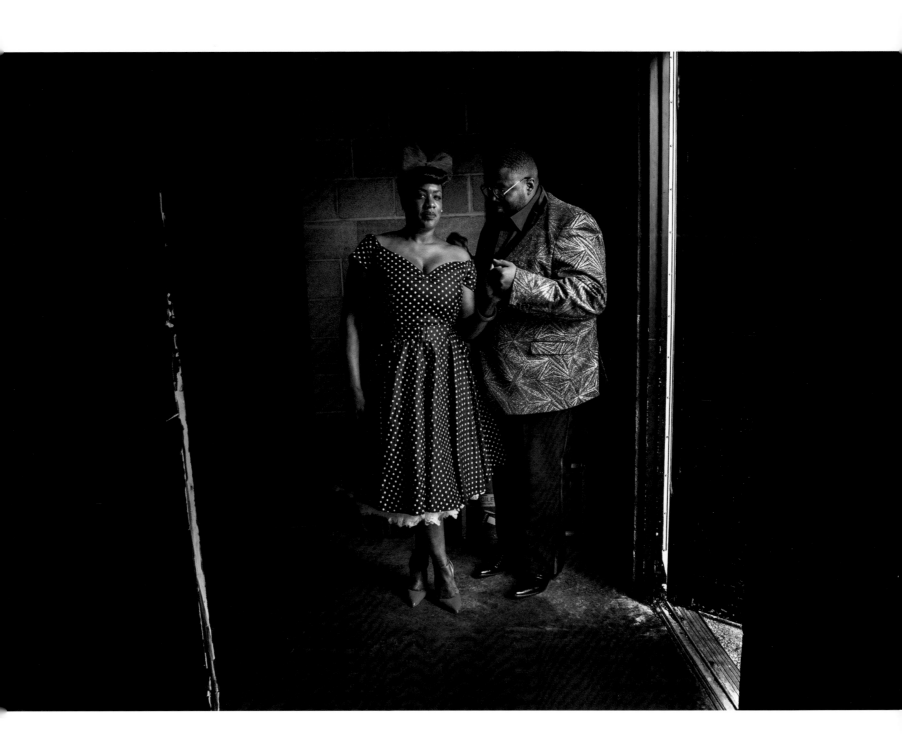

THE WAR AND TREATY

Nashville, Tennessee

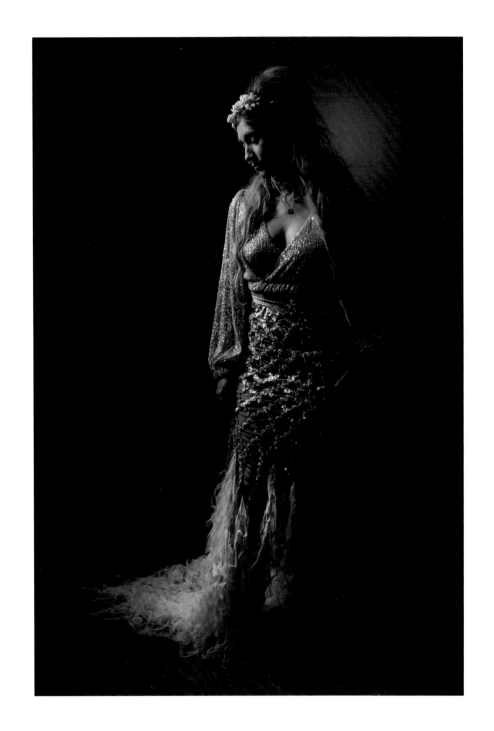

SIERRA FERRELL
Nashville, Tennessee

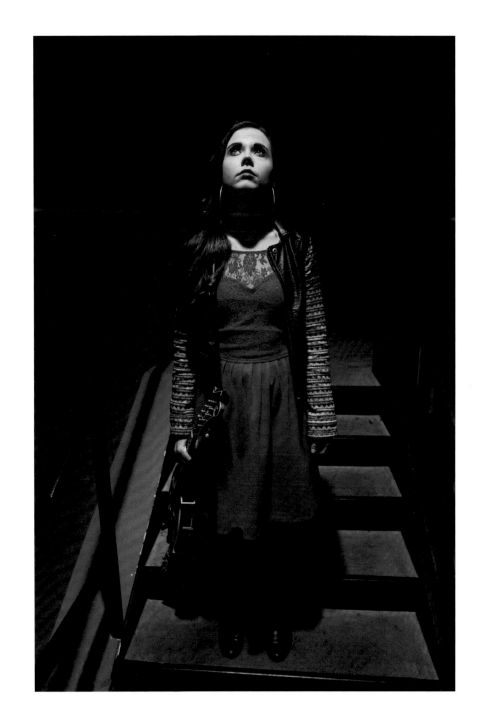

SIERRA HULL
Nashville, Tennessee

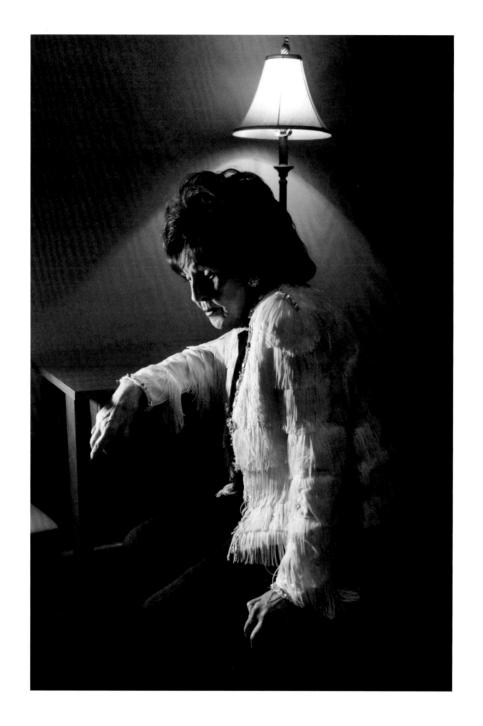

WANDA JACKSON
Nashville, Tennessee

DAVE ALVIN
Los Angeles, California

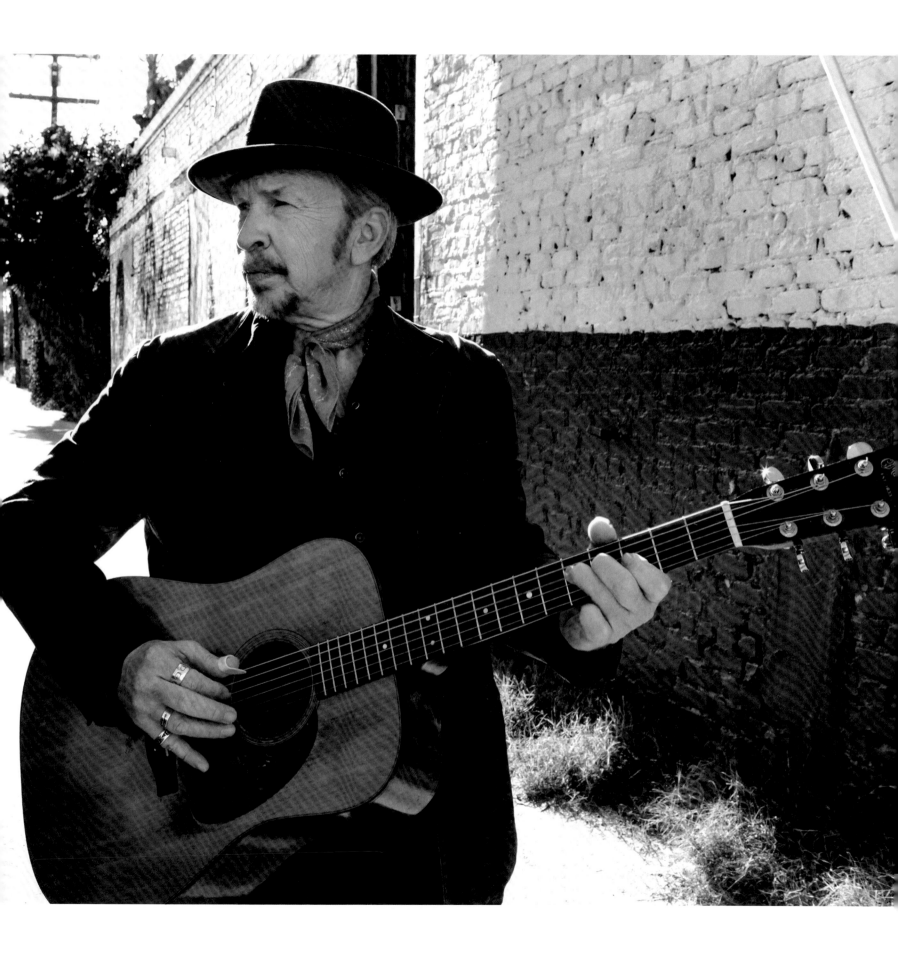

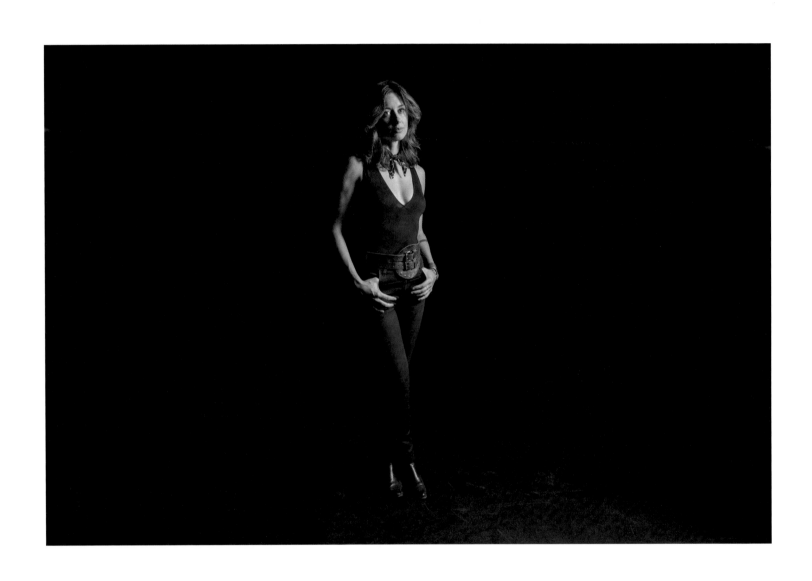

LERA LYNN

Nashville, Tennessee

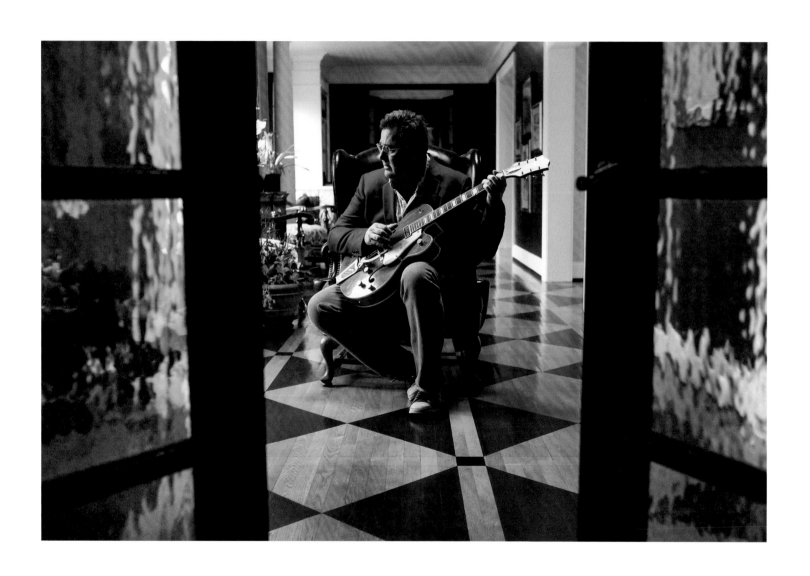

VINCE GILL

Nashville, Tennessee

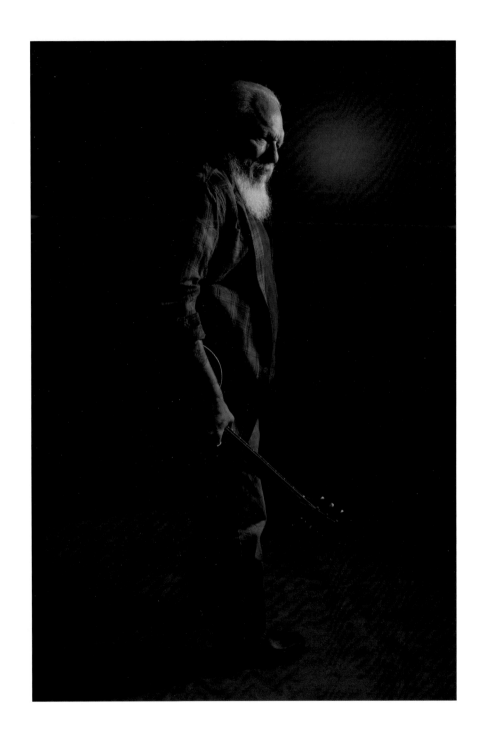

JORMA KAUKONEN

Nashville, Tennessee

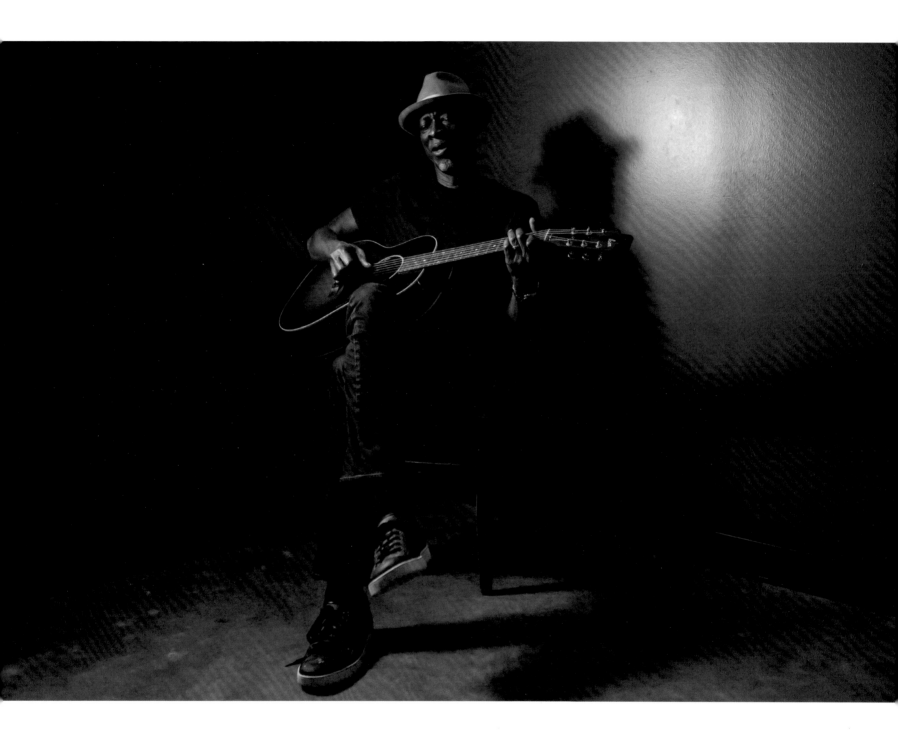

KEB' MO'
Nashville, Tennessee

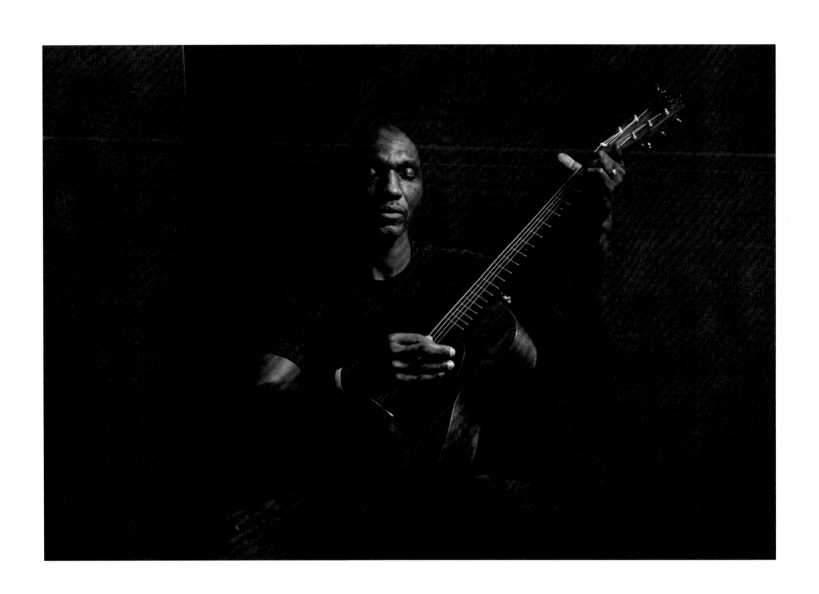

CEDRIC BURNSIDE
Nashville, Tennessee

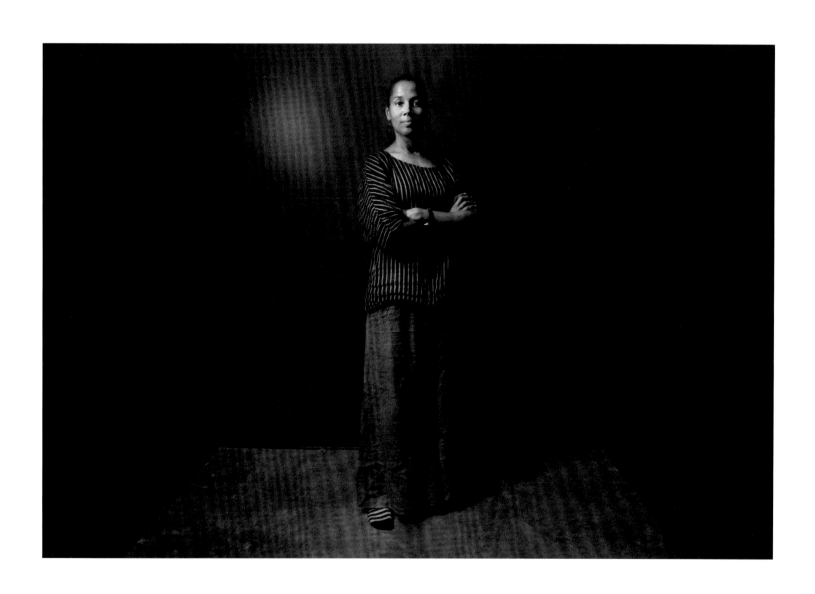

RHIANNON GIDDENS
Nashville, Tennessee

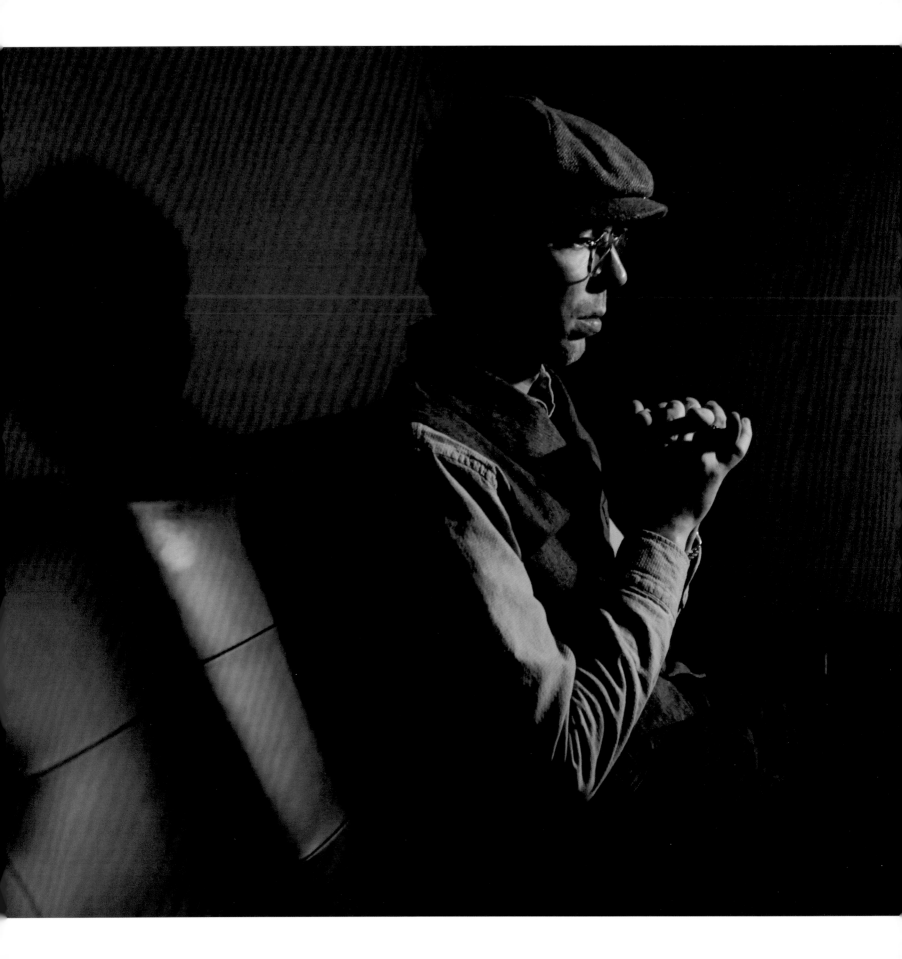

JUSTIN TOWNES EARLE
Nashville, Tennessee

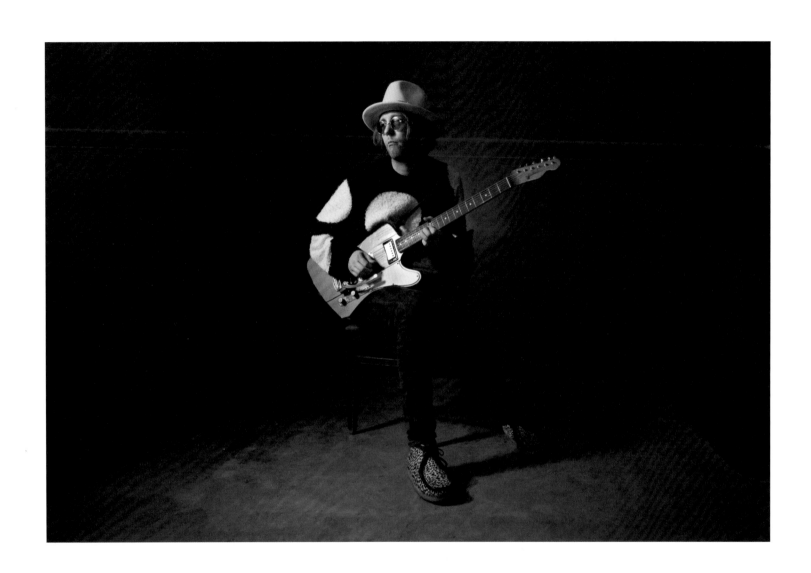

AARON LEE TASJAN

Nashville, Tennessee

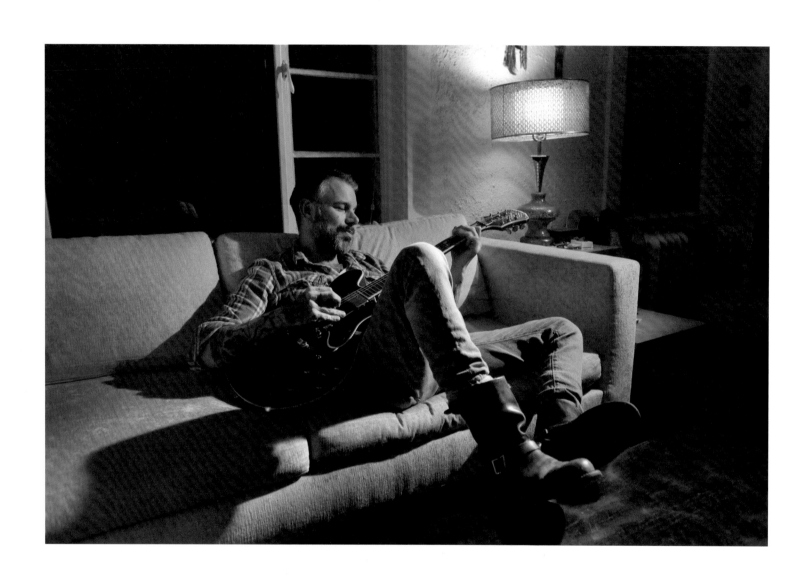

BEN NICHOLS
Memphis, Tennessee

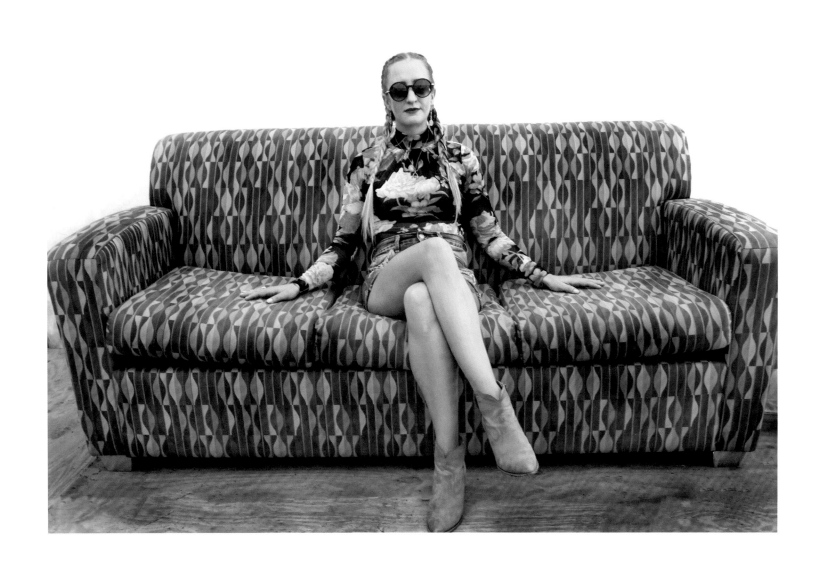

MARGO PRICE
Manchester, Tennessee

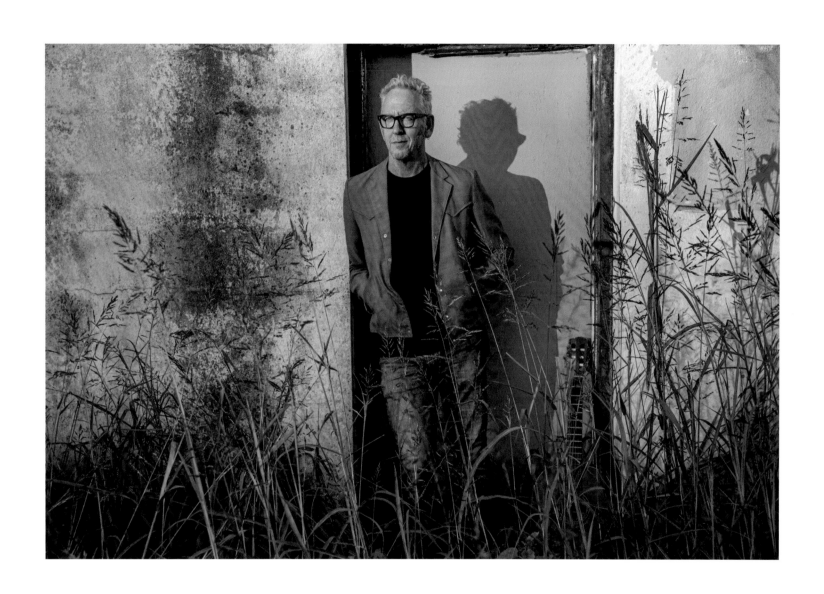

DARDEN SMITH
Austin, Texas

CHASTITY BROWN
Nashville, Tennessee

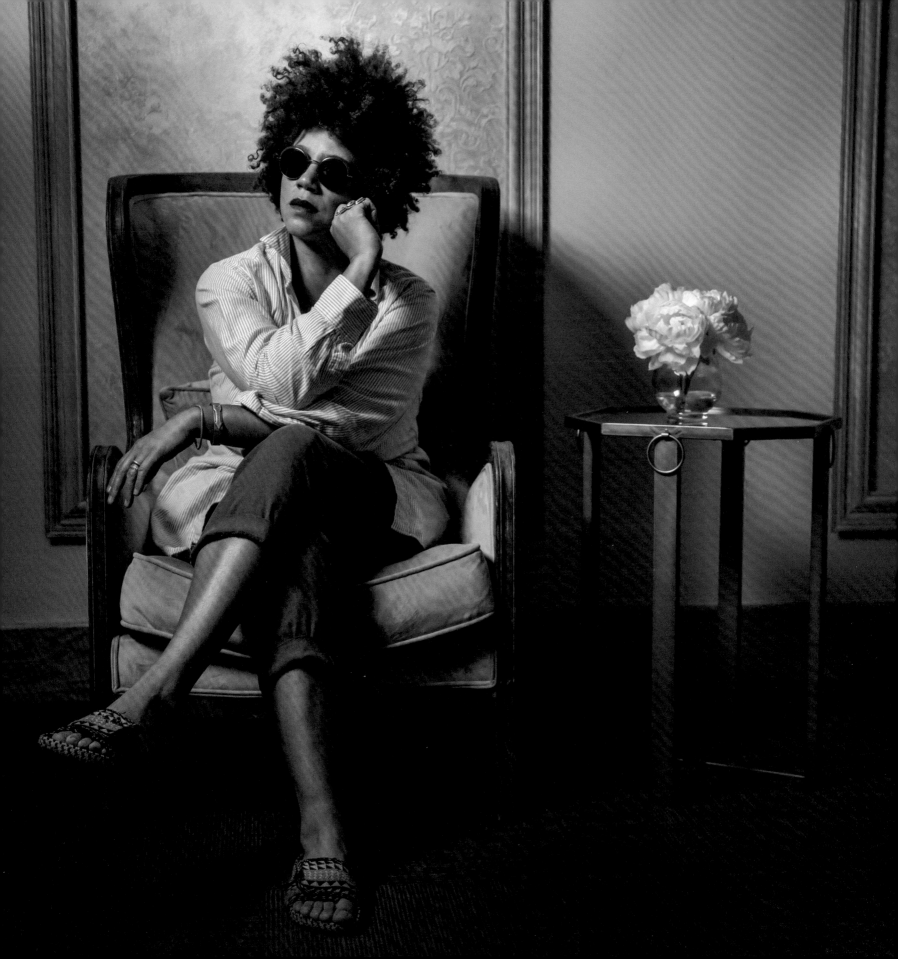

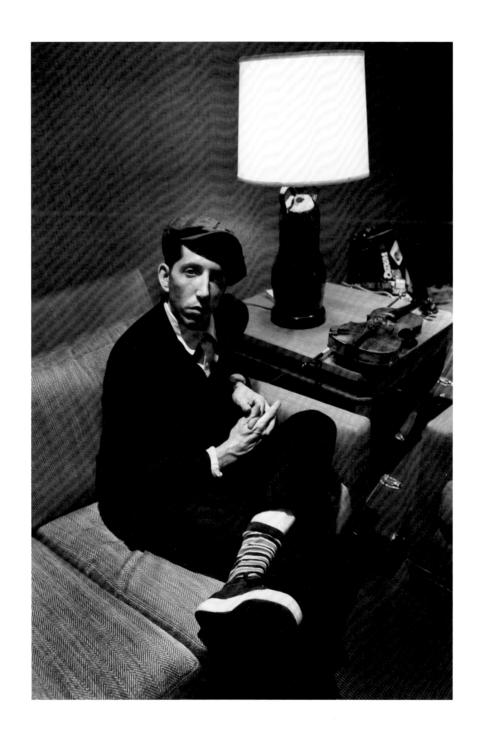

POKEY LAFARGE
Nashville, Tennessee

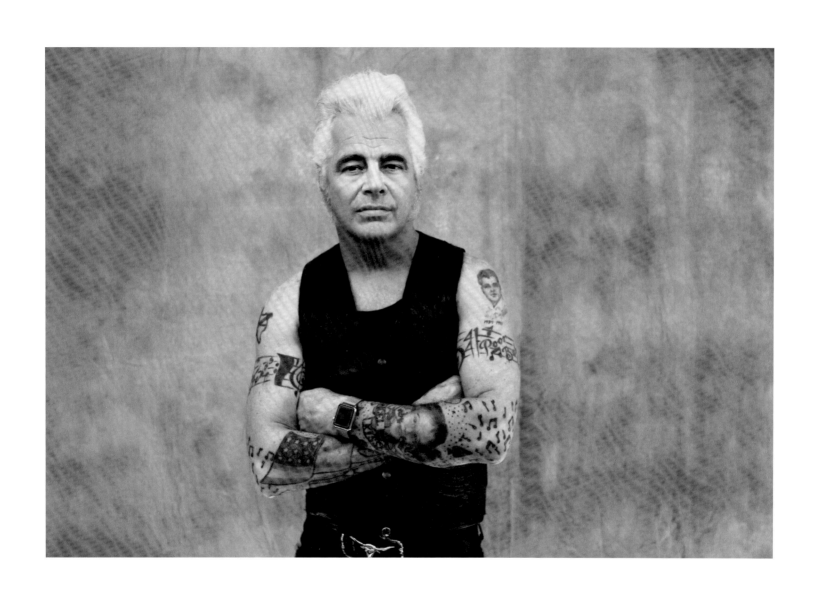

DALE WATSON
Los Angeles, California

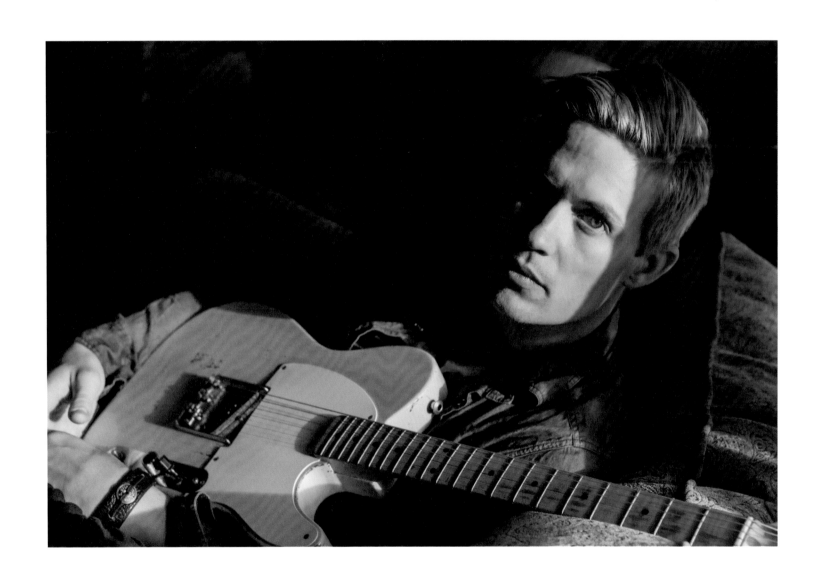

JONNY LANG
Los Angeles, California

OPPOSITE:
KING CORDUROY
Nashville, Tennessee

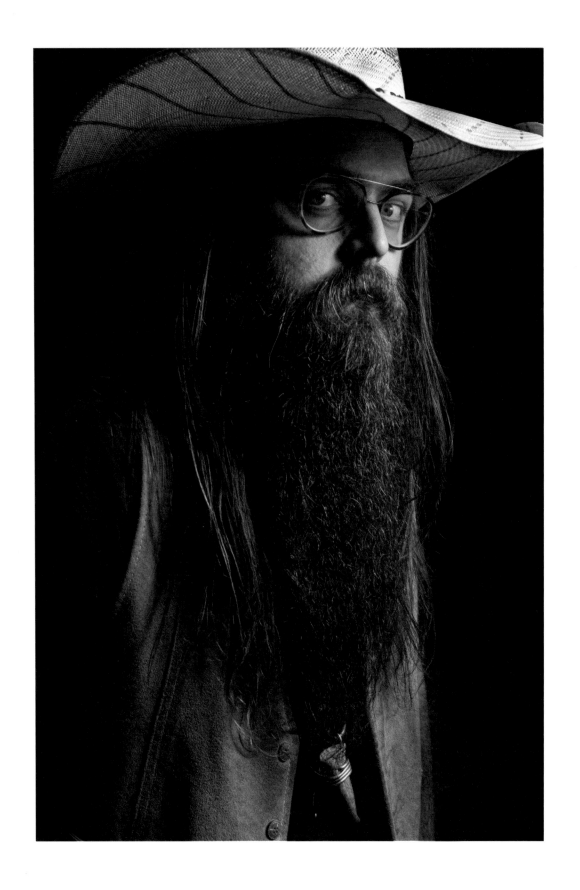

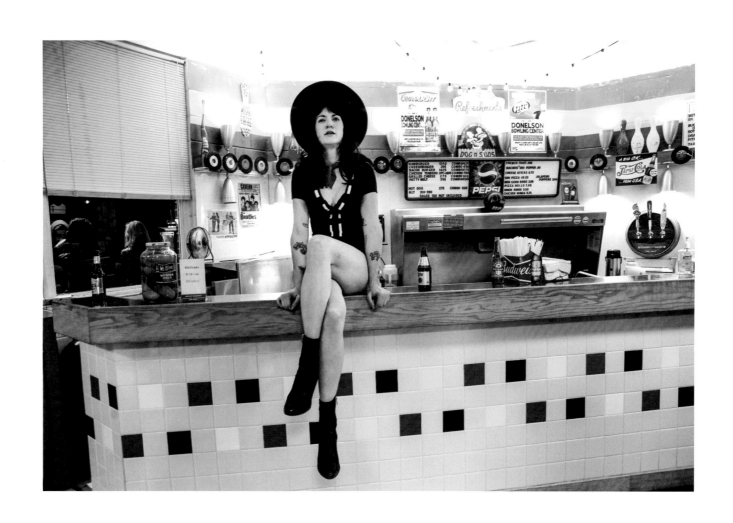

NIKKI LANE

Nashville, Tennessee

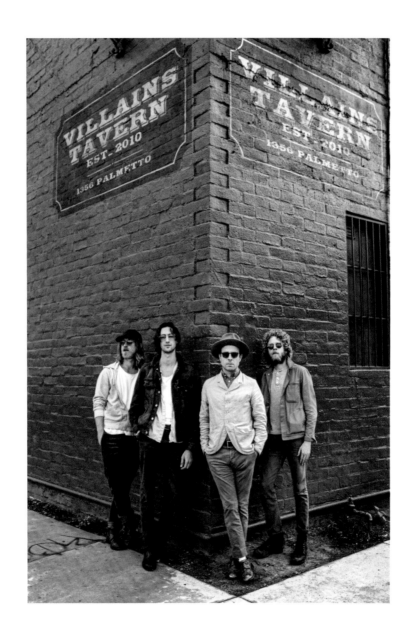

DAWES

Los Angeles, California

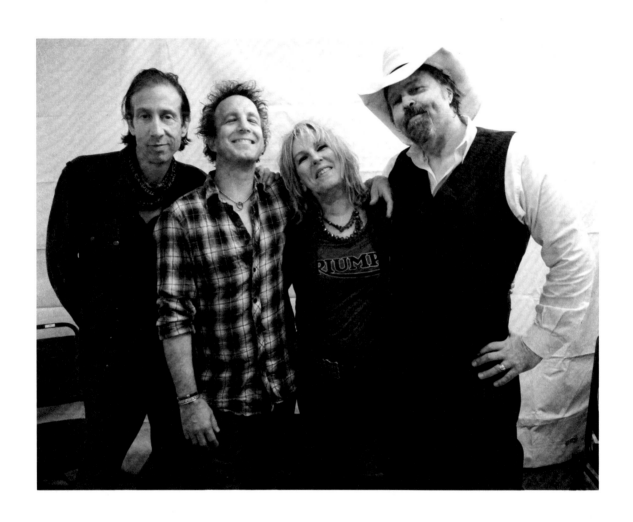

LUCINDA WILLIAMS AND BUICK 6
Los Angeles, California

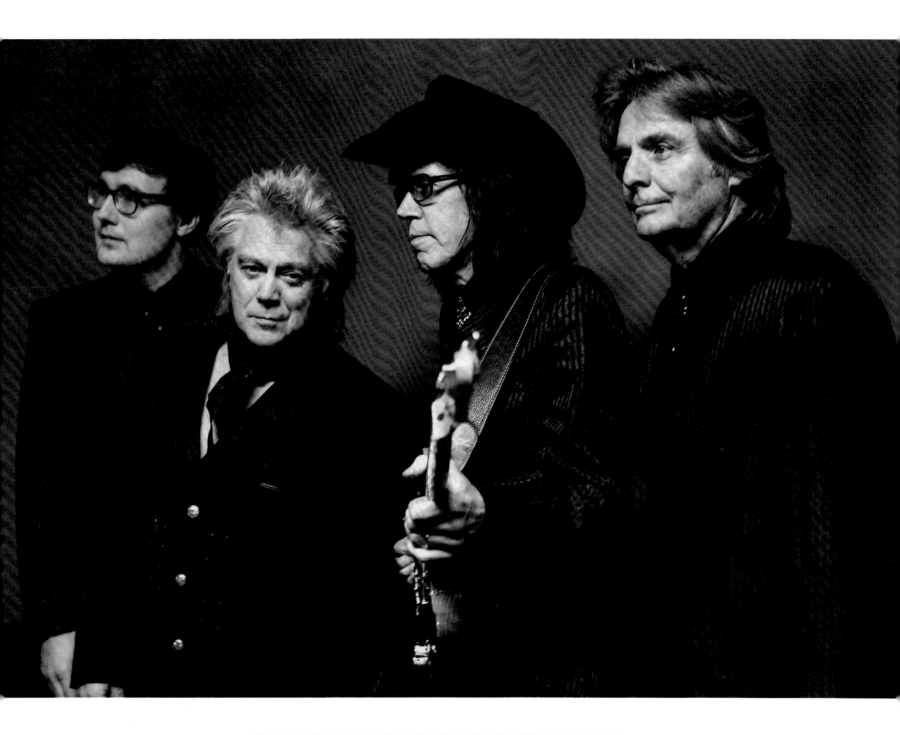

MARTY STUART AND THE FABULOUS SUPERLATIVES

Nashville, Tennessee

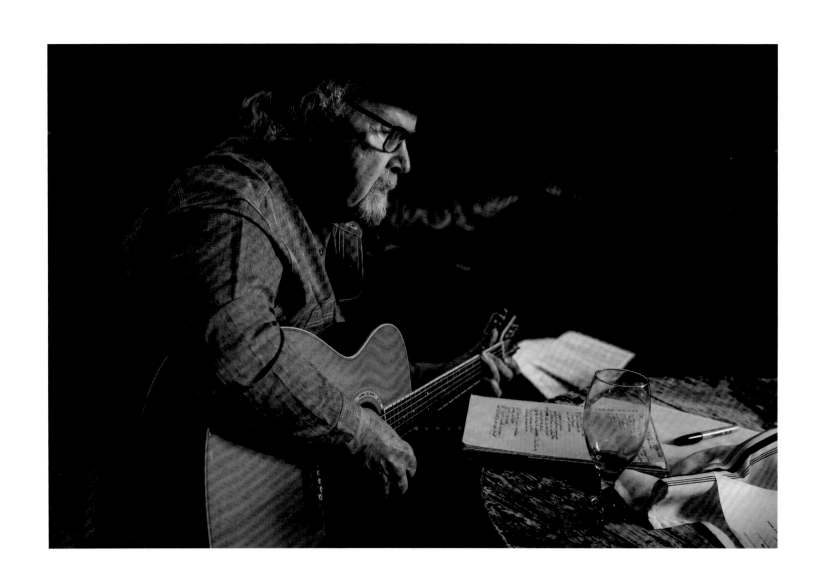

TOM PAXTON
Nashville, Tennessee

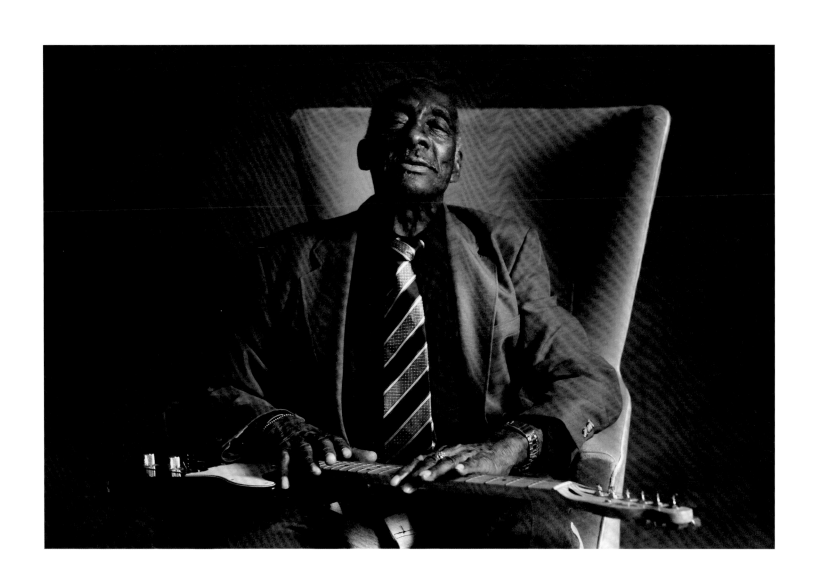

LEO "BUD" WELCH
Nashville, Tennessee

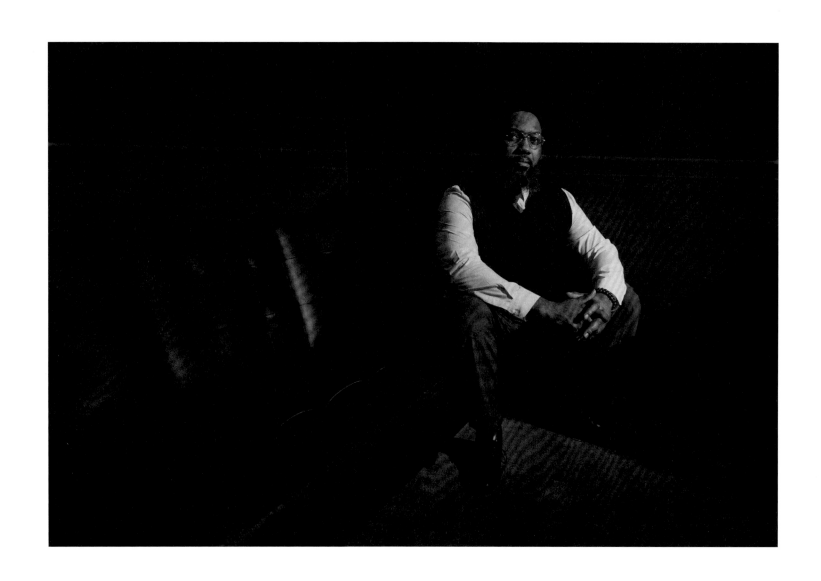

JASON ESKRIDGE

Nashville, Tennessee

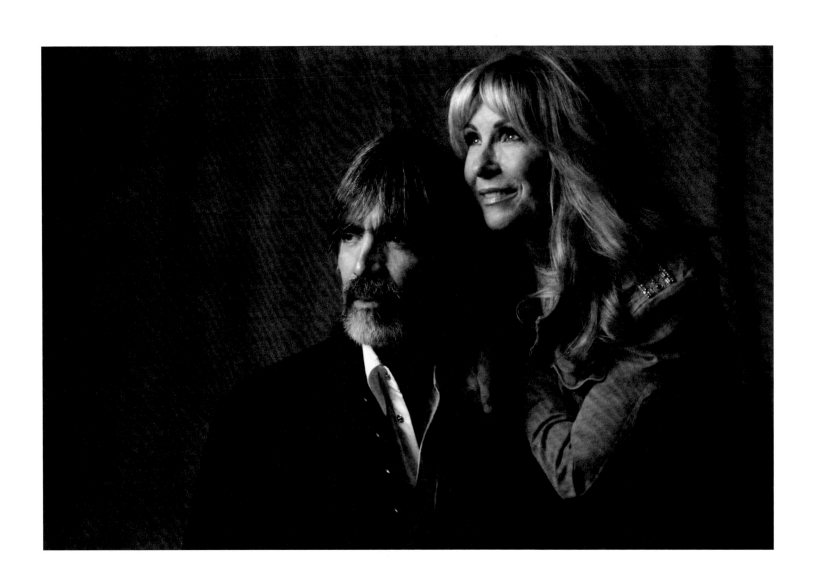

LARRY CAMPBELL AND TERESA WILLIAMS
Nashville, Tennessee

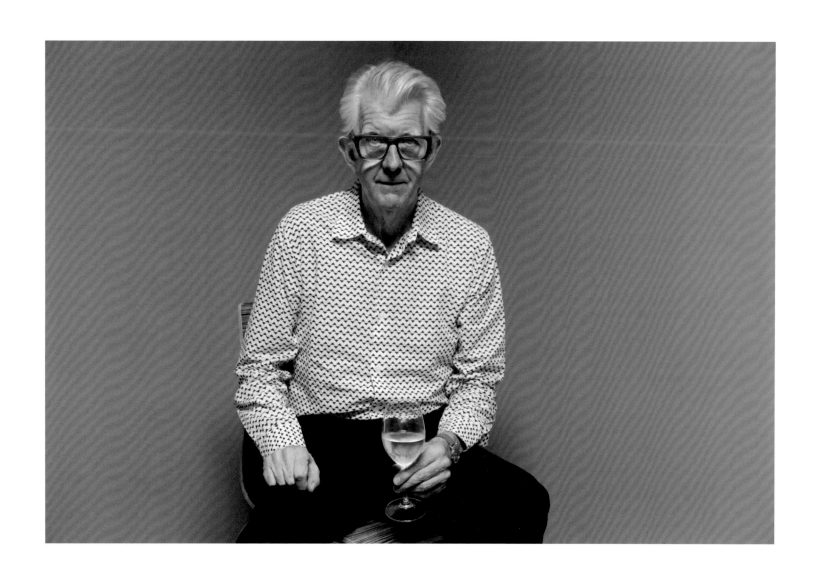

NICK LOWE

Nashville, Tennessee

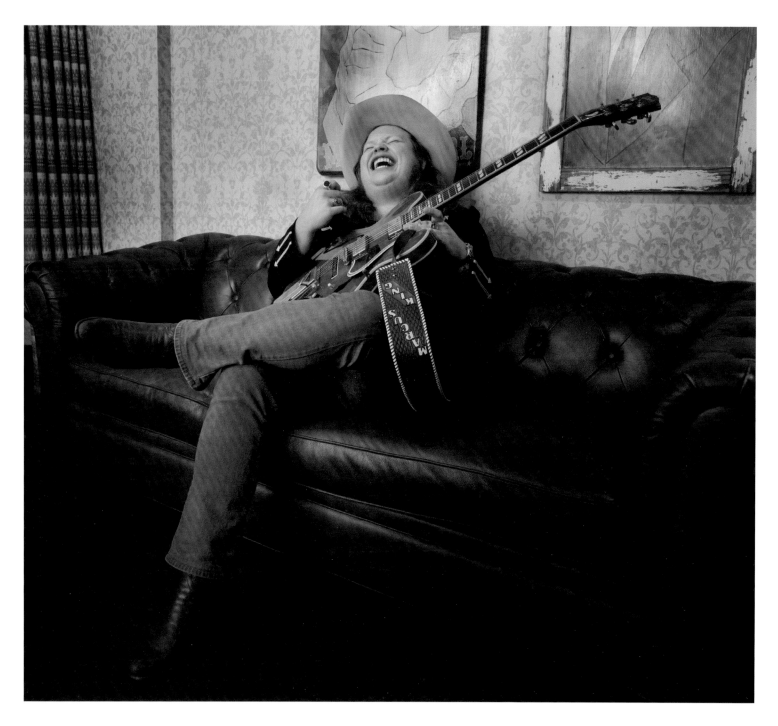

MARCUS KING

Nashville, Tennessee

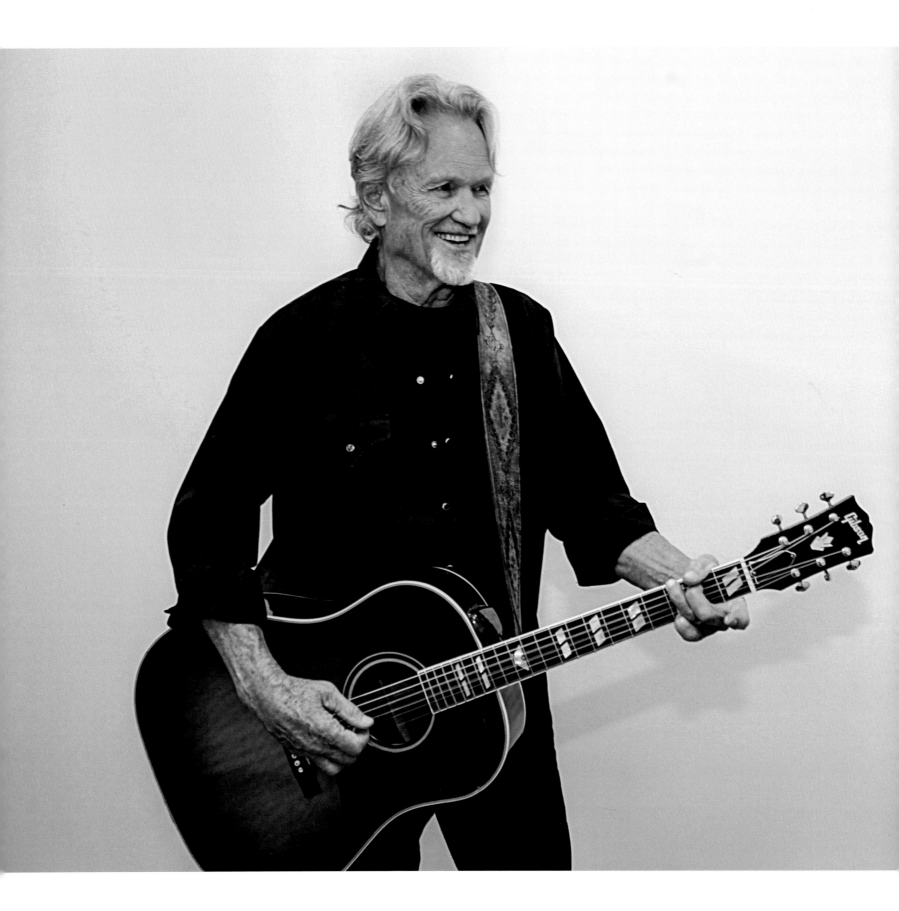

KRIS KRISTOFFERSON
Los Angeles, California

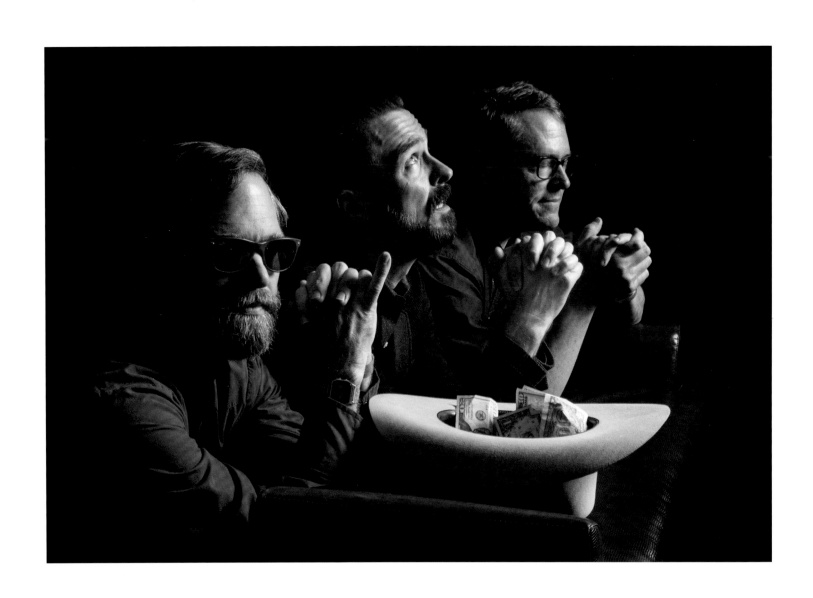

CHATHAM COUNTY LINE
New Orleans, Louisiana

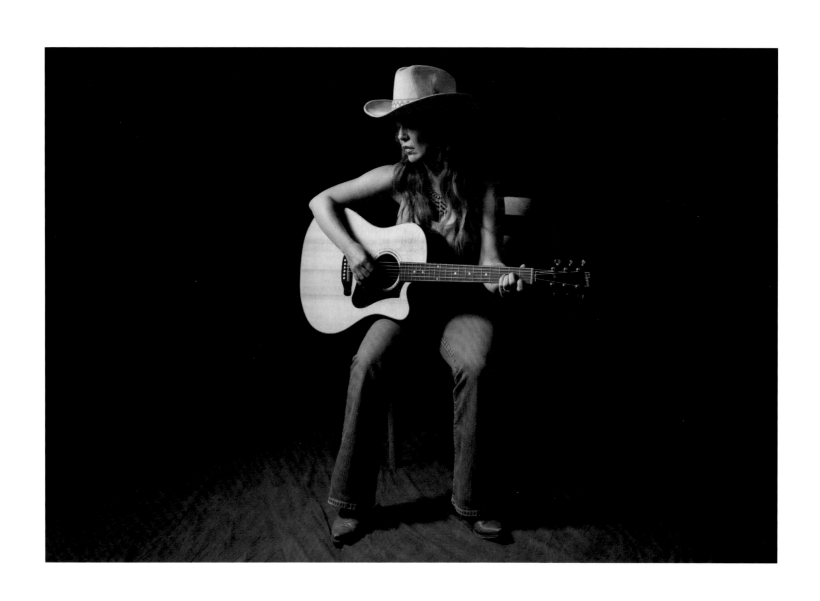

INDIA RAMEY

Nashville, Tennessee

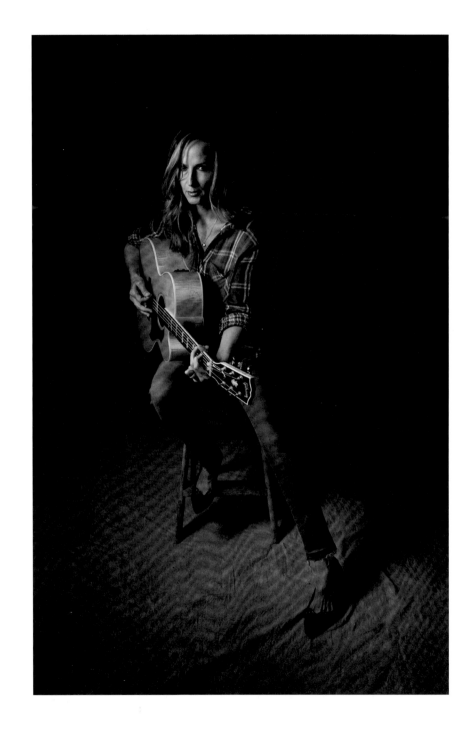

CHELY WRIGHT

Nashville, Tennessee

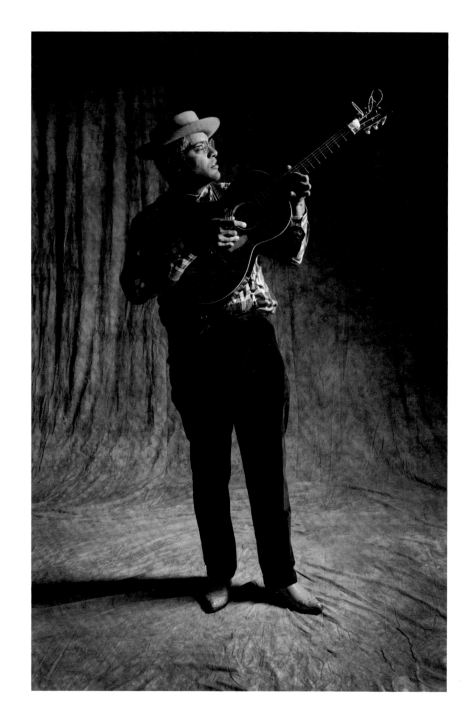

DOM FLEMONS

Memphis, Tennessee

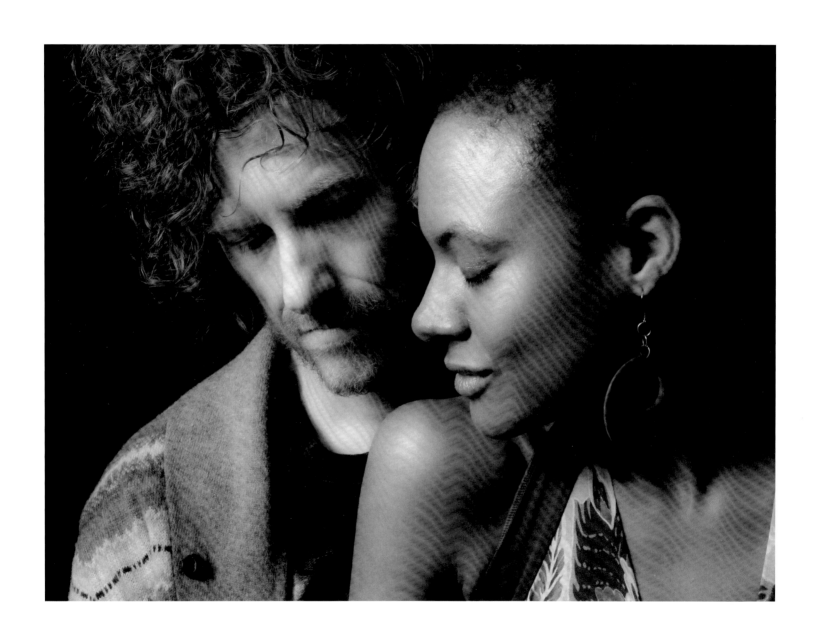

BIRDS OF CHICAGO
Allison Russell and JT Nero
Montreal, Quebec

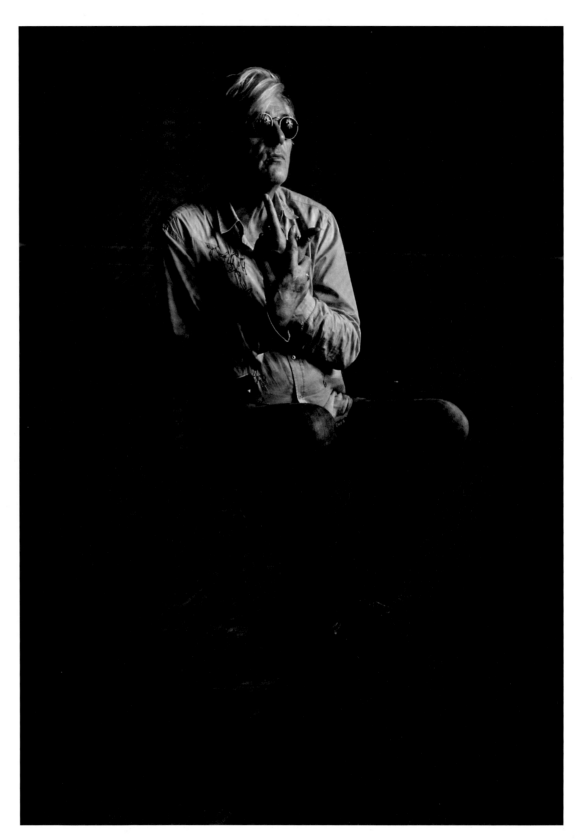

**ROBYN
HITCHCOCK**
Nashville, Tennessee

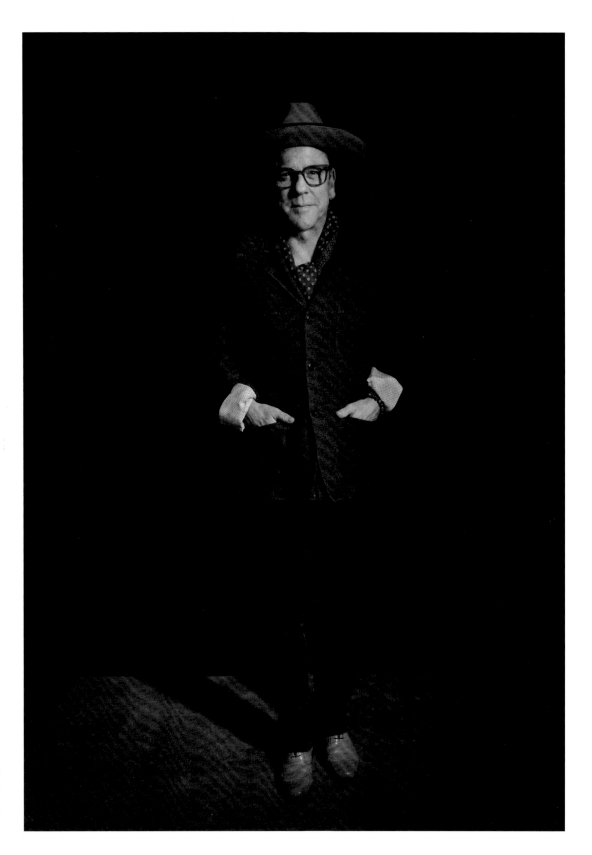

**KIEFER
SUTHERLAND**
Nashville, Tennessee

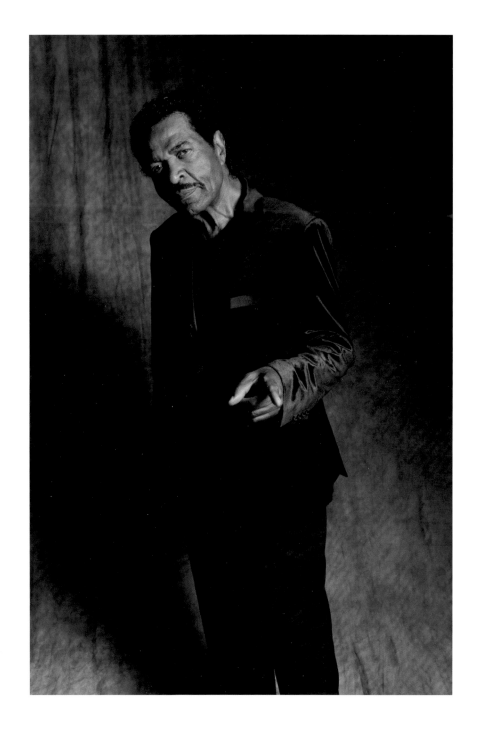

BOBBY RUSH
Memphis, Tennessee

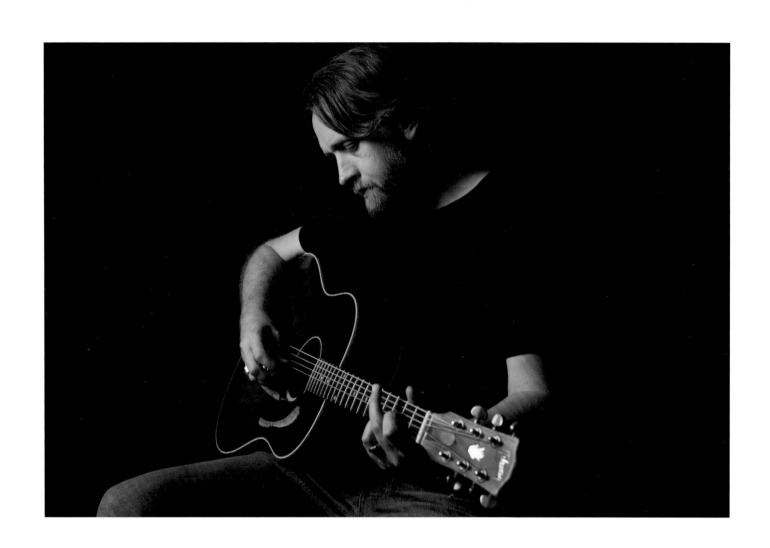

HAYES CARLL

Nashville, Tennessee

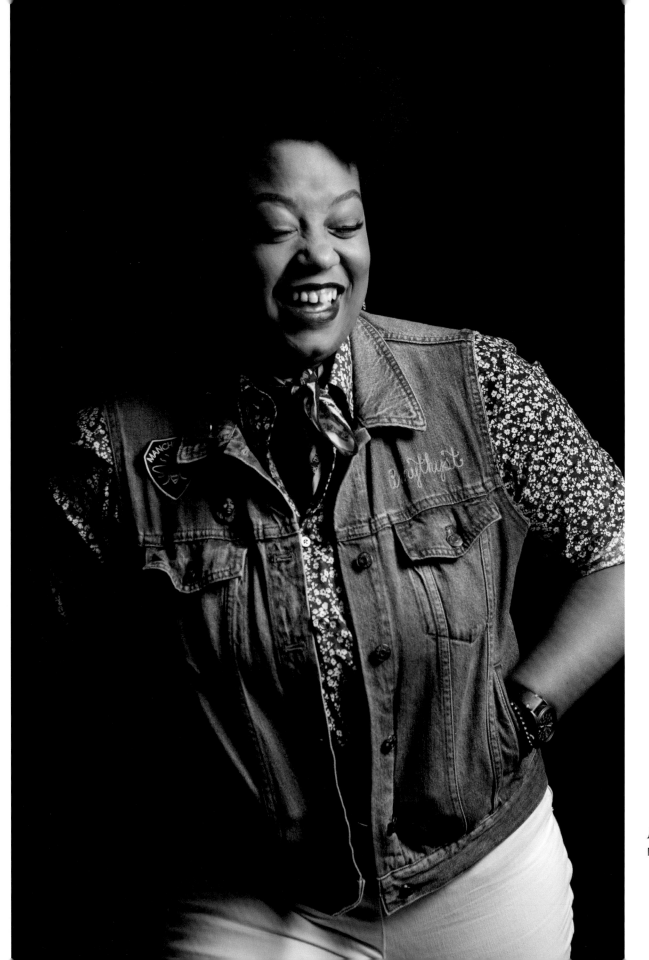

AMYTHYST KIAH
Nashville, Tennessee

75

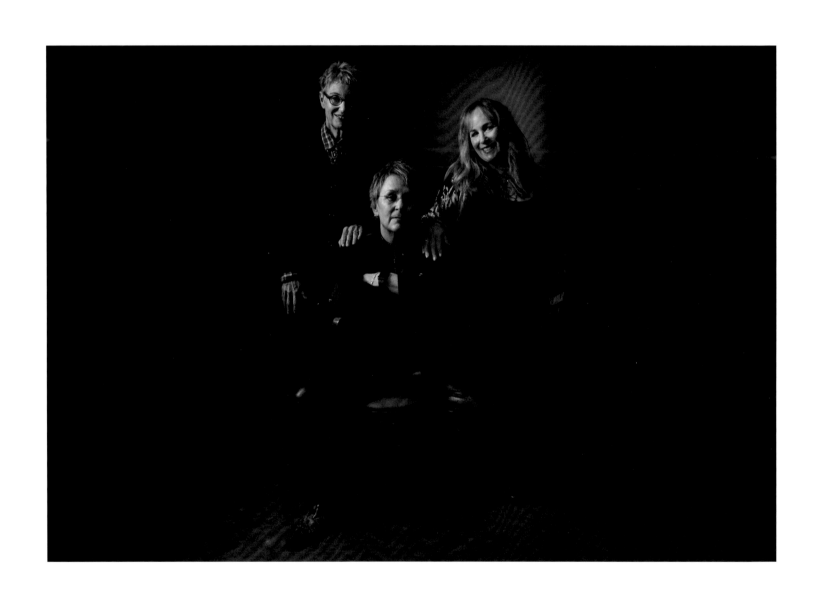

THREE WOMEN AND THE TRUTH
Eliza Gilkyson, Mary Gauthier, Gretchen Peters
Nashville, Tennessee

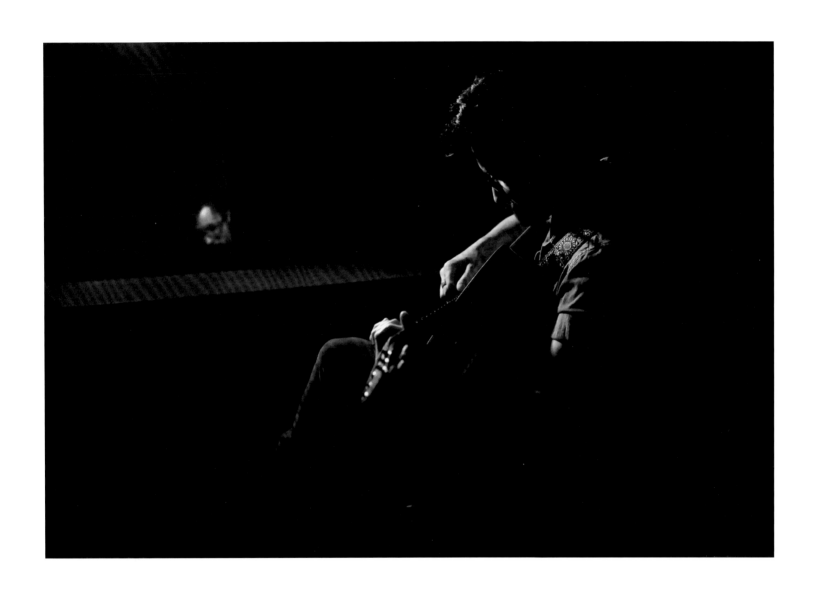

SEAN MCCONNELL
Nashville, Tennessee

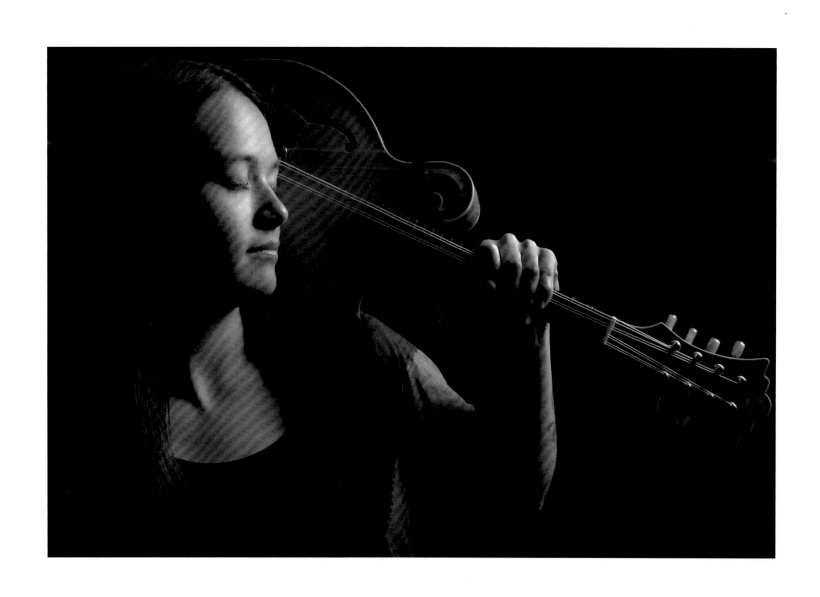

AJ LEE
Raleigh, North Carolina

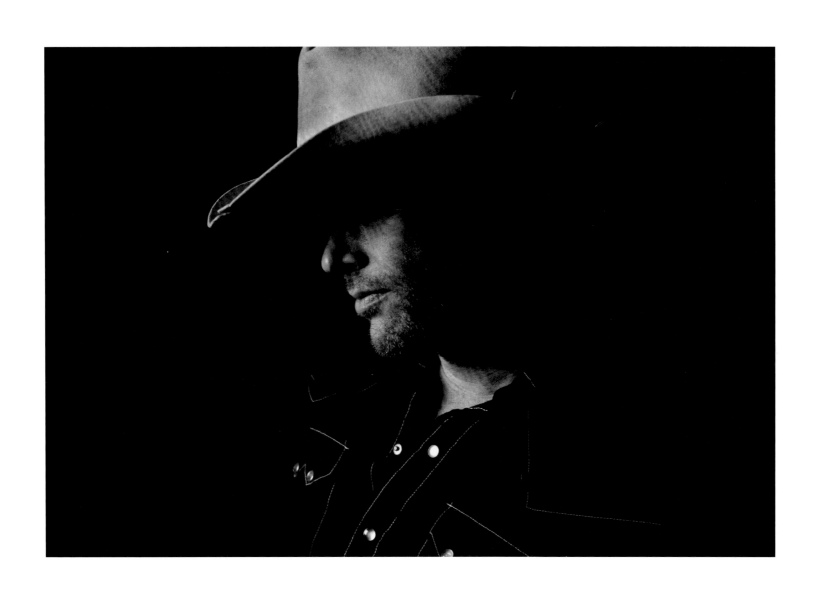

CORB LUND
Nashville, Tennessee

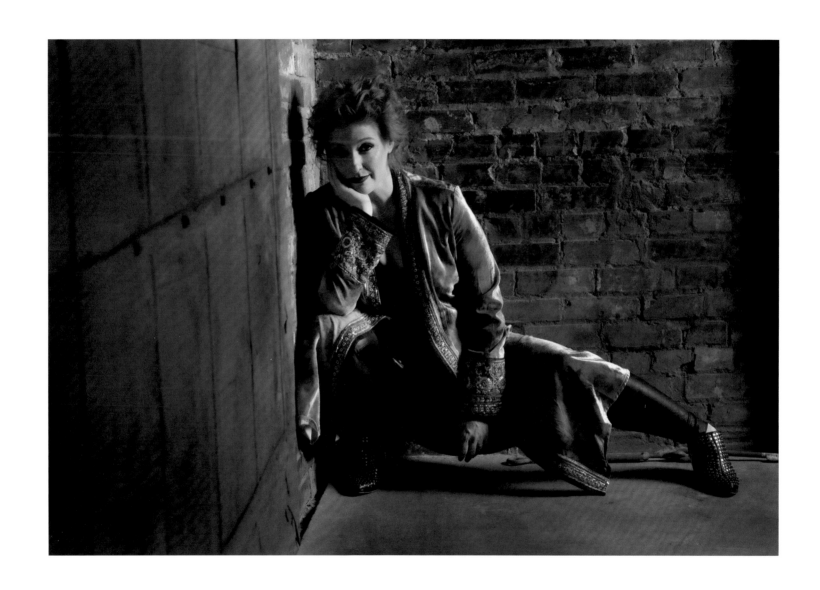

LEIGH NASH
Nashville, Tennessee

OPPOSITE:
MOLLY PARDEN
Nashville, Tennessee

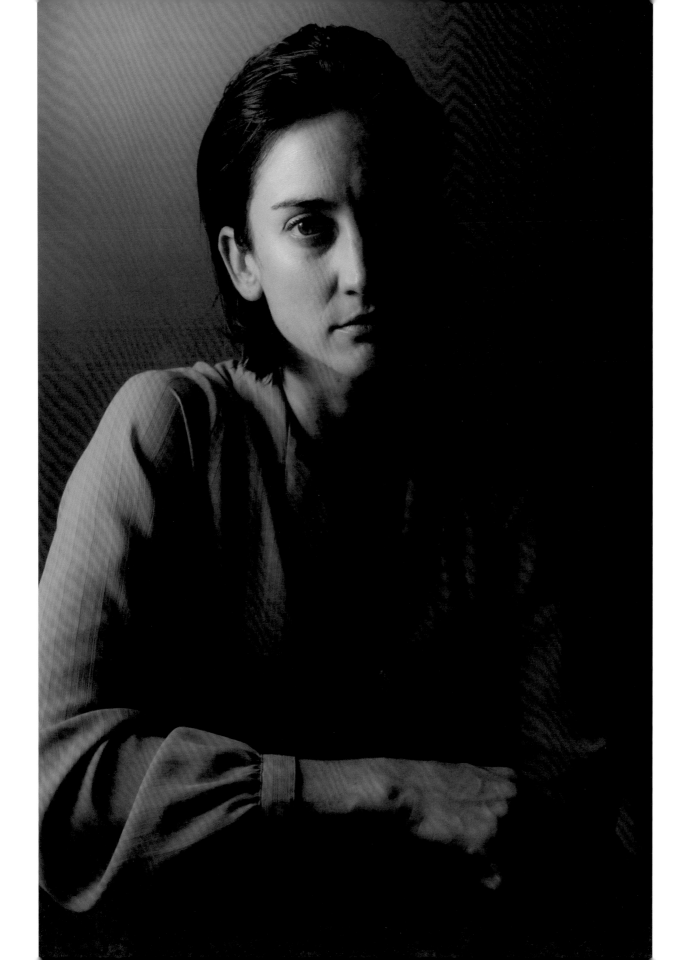

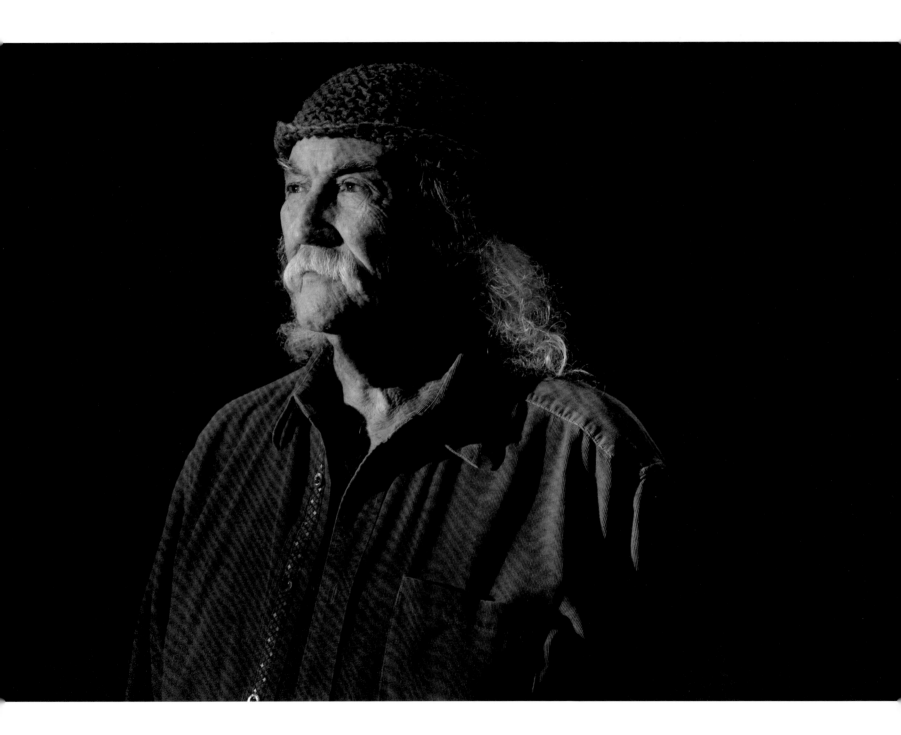

DAVID CROSBY

Nashville, Tennessee

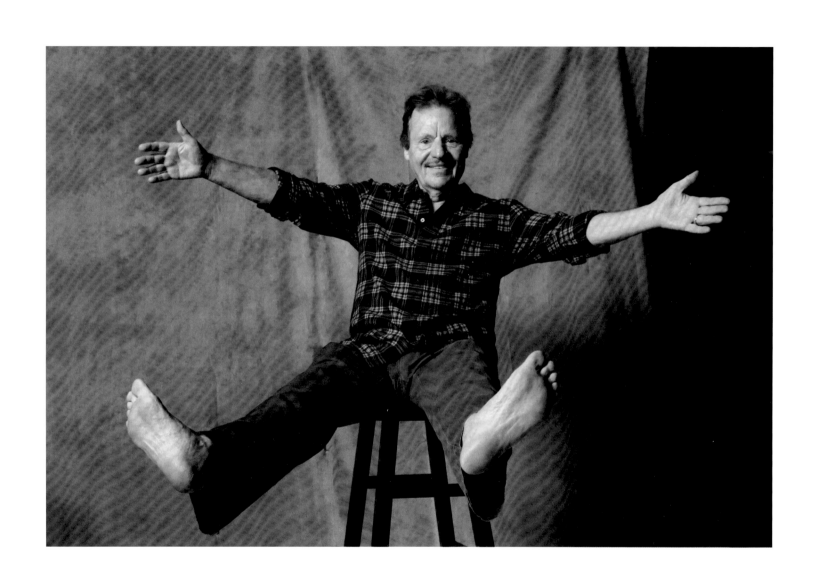

DELBERT MCCLINTON
Nashville, Tennessee

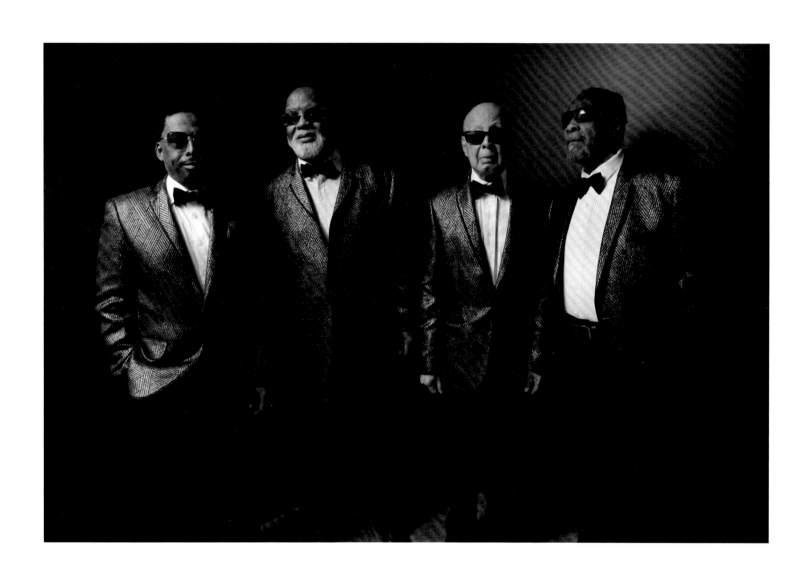

THE BLIND BOYS OF ALABAMA
Nashville, Tennessee

KELSEY WALDON
Manchester, Tennessee

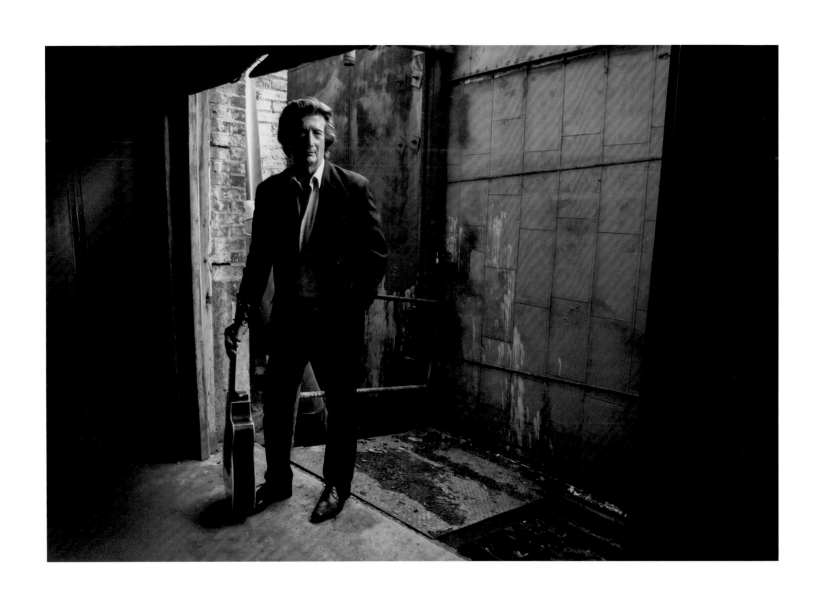

CHRIS SMITHER

Nashville, Tennessee

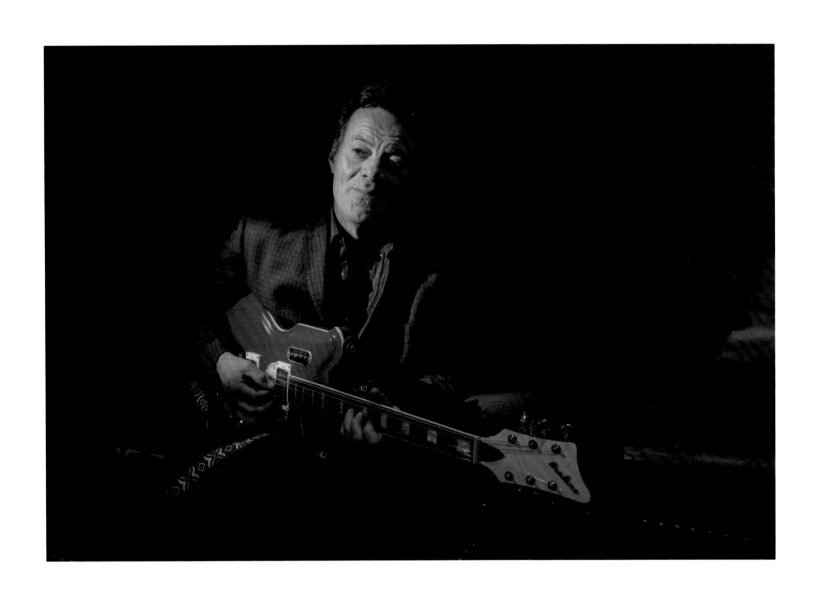

JAMES HUNTER

Nashville, Tennessee

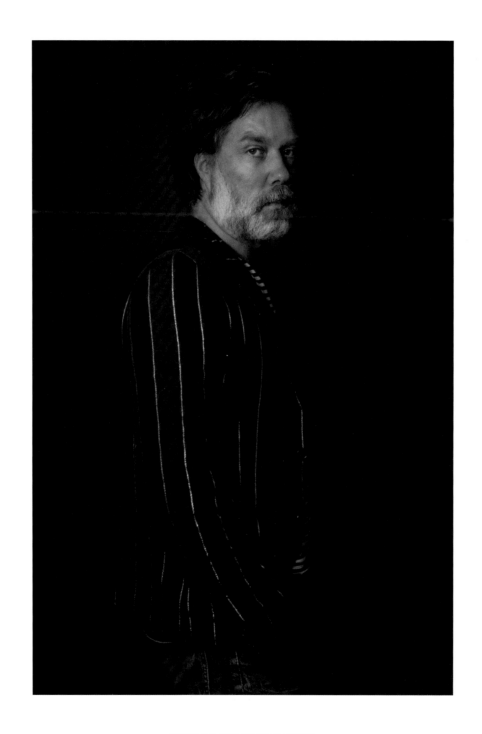

RUFUS WAINWRIGHT

Nashville, Tennessee

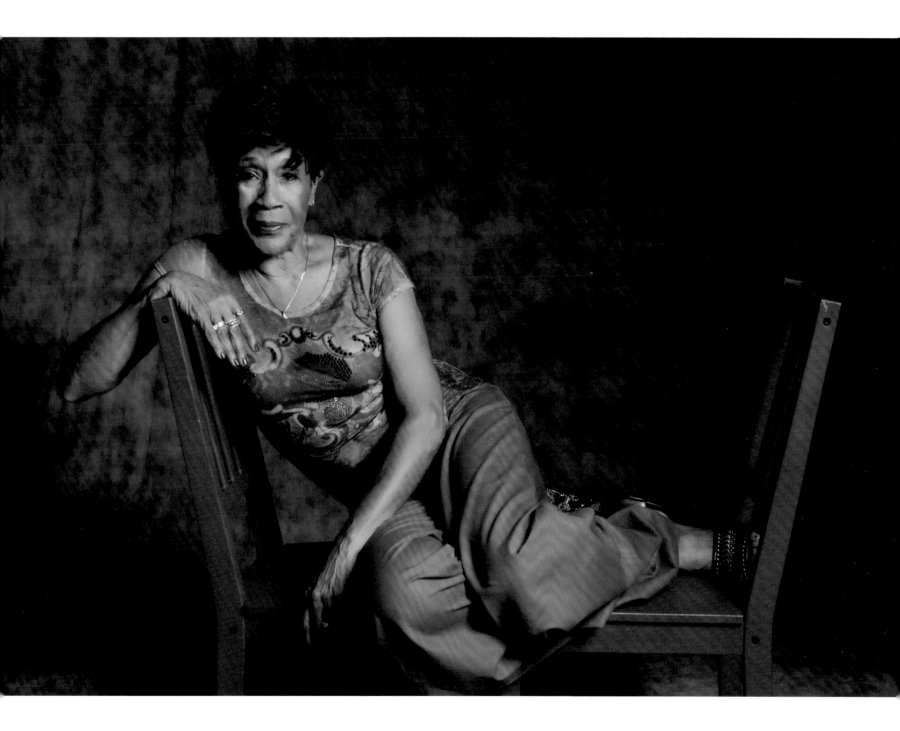

BETTYE LAVETTE
Nashville, Tennessee

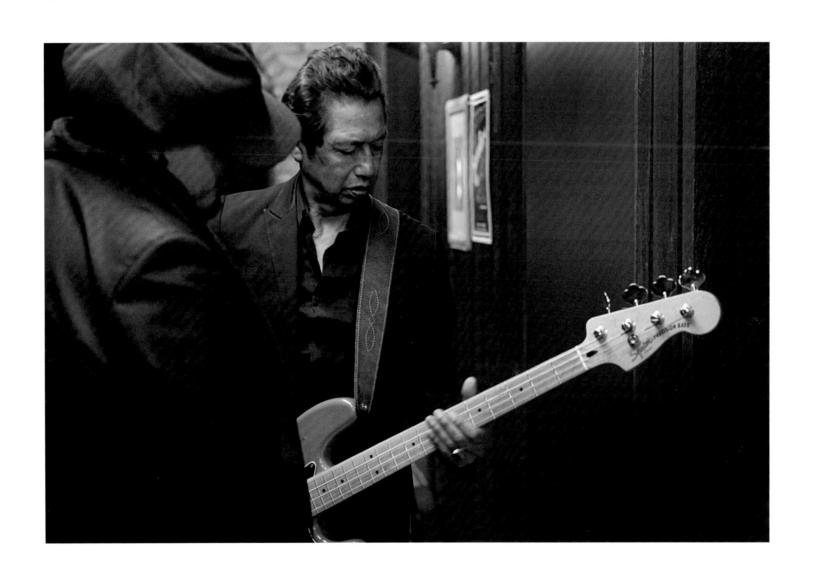

NICHOLAS TREMULIS AND ALEJANDRO ESCOVEDO
Austin, Texas

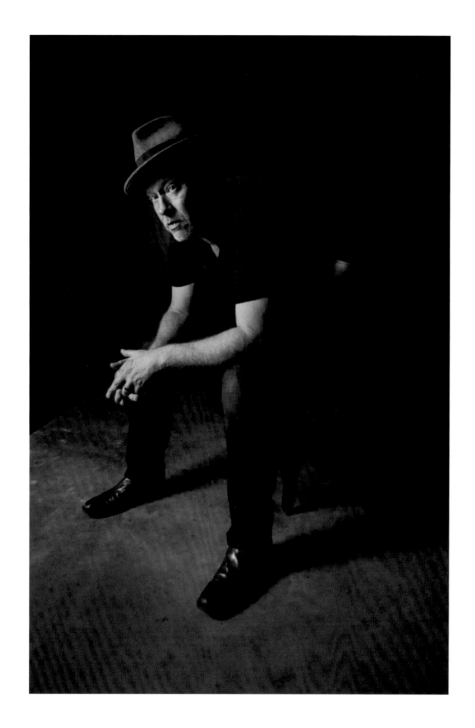

SHAWN MULLINS
Nashville, Tennessee

THE AVETT BROTHERS
Austin, Texas

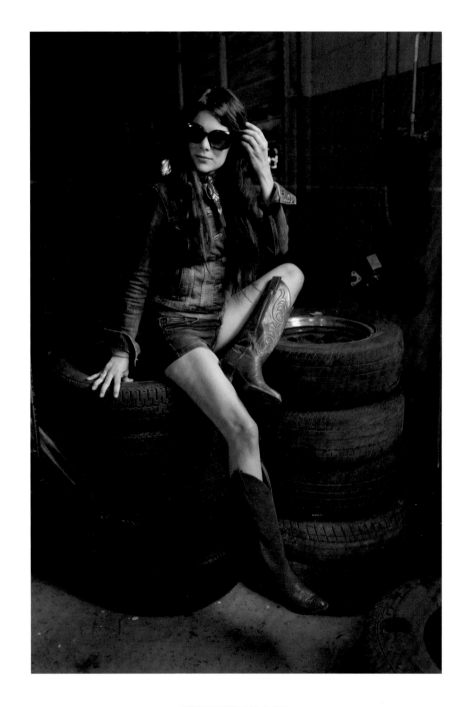

WHITNEY ROSE

Nashville, Tennessee

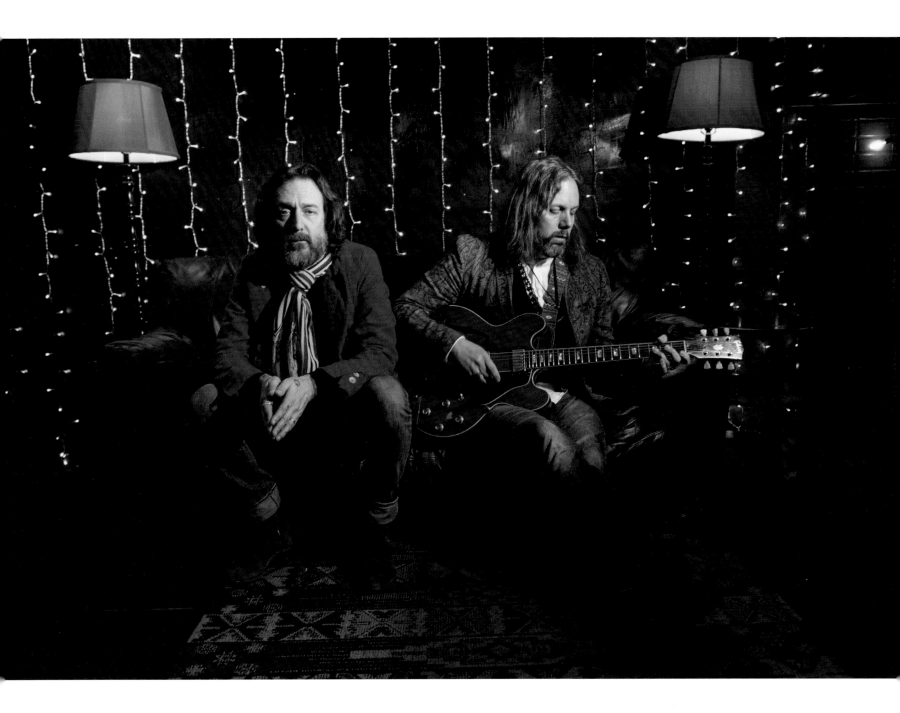

RICH AND CHRIS ROBINSON OF THE BLACK CROWES
Nashville, Tennessee

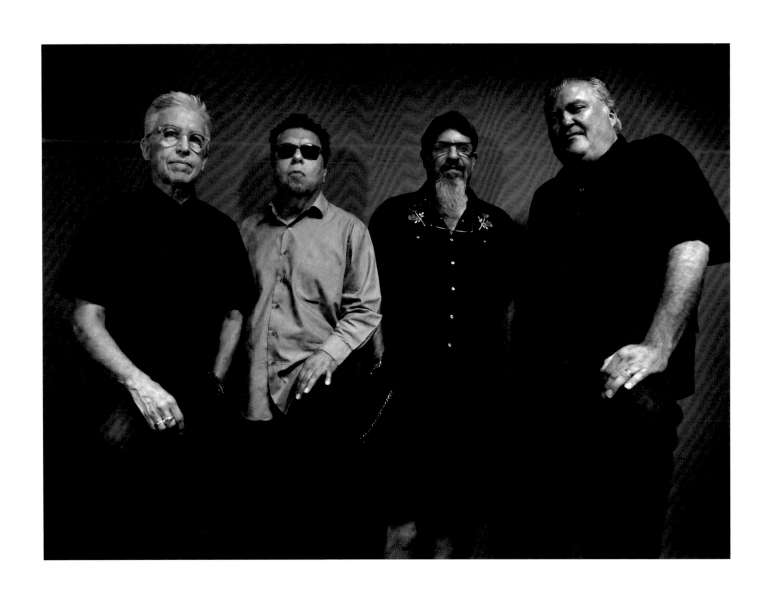

LOS LOBOS
Nashville, Tennessee

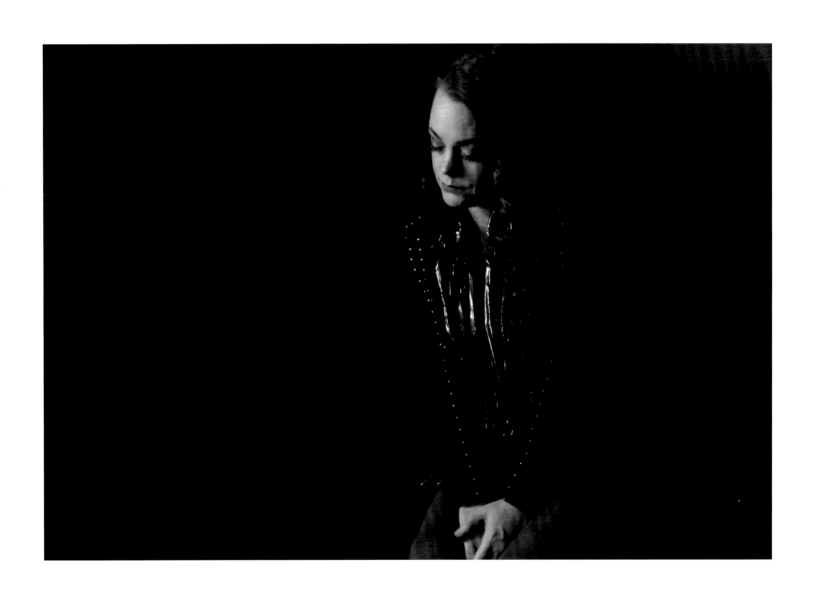

MINDY SMITH
Nashville, Tennessee

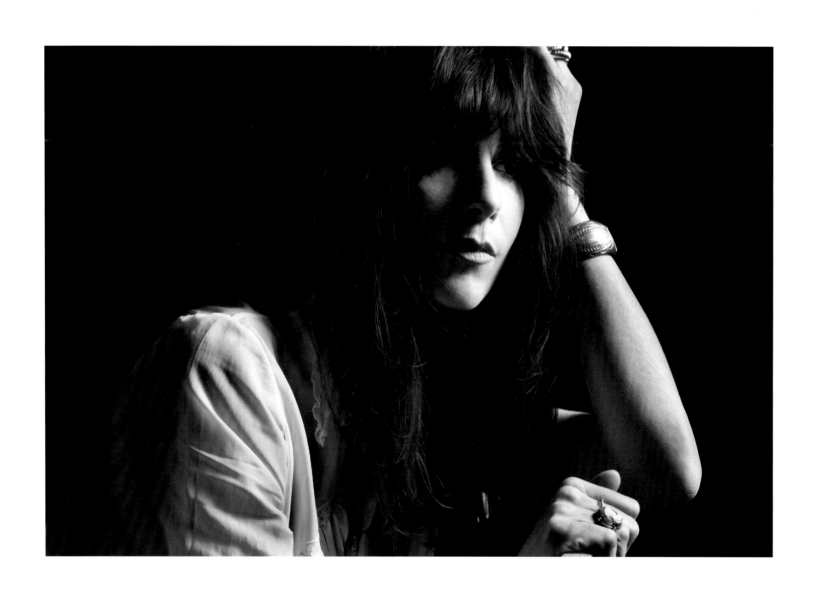

NICKI BLUHM

Nashville, Tennessee

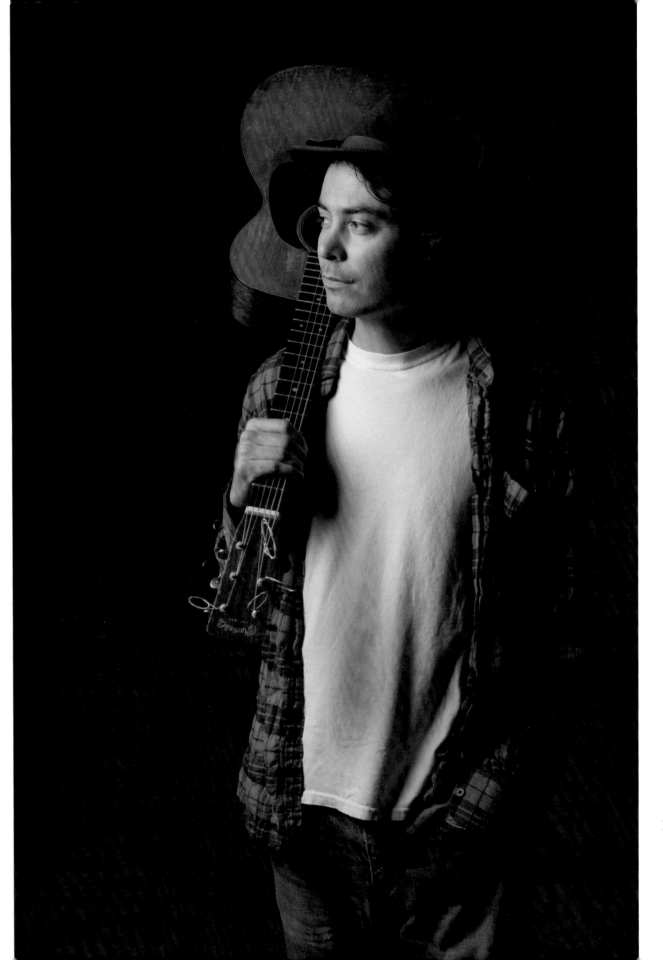

MAX GOMEZ
Nashville, Tennessee

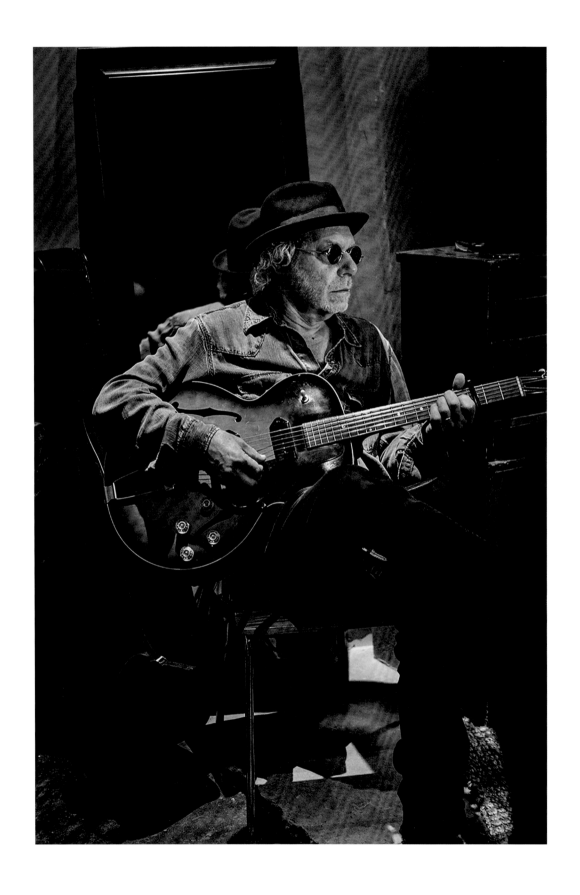

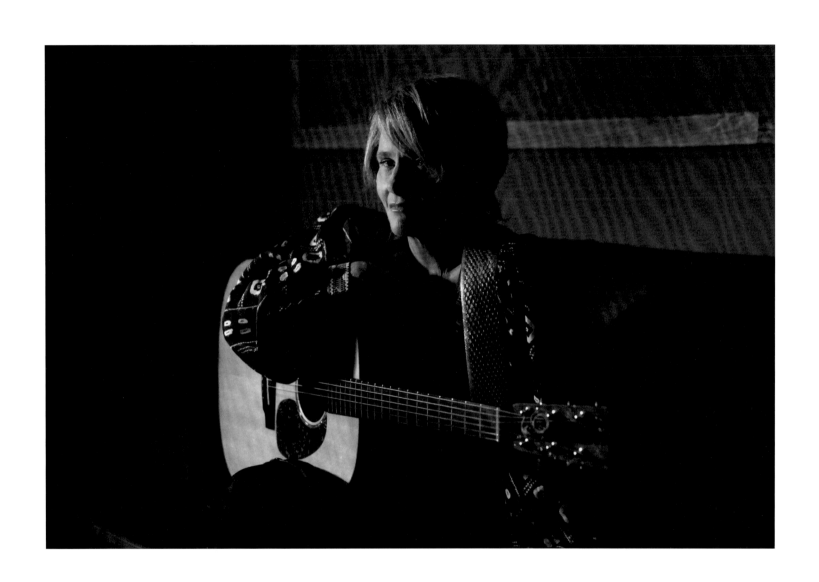

SHAWN COLVIN
Nashville, Tennessee

OPPOSITE:
BUDDY MILLER
Nashville, Tennessee

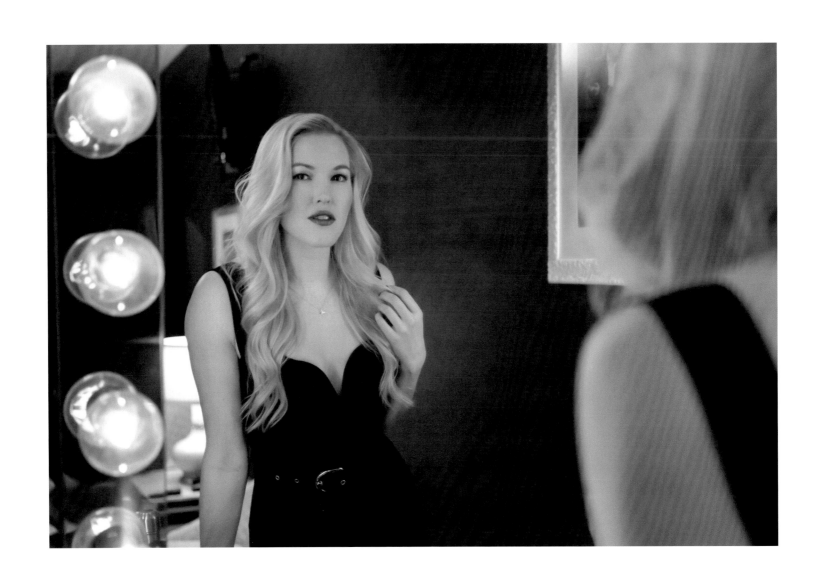

ASHLEY CAMPBELL
Nashville, Tennessee

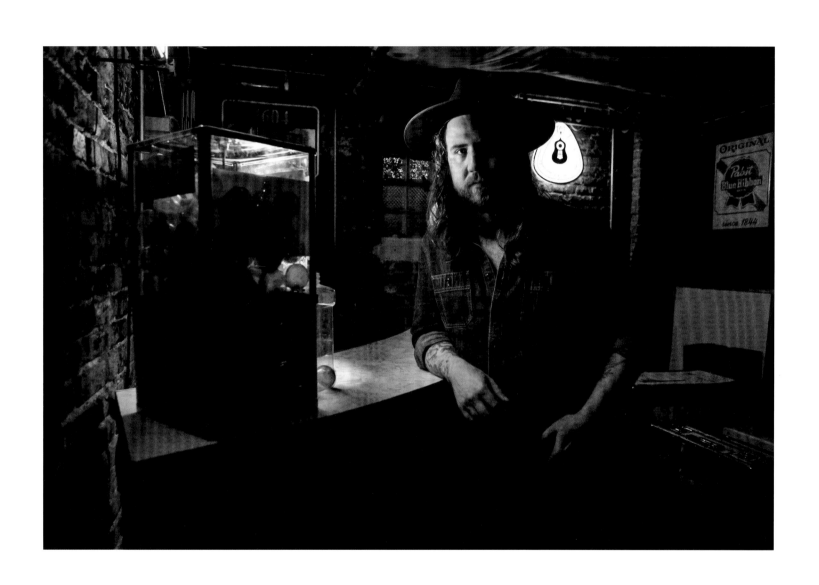

SAM MORROW

Nashville, Tennessee

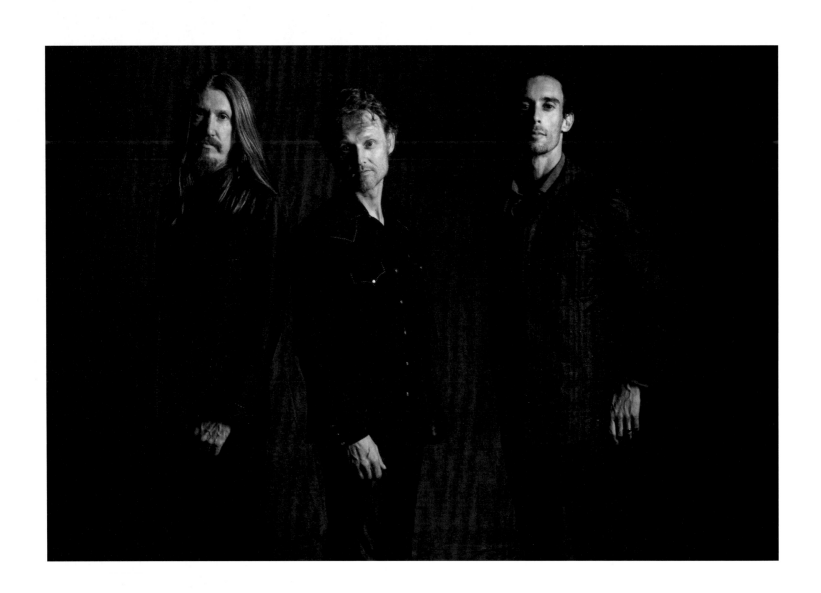

THE WOOD BROTHERS

Nashville, Tennessee

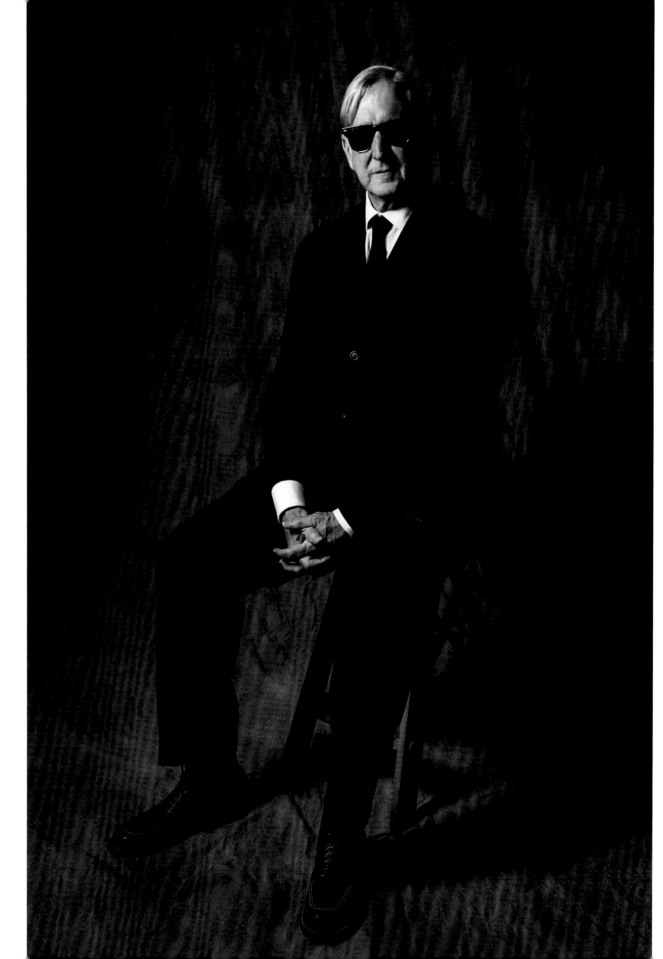

T BONE BURNETT
Nashville, Tennessee

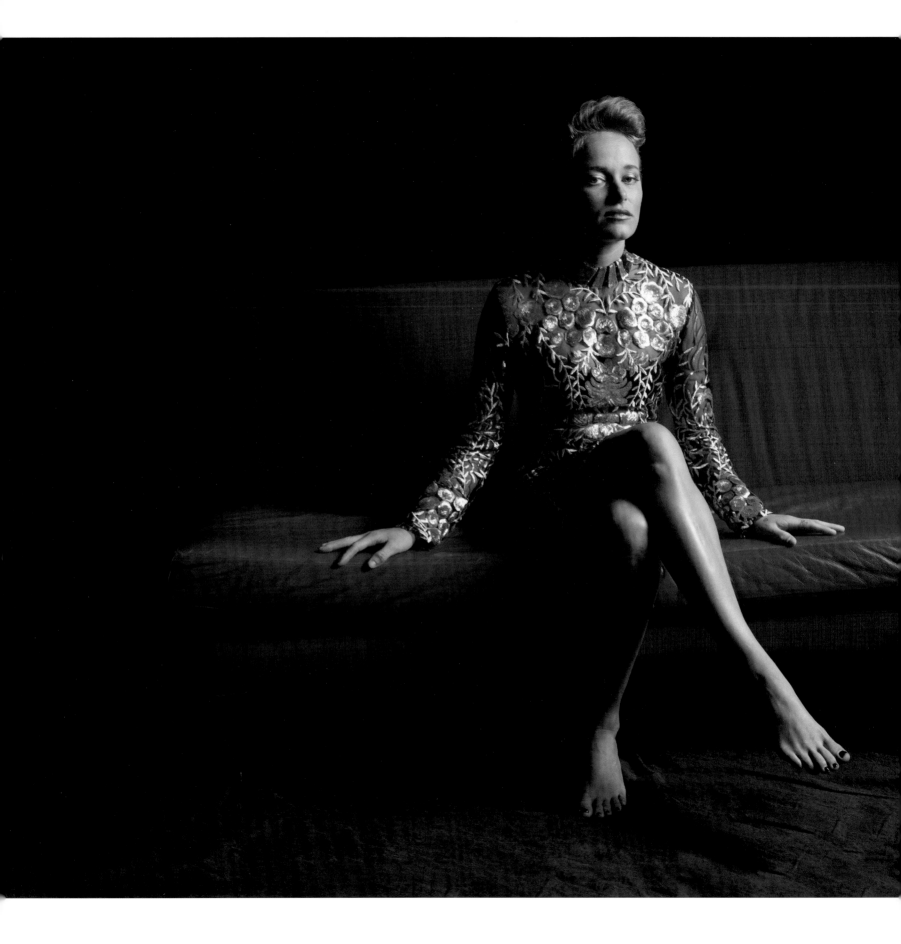

LEAH BLEVINS
Nashville, Tennessee

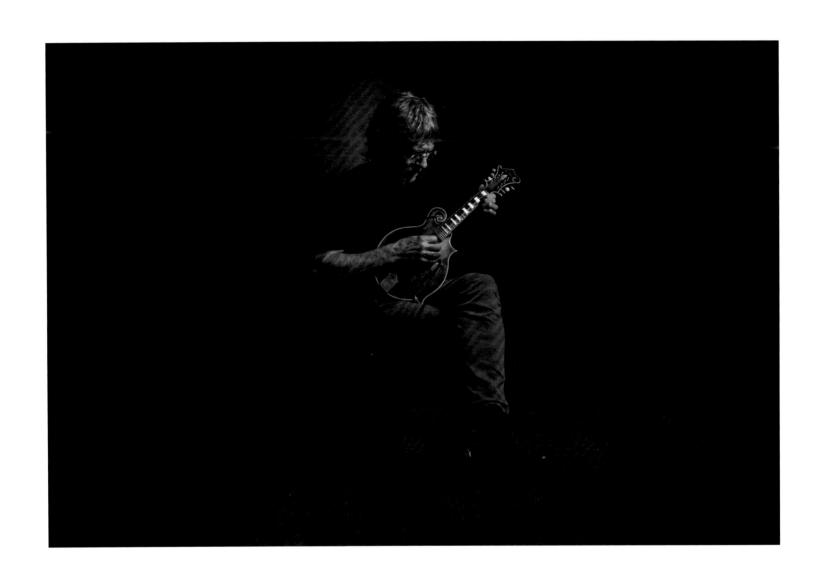

SAM BUSH

Nashville, Tennessee

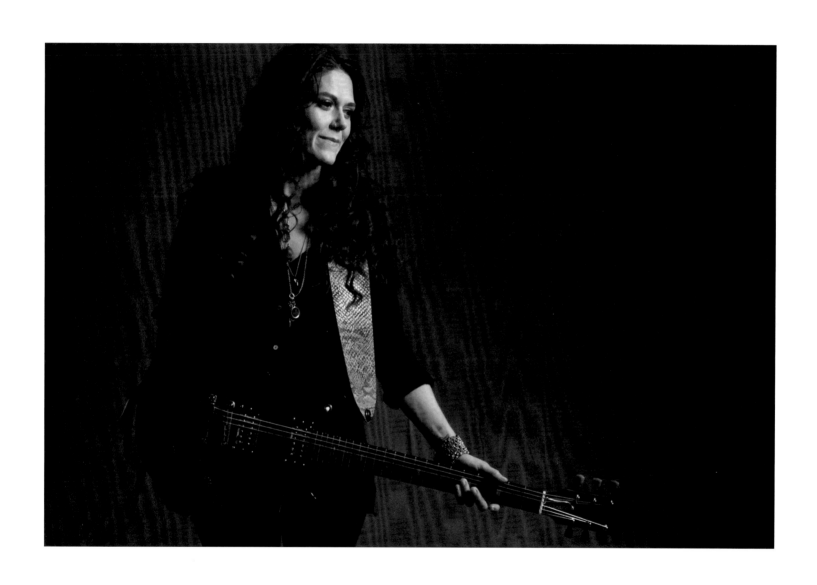

LILLY HIATT

Nashville, Tennessee

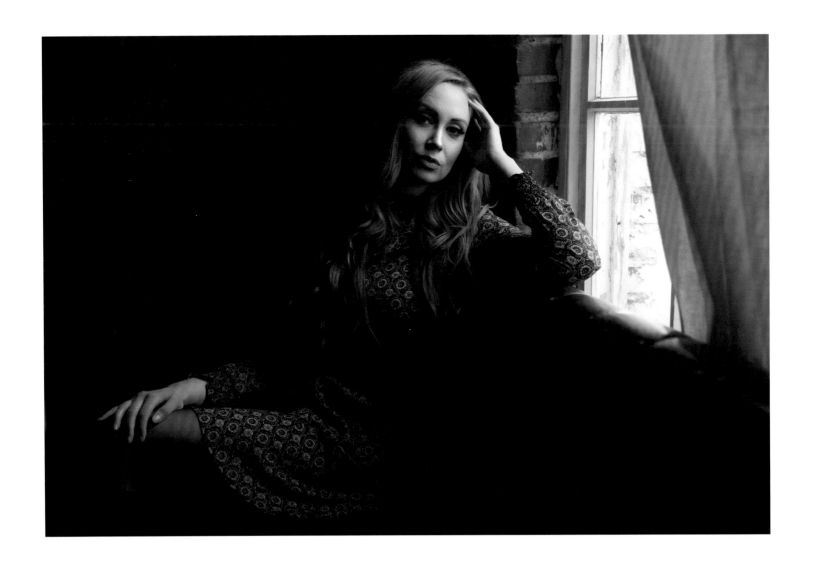

KATIE COLE

Nashville, Tennessee

OPPOSITE:

KENDELL MARVEL

Nashville, Tennessee

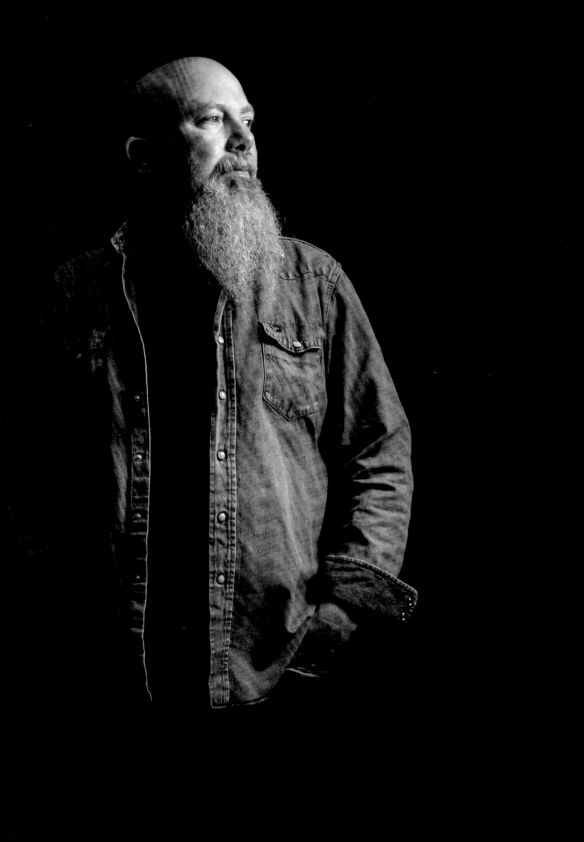

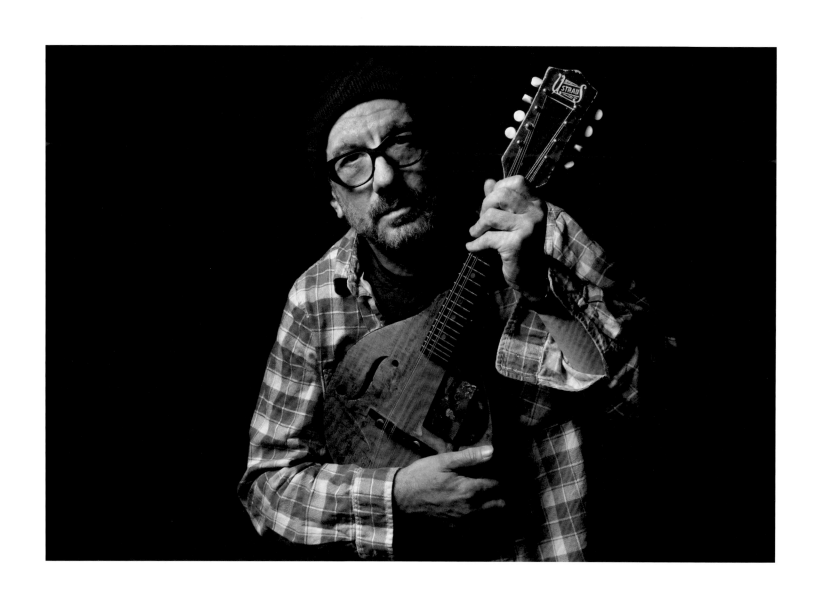

MARVIN ETZIONI
Nashville, Tennessee

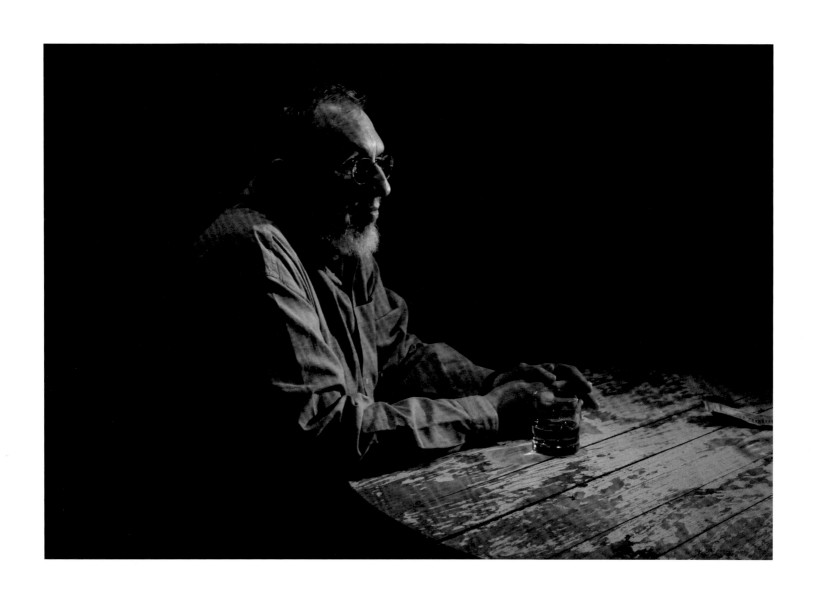

DAVID BROMBERG
Nashville, Tennessee

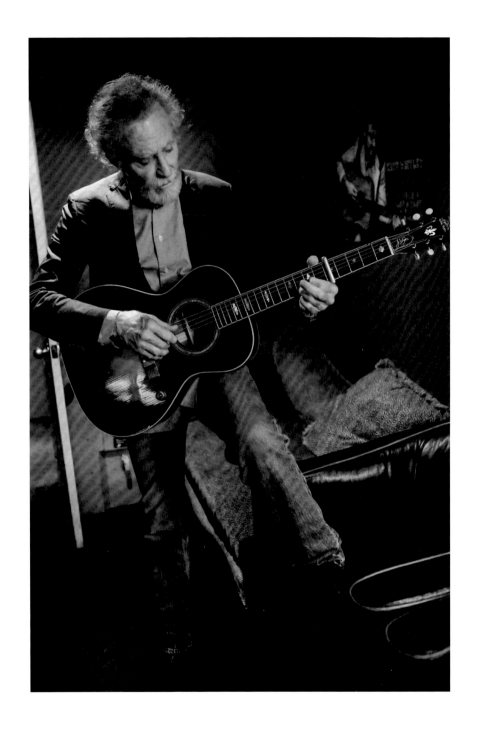

J. D. SOUTHER
Nashville, Tennessee

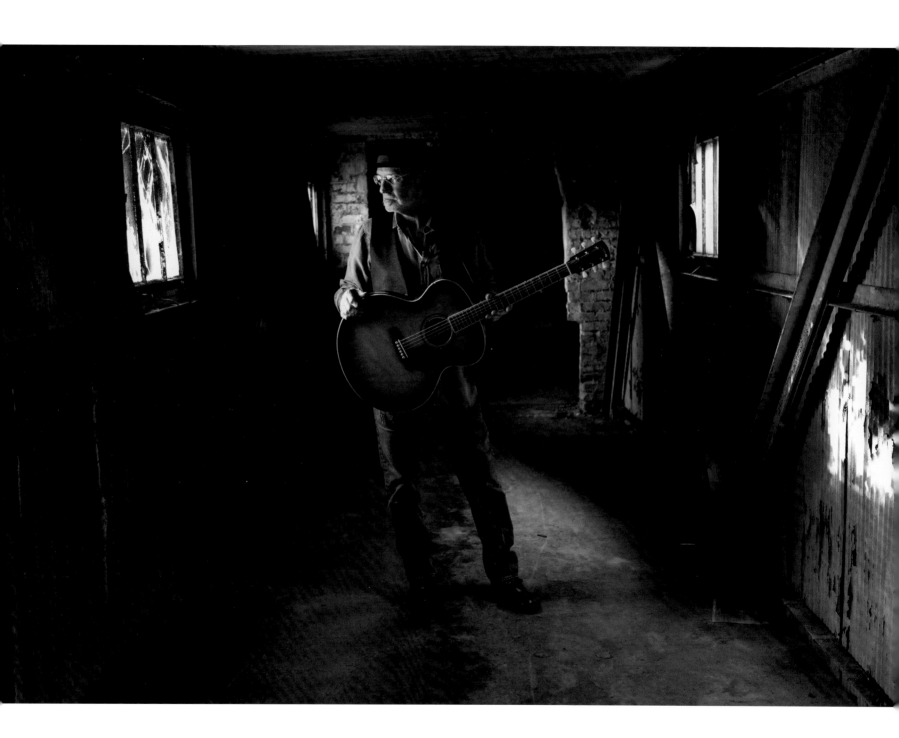

DAVID STARR
Nashville, Tennessee

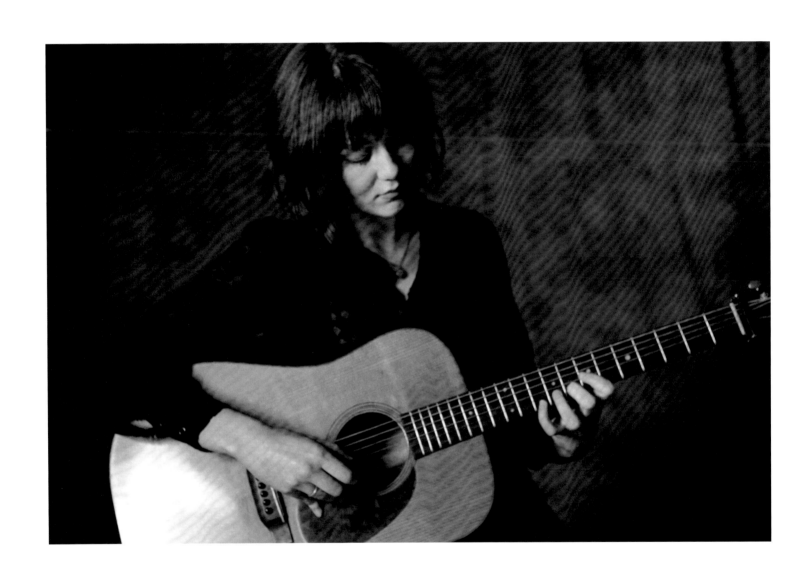

MOLLY TUTTLE

Nashville, Tennessee

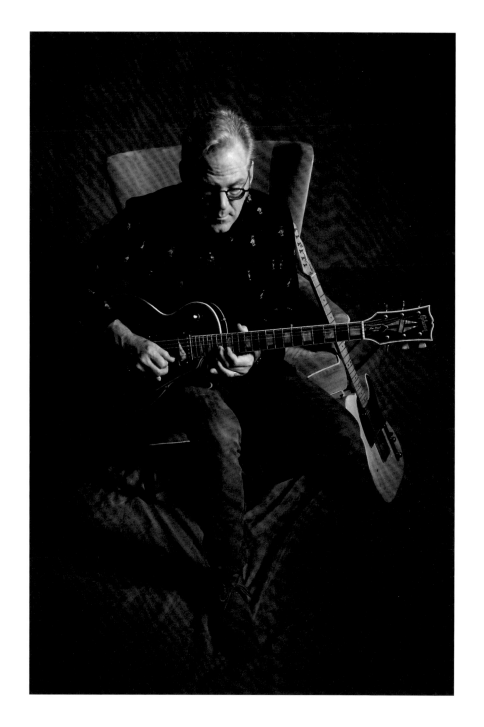

JOHN JORGENSON
Nashville, Tennessee

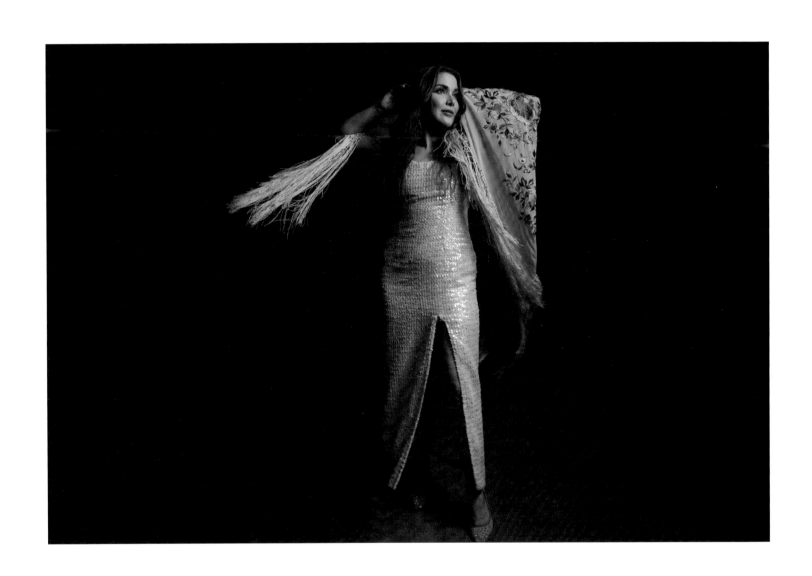

CAYLEE HAMMACK

Nashville, Tennessee

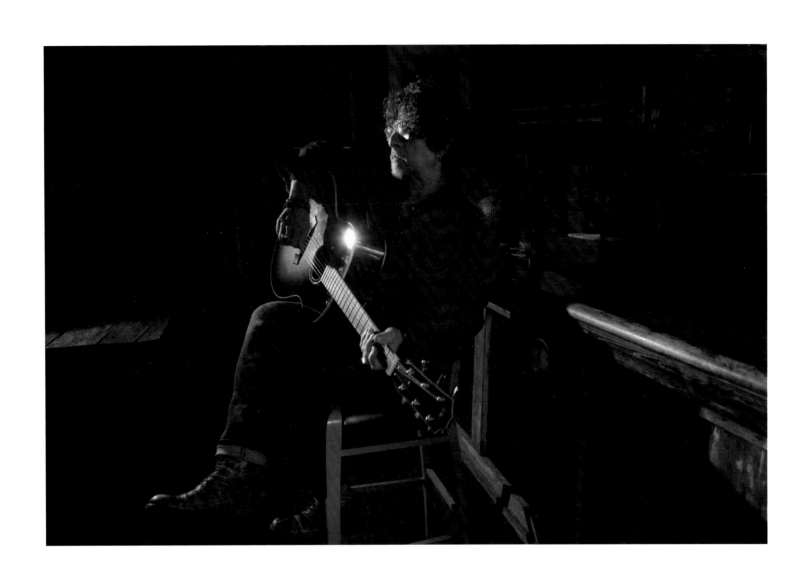

DAN NAVARRO
Franklin, Tennessee

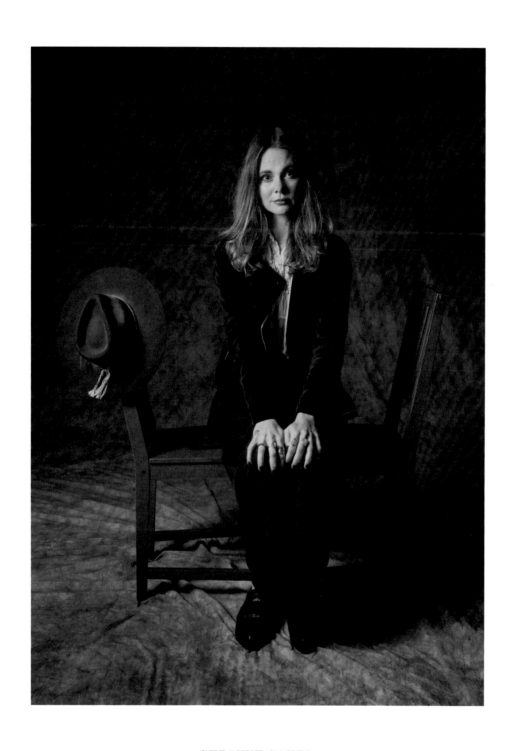

SUZANNE SANTO
Nashville, Tennessee

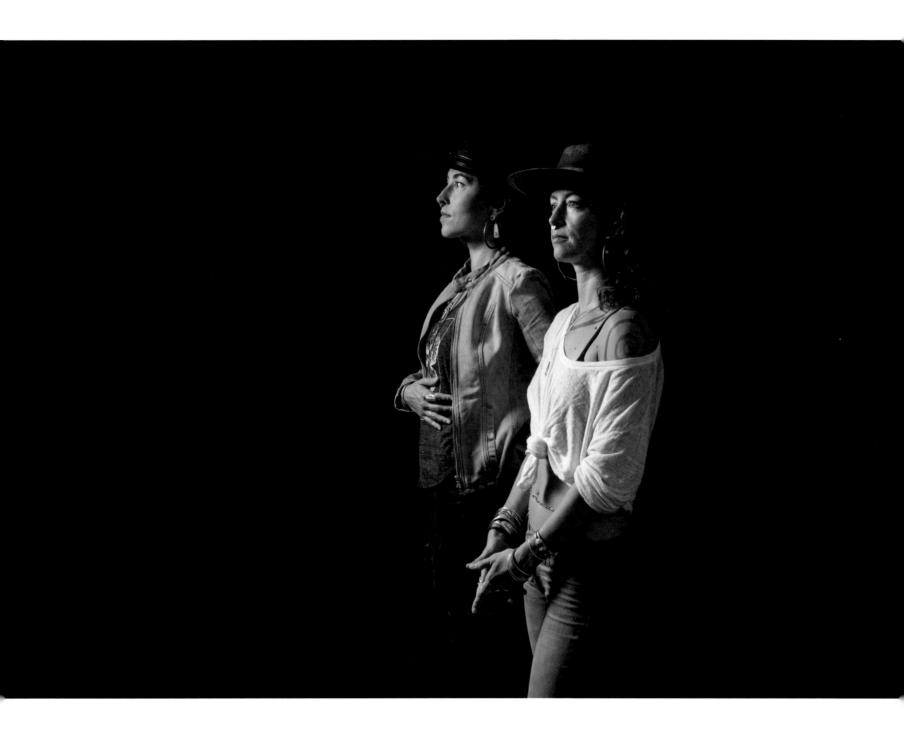

RISING APPALACHIA

Nashville, Tennessee

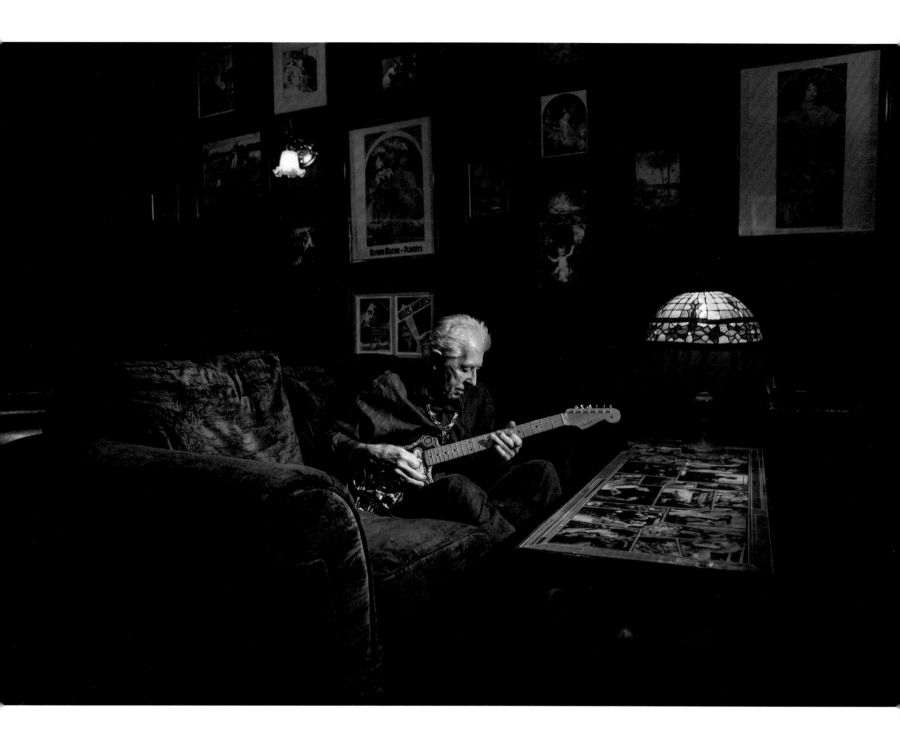

JOHN MAYALL
Los Angeles, California

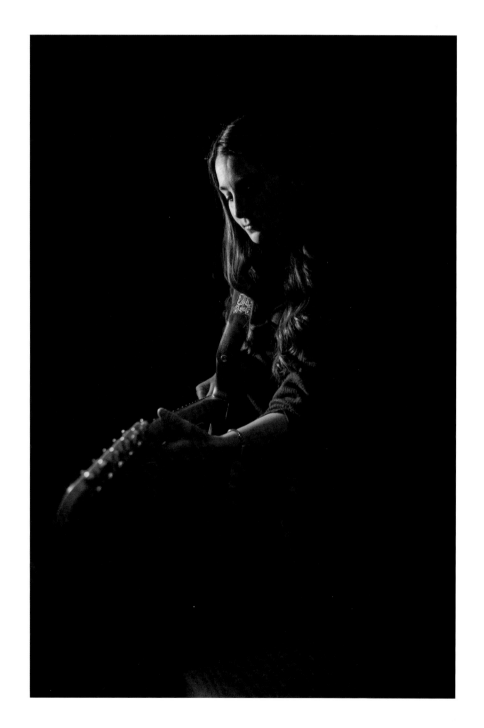

KATIE PRUITT

Nashville, Tennessee

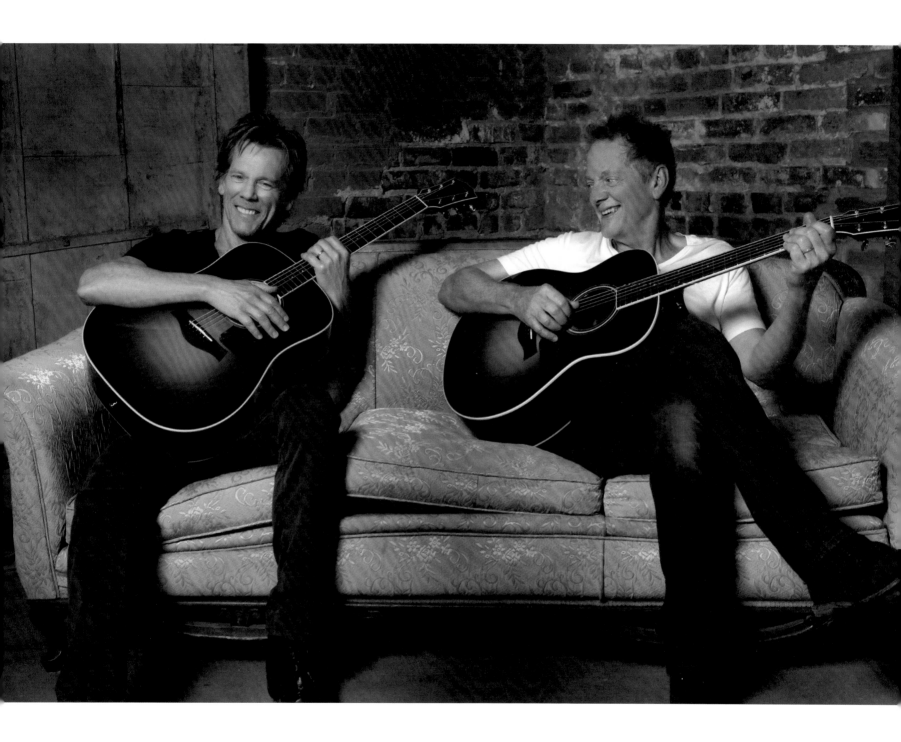

BACON BROTHERS

Nashville, Tennessee

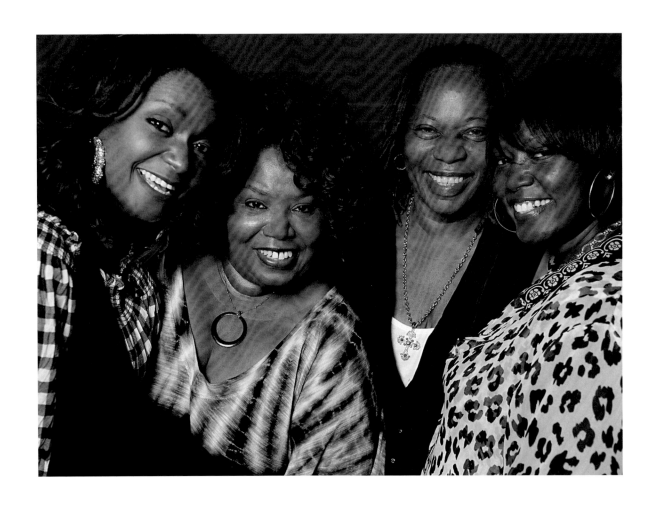

THE MCCRARY SISTERS
Nashville, Tennessee

OPPOSITE:
MIKE FARRIS
Nashville, Tennessee

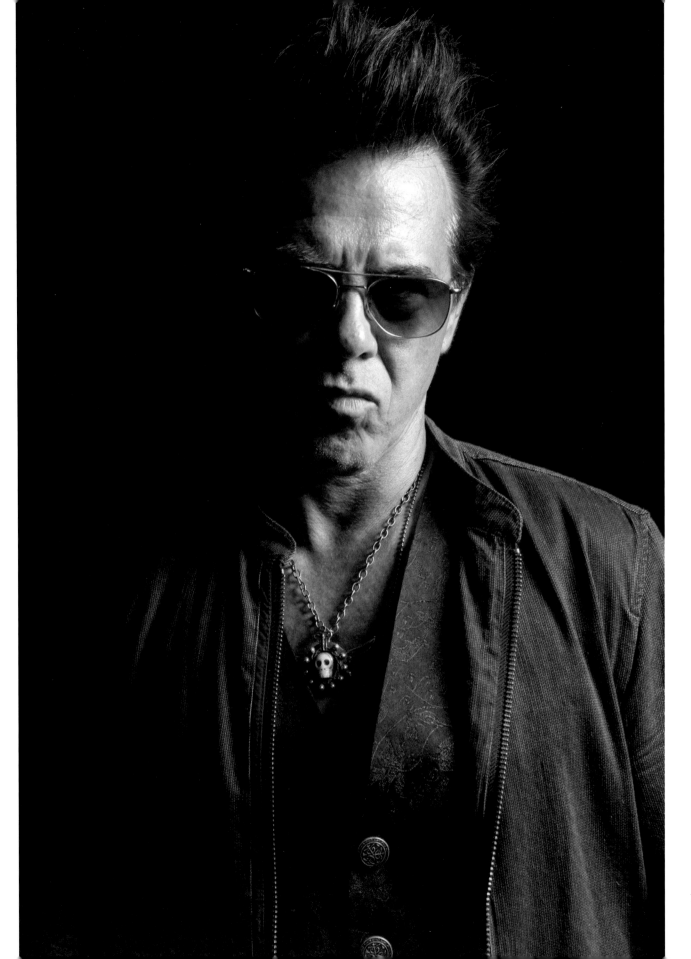

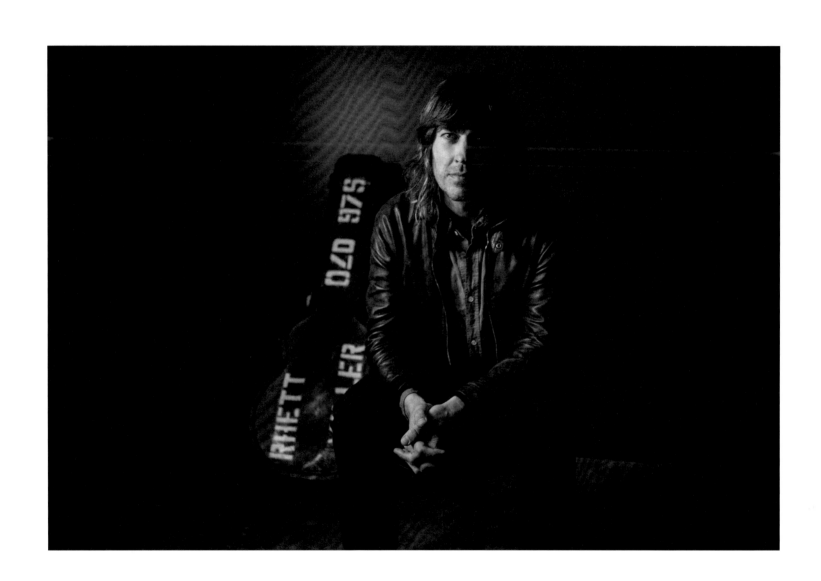

RHETT MILLER

Nashville, Tennessee

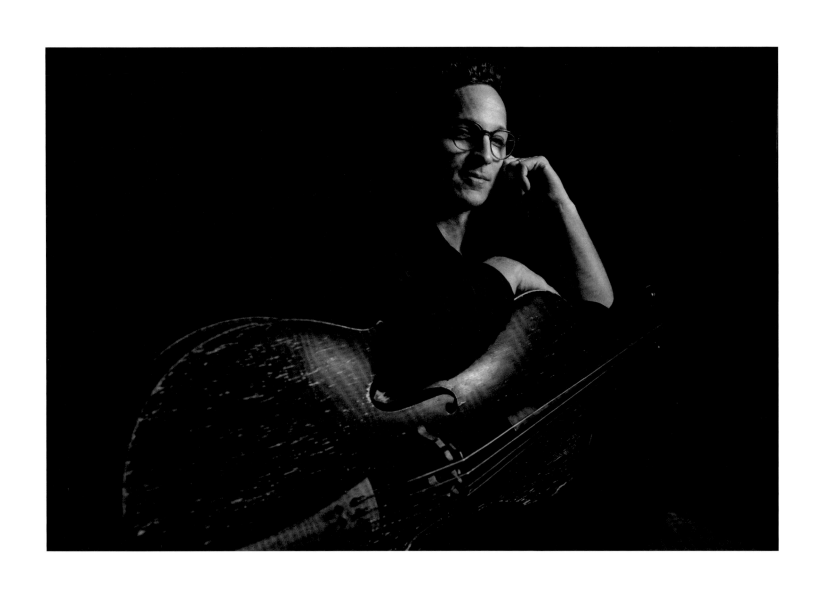

BEN SOLLEE

Nashville, Tennessee

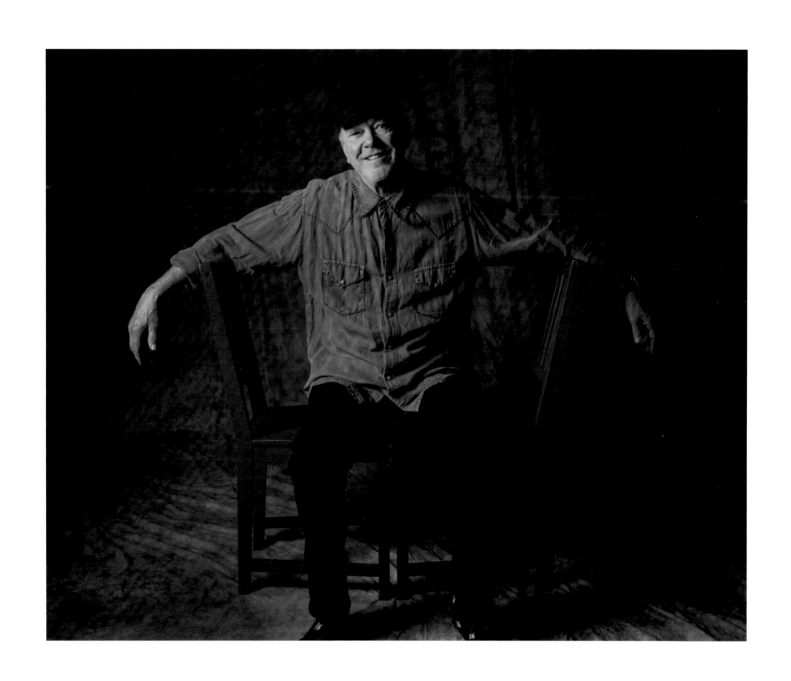

RUSTY YOUNG

Nashville, Tennessee

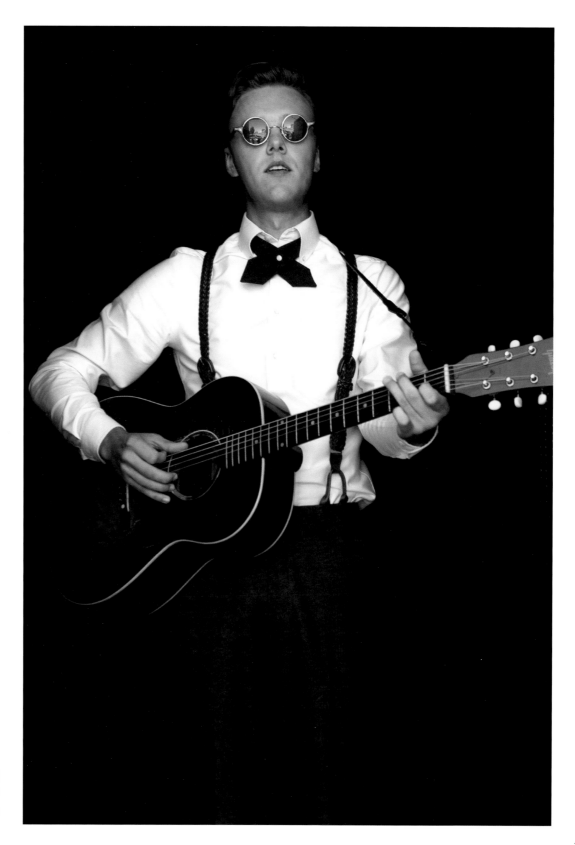

PARKER MILLSAP
Nashville, Tennessee

STEVE POLTZ
Nashville, Tennessee

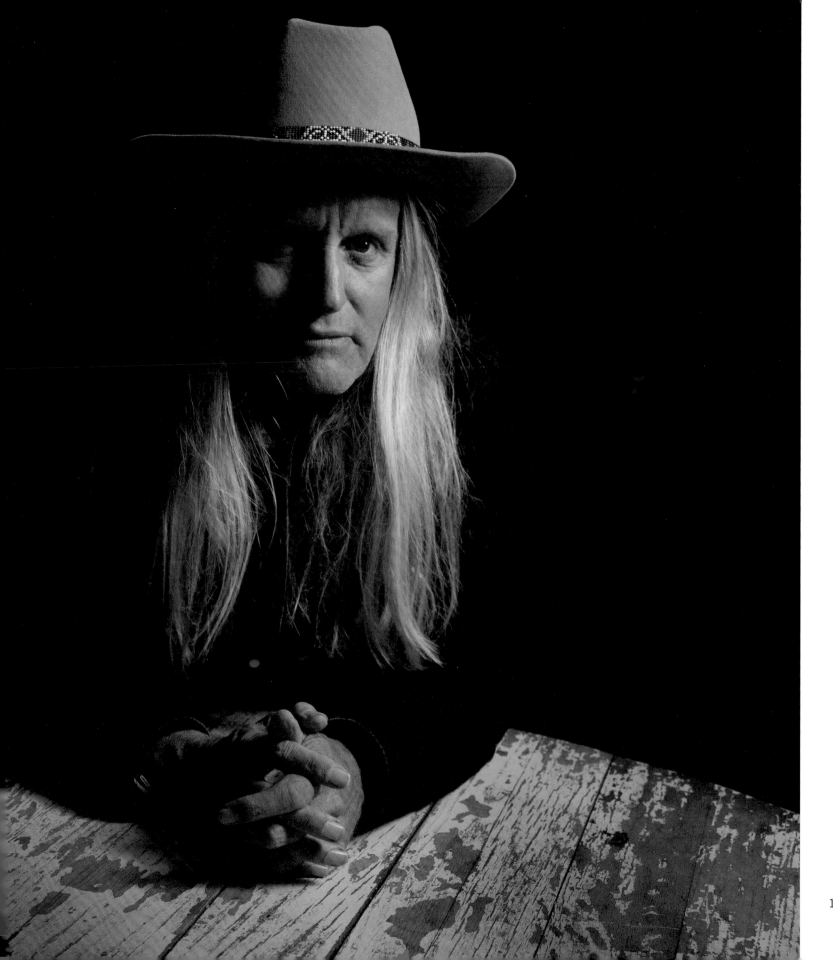

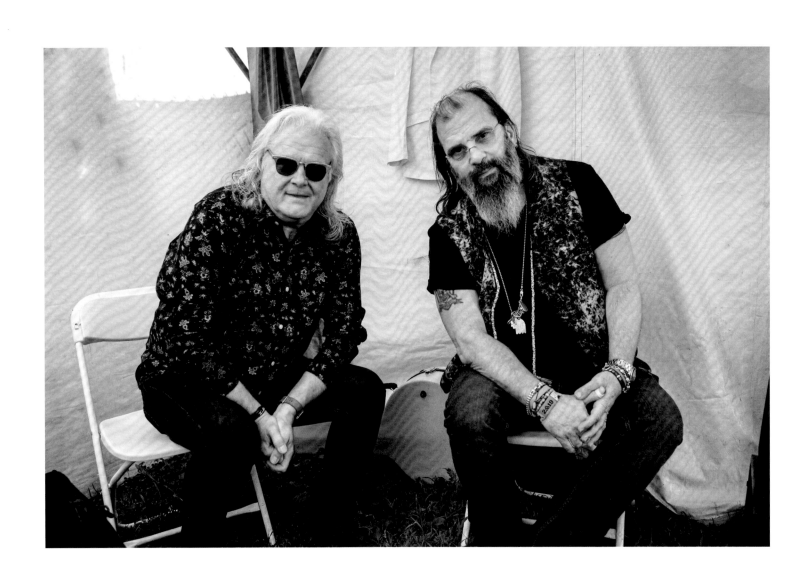

RICKY SKAGGS AND STEVE EARLE

Manchester, Tennessee

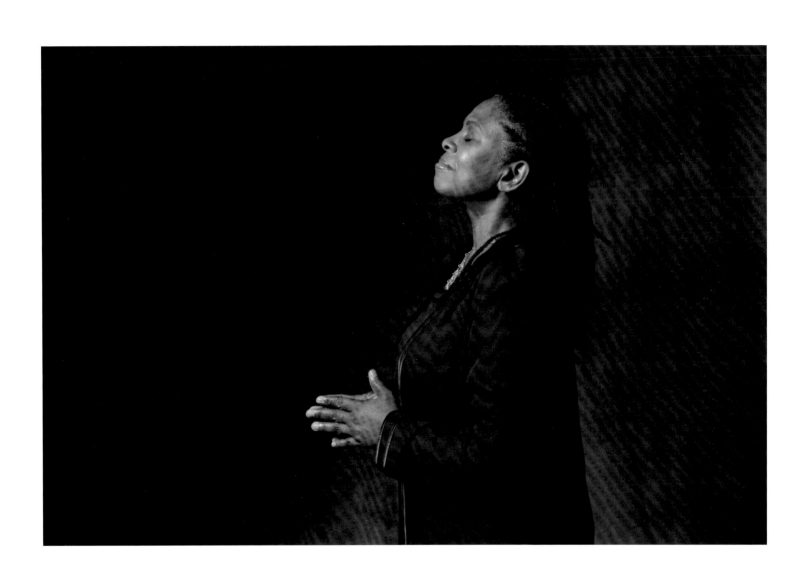

RUTHIE FOSTER
Memphis, Tennessee

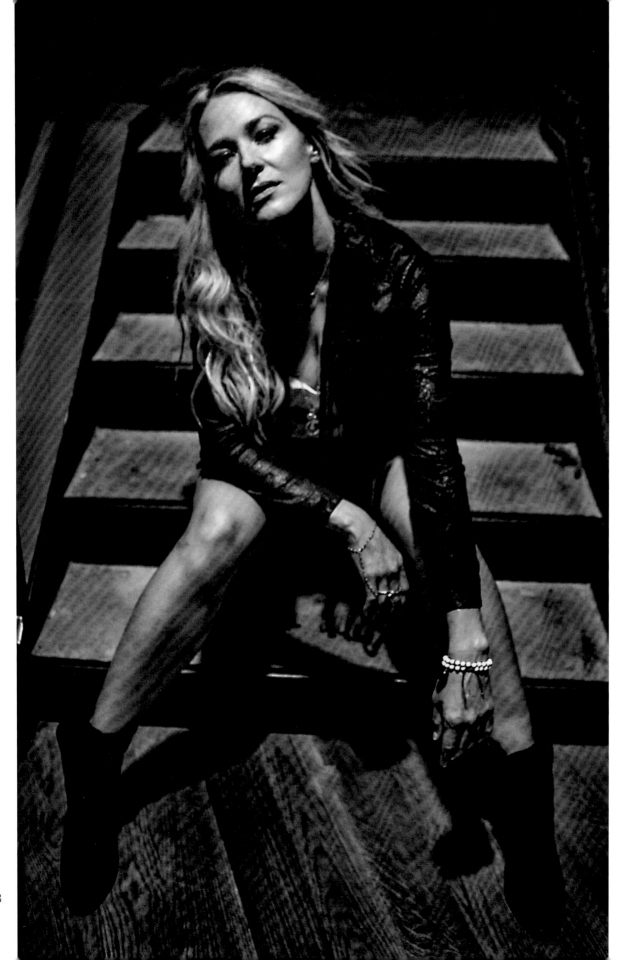

JEWEL
Nashville, Tennessee

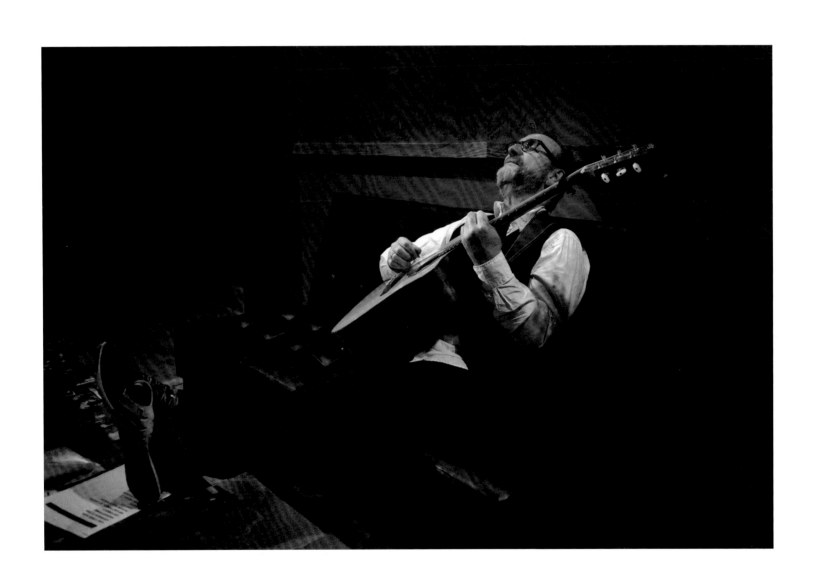

COLIN HAY
Nashville, Tennessee

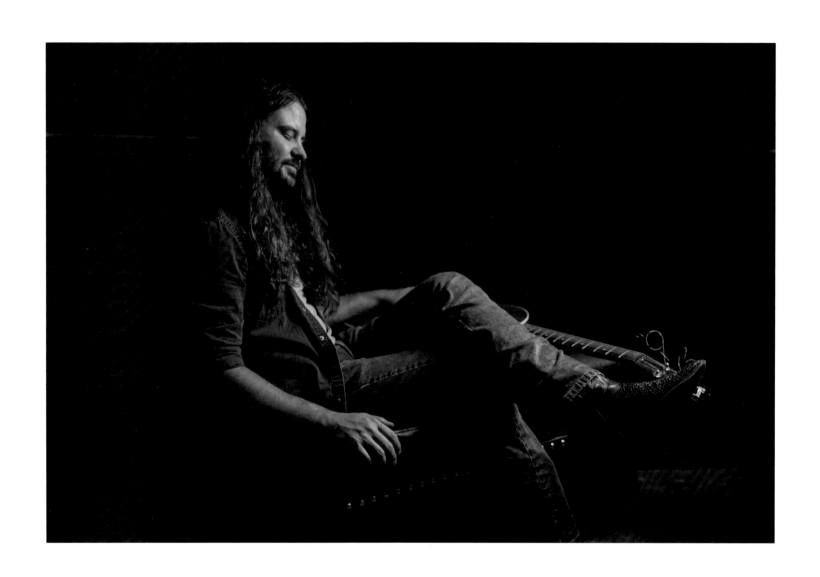

BRENT COBB

Nashville, Tennessee

CHRIS ISAAK
Anaheim, California

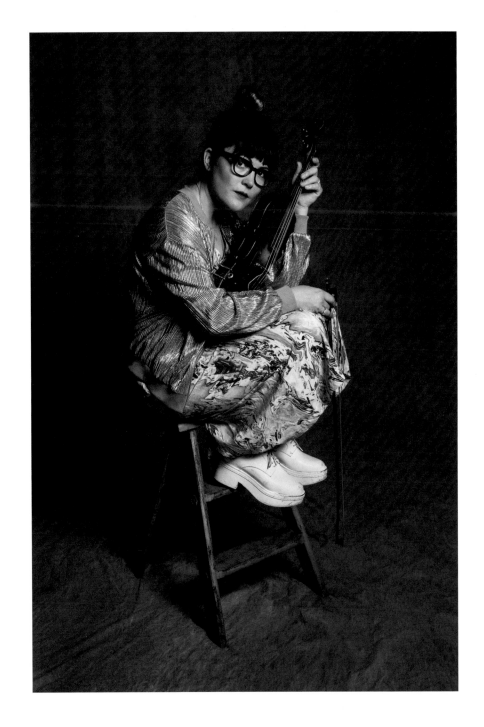

SARA WATKINS

Nashville, Tennessee

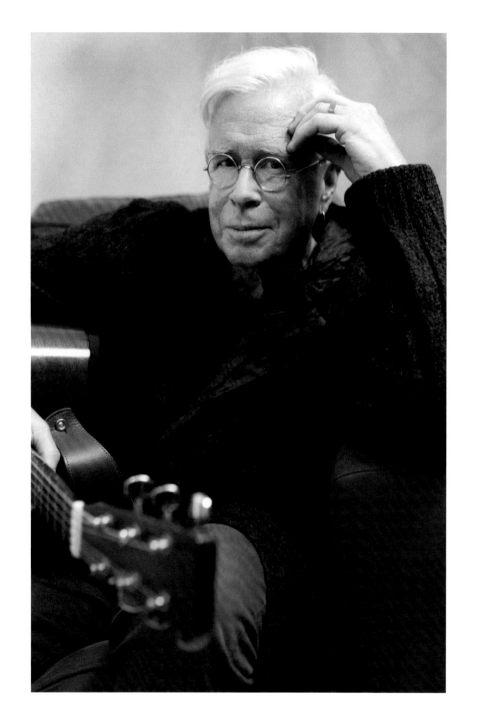

BRUCE COCKBURN
San Francisco, California

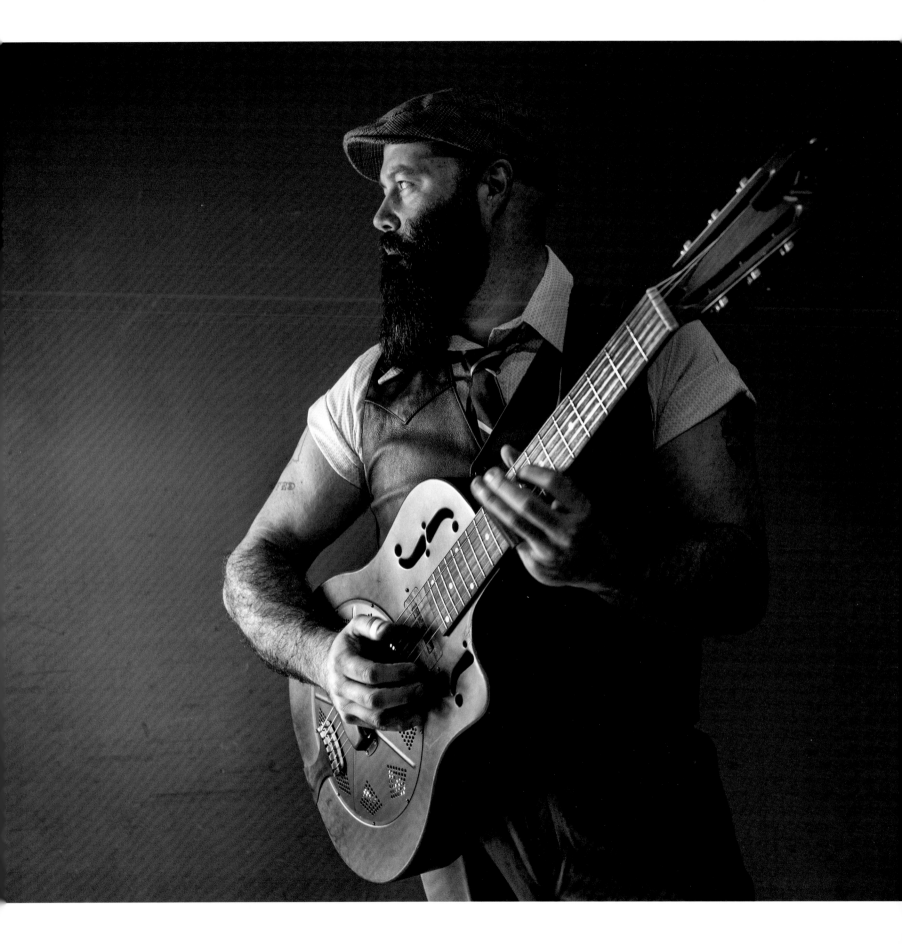

REVEREND PEYTON
Nashville, Tennessee

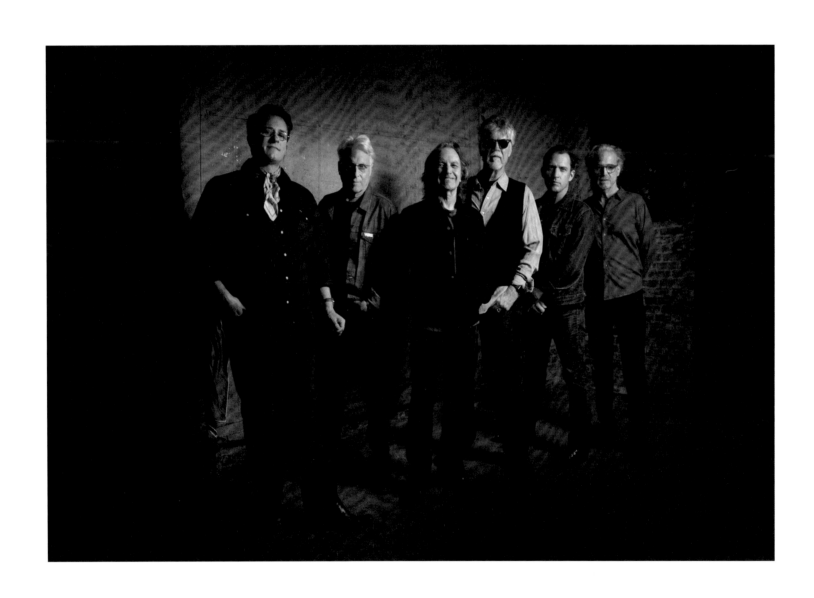

NITTY GRITTY DIRT BAND

Nashville, Tennessee

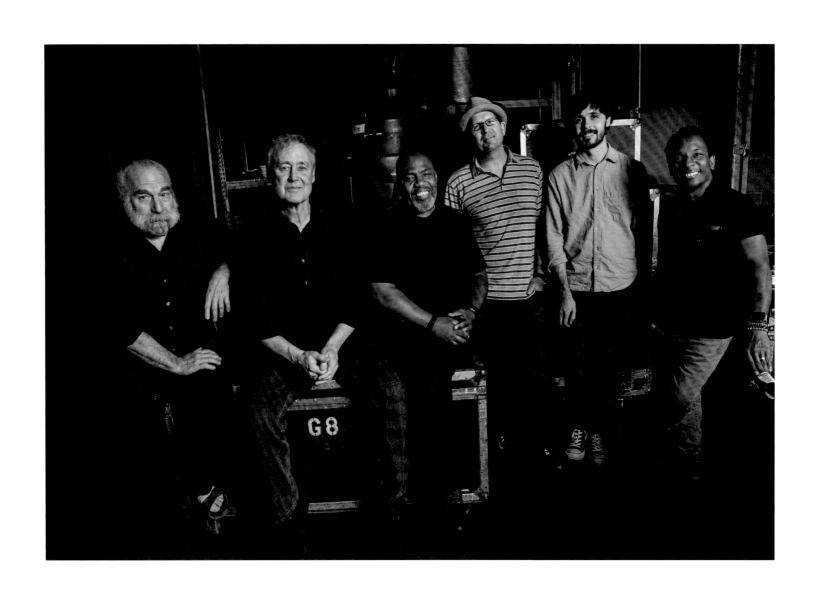

BRUCE HORNSBY AND THE NOISEMAKERS
Nashville, Tennessee

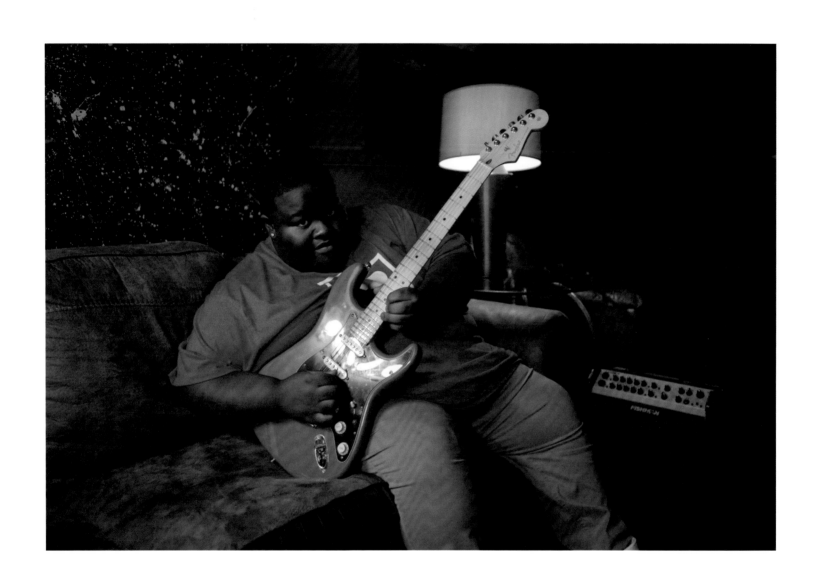

CHRISTONE "KINGFISH" INGRAM

Nashville, Tennessee

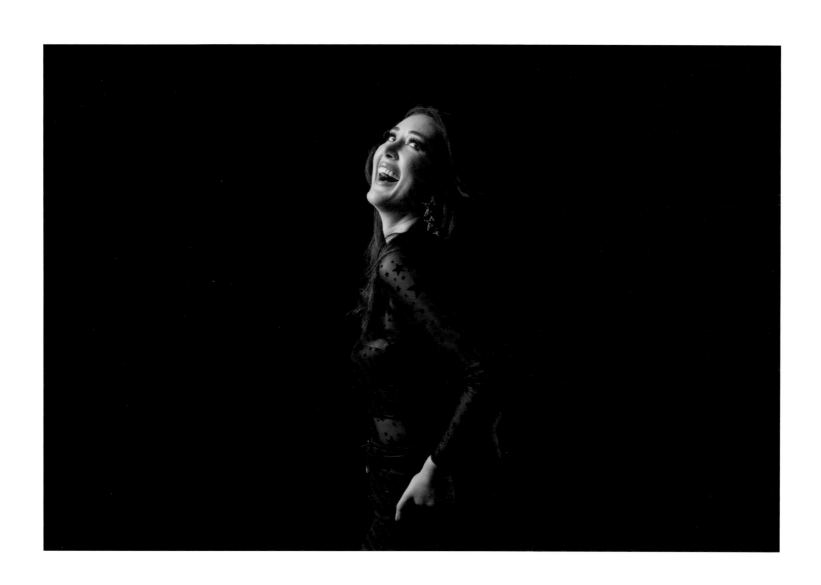

AUBRIE SELLERS
Nashville, Tennessee

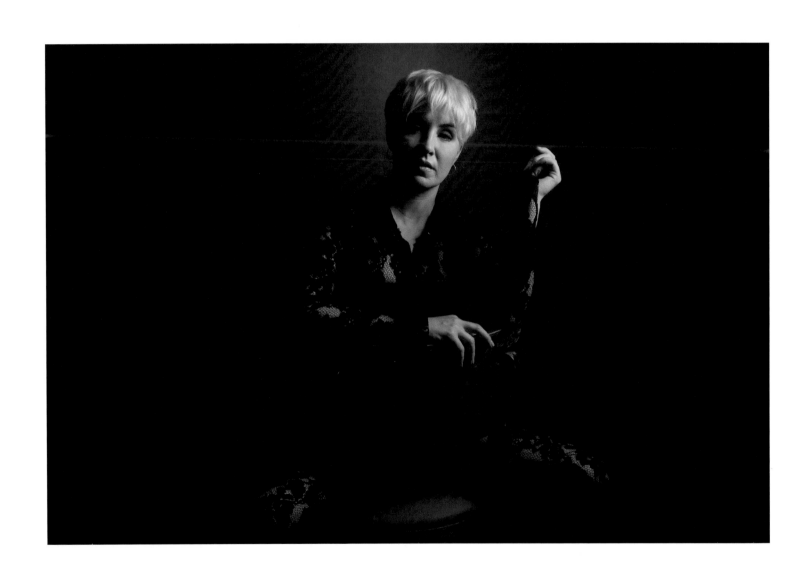

MAGGIE ROSE

Nashville, Tennessee

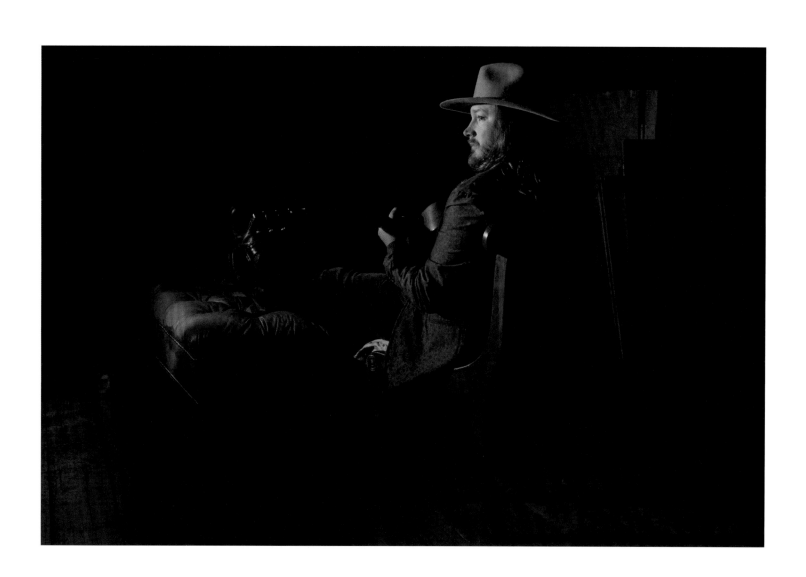

ADAM WAKEFIELD

Nashville, Tennessee

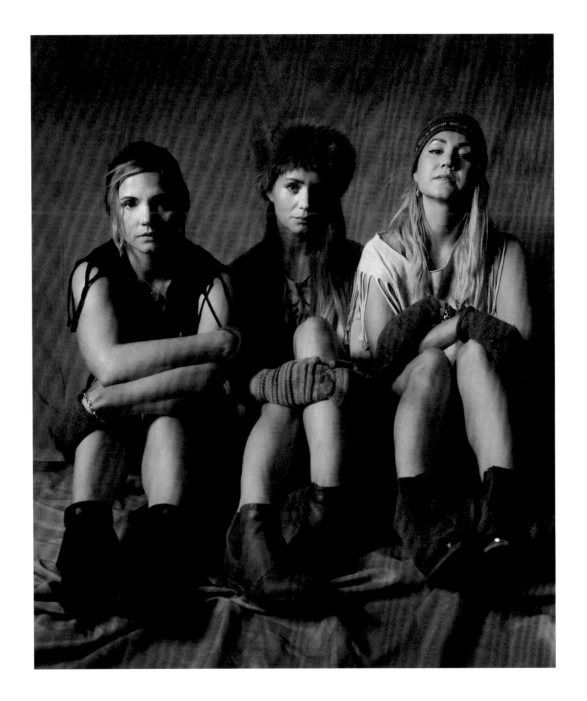

BASKERY

Nashville, Tennessee

OPPOSITE:

JASON RINGENBERG

Nashville, Tennessee

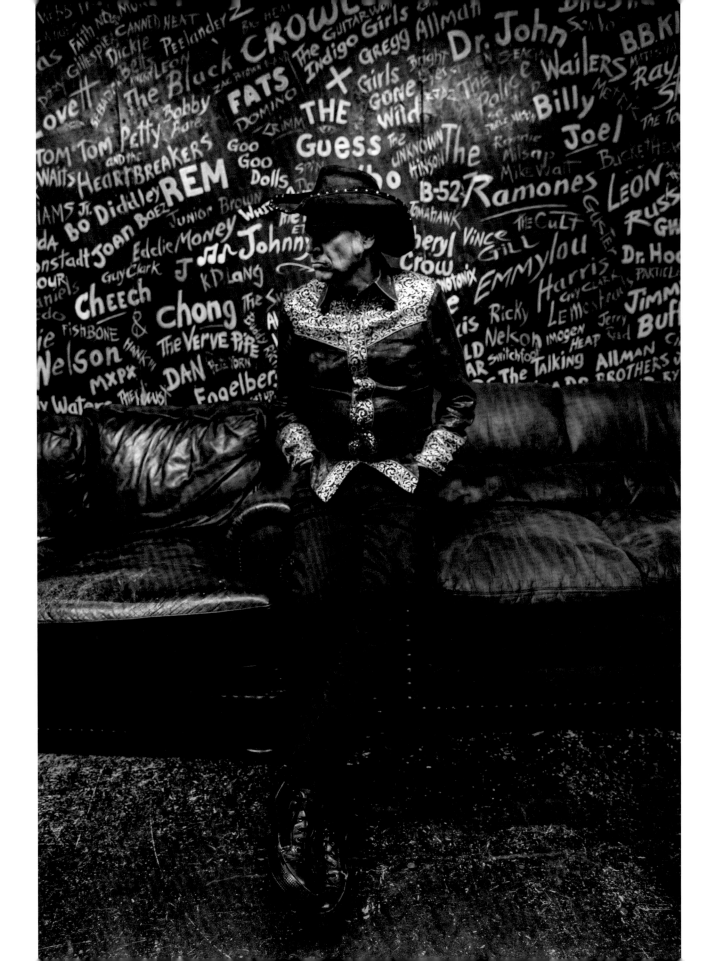

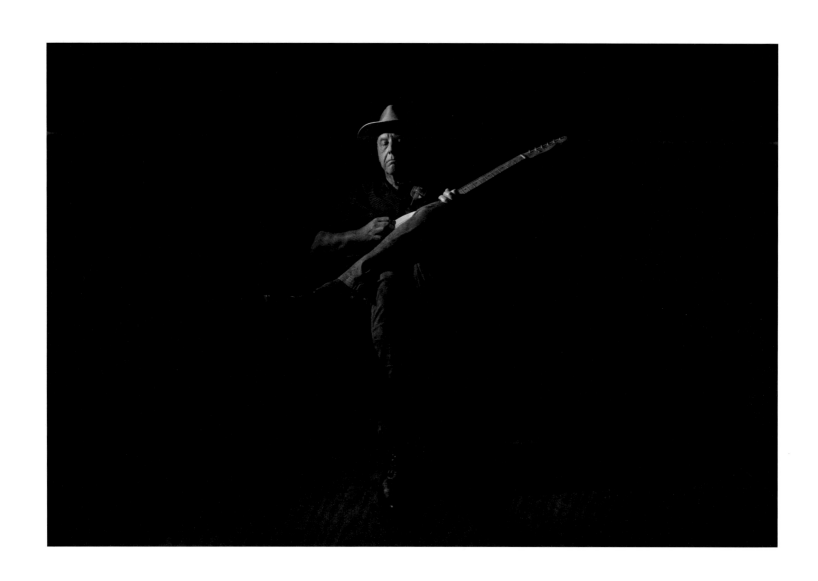

WEBB WILDER

Nashville, Tennessee

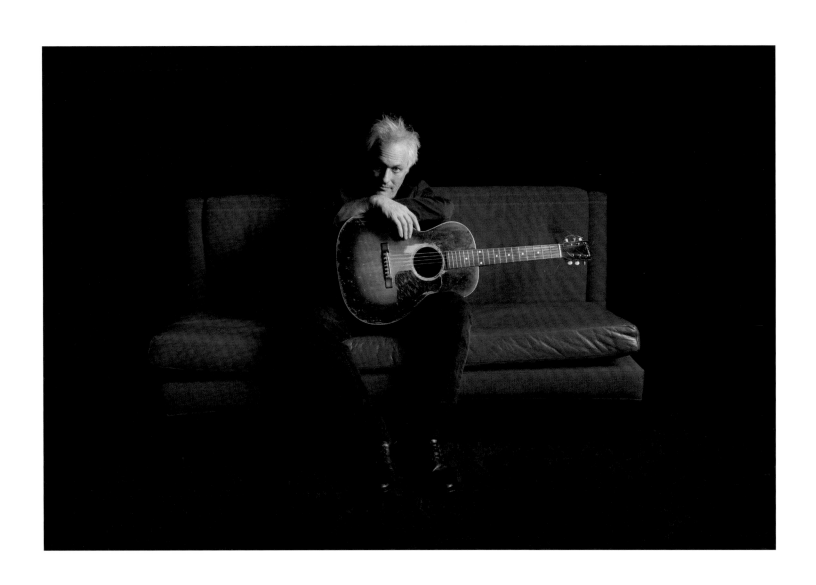

MARC RIBOT

Nashville, Tennessee

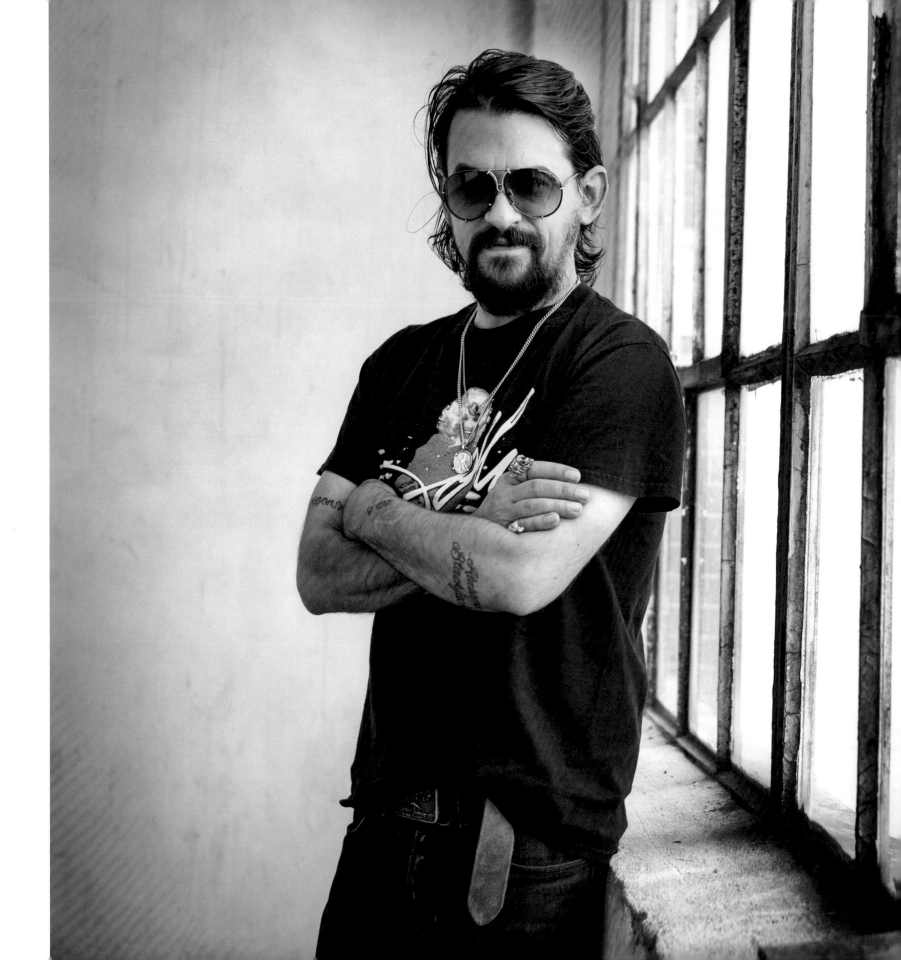

SHOOTER JENNINGS
Black Mountain, North Carolina

157

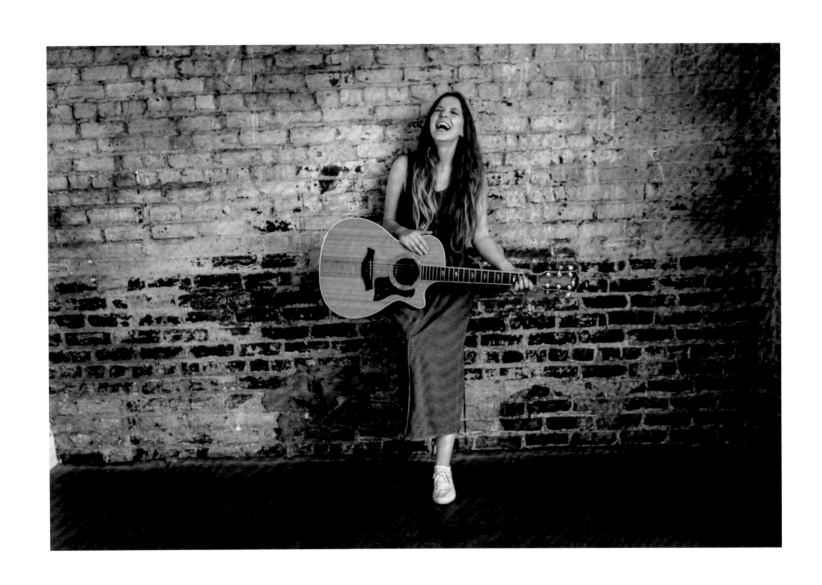

JADE BIRD

Nashville, Tennessee

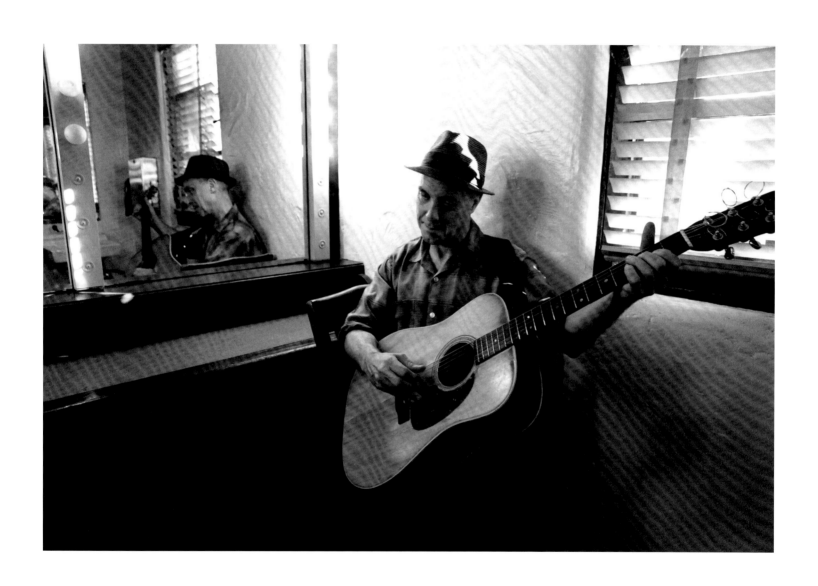

FREEDY JOHNSTON
Santa Barbara, California

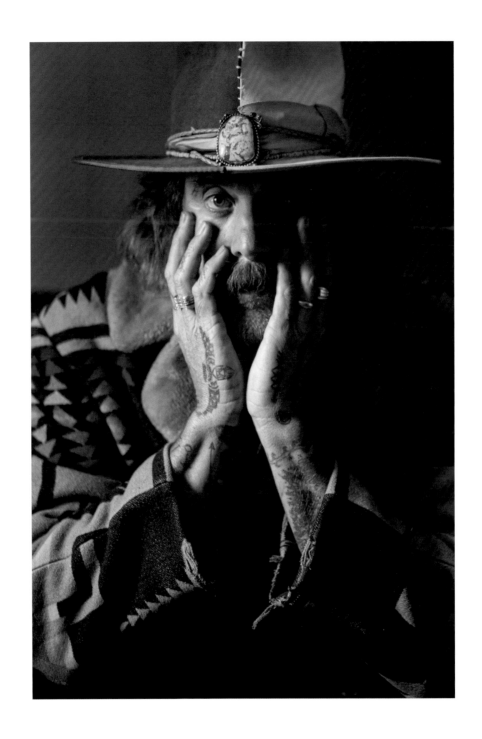

DONAVON FRANKENREITER
Nashville, Tennessee

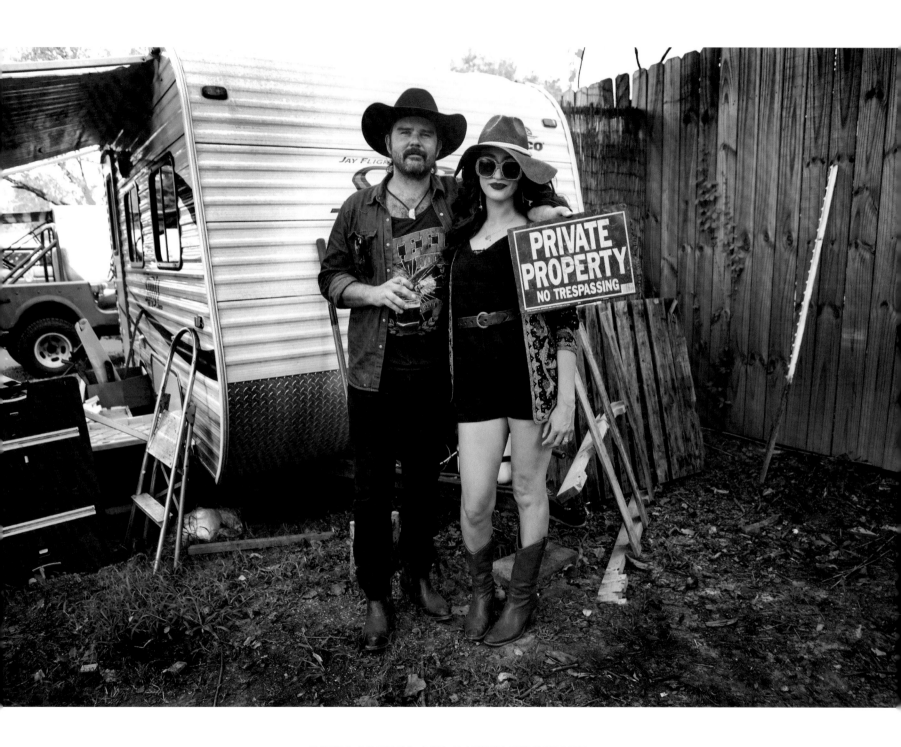

LINDI ORTEGA AND DANIEL HUSCROFT

Black Mountain, North Carolina

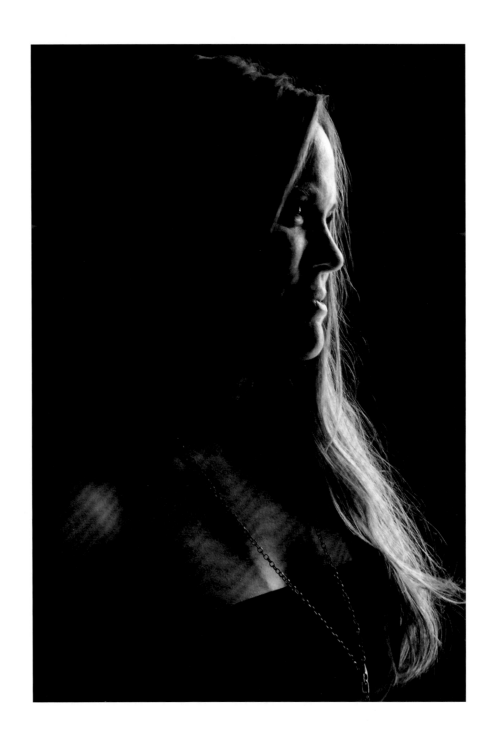

BONNIE BISHOP
Nashville, Tennessee

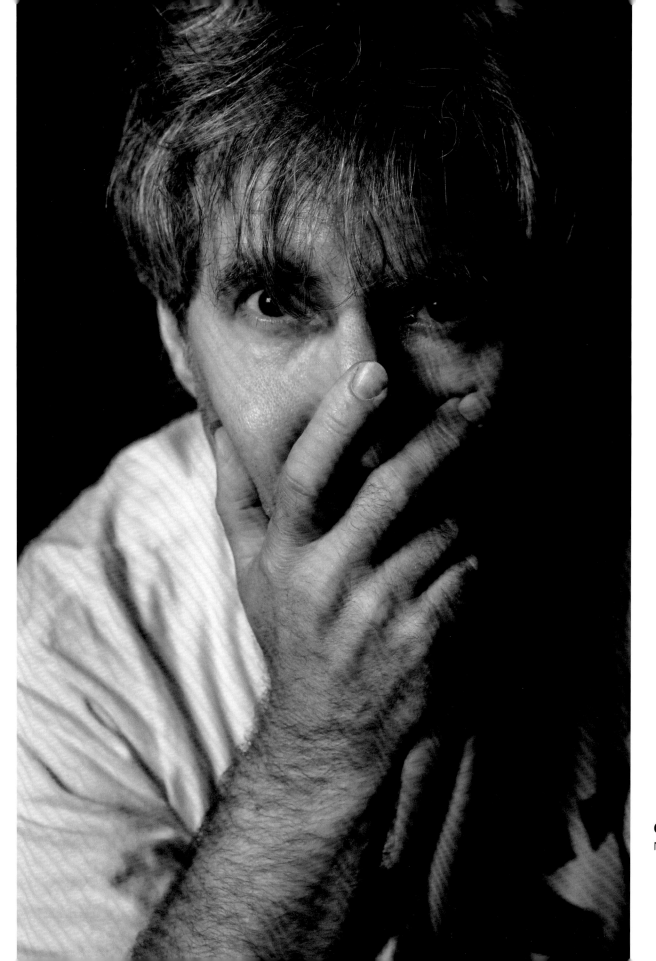

CHRIS STAMEY
Nashville, Tennessee

163

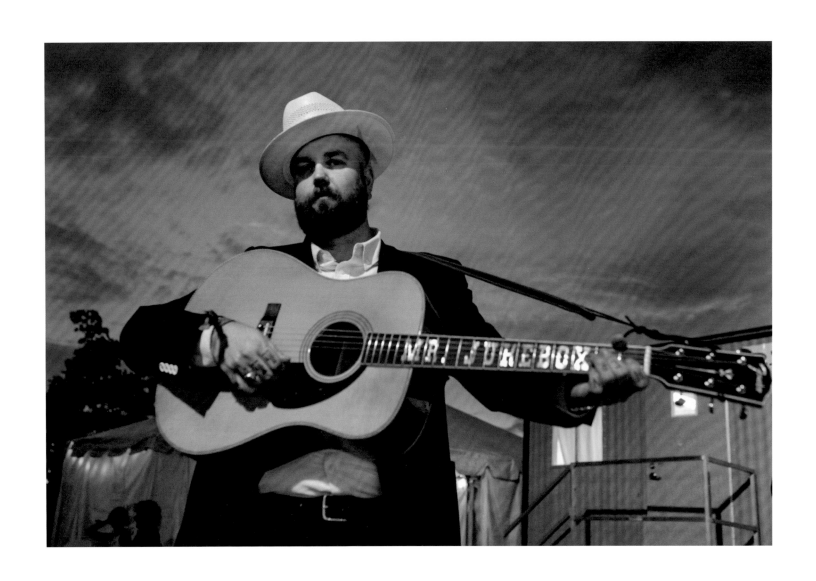

JOSHUA HEDLEY
Manchester, Tennessee

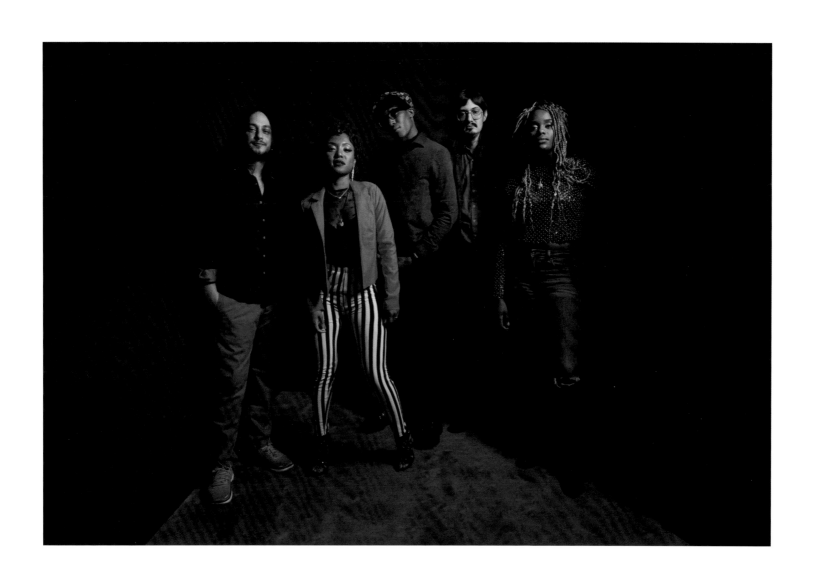

SOUTHERN AVENUE
Nashville, Tennessee

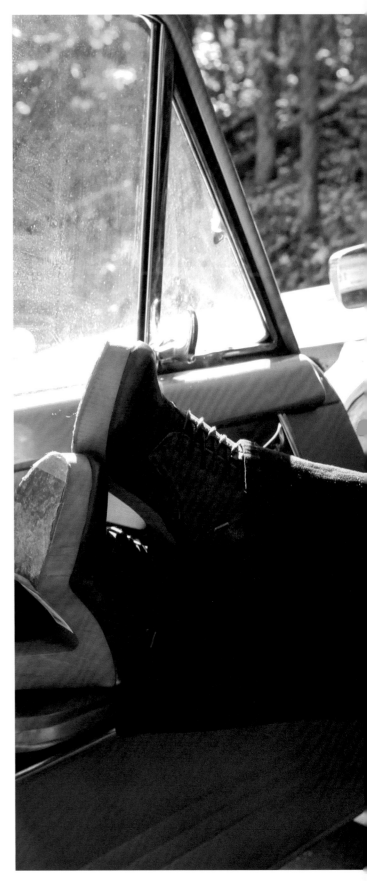

JOAN OSBORNE
Callicoon Center, New York

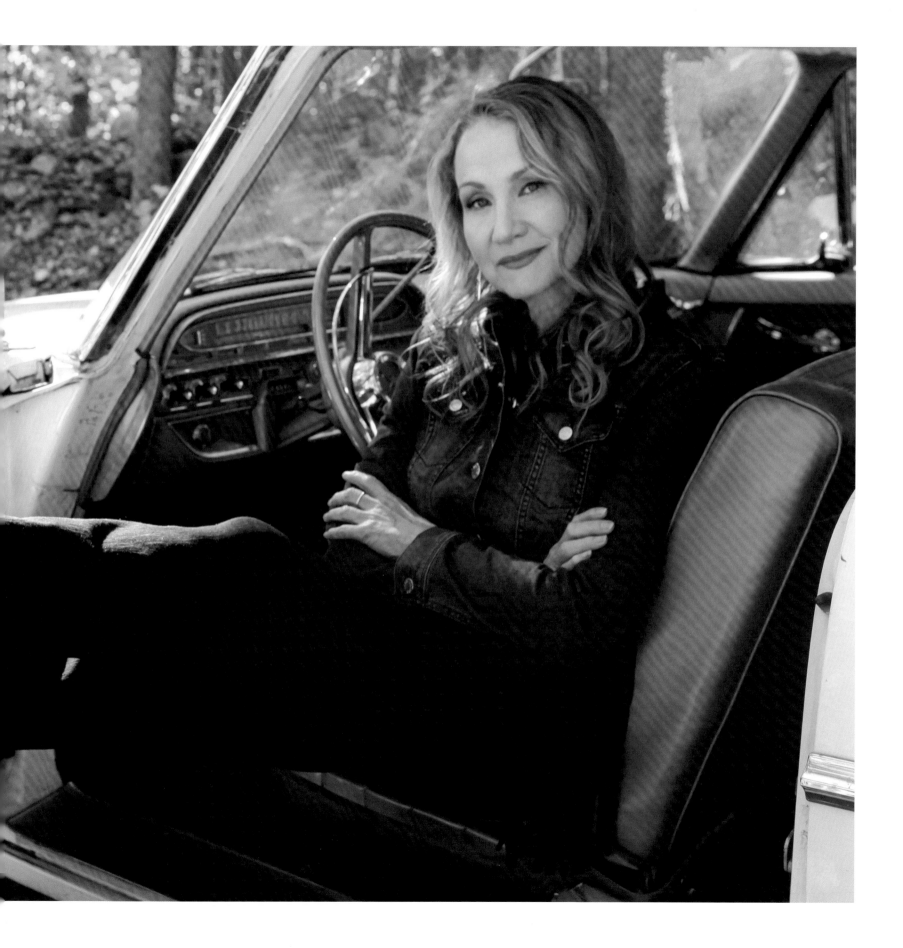

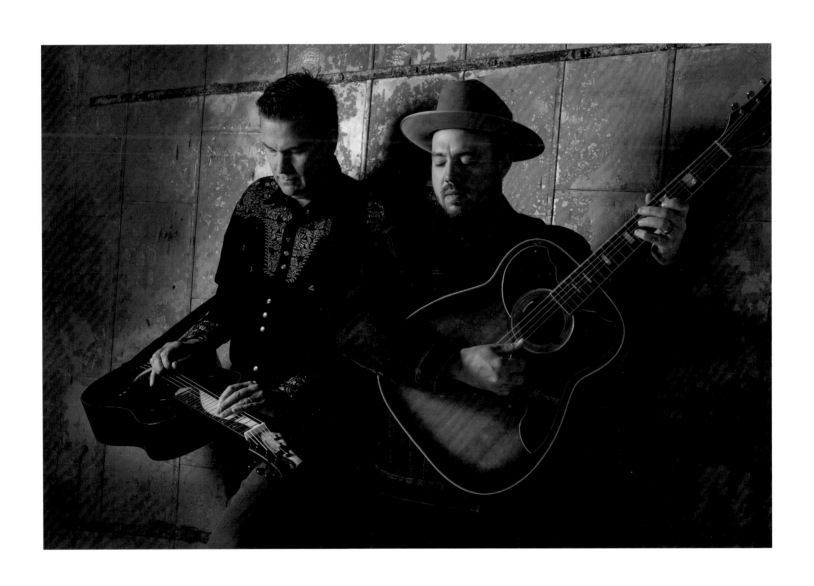

ROB ICKES AND TREY HENSLEY

Nashville, Tennessee

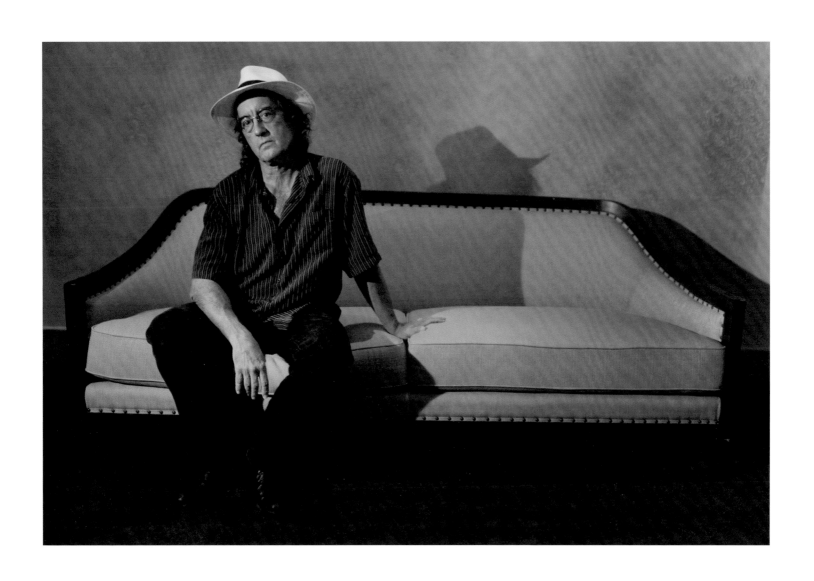

JAMES MCMURTRY
Nashville, Tennessee

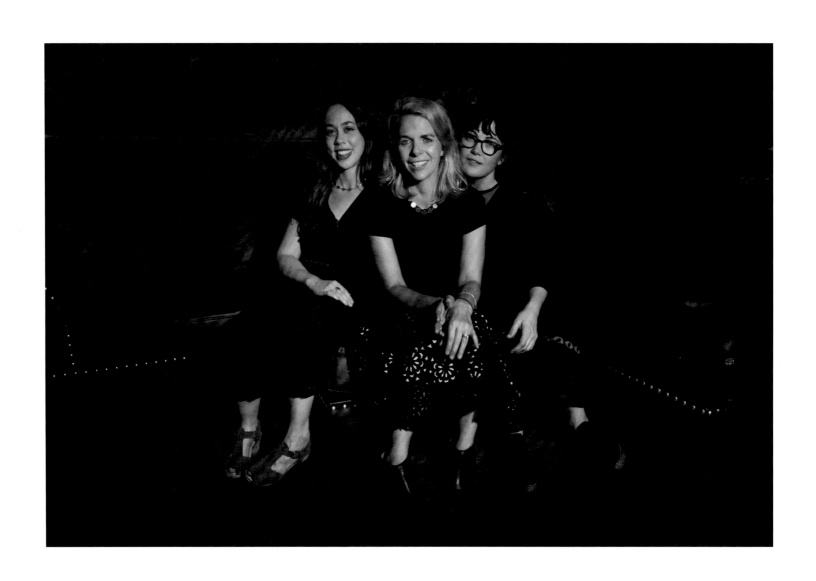

I'M WITH HER
Sarah Jarosz, Aoife O'Donovan, Sara Watkins
Nashville, Tennessee

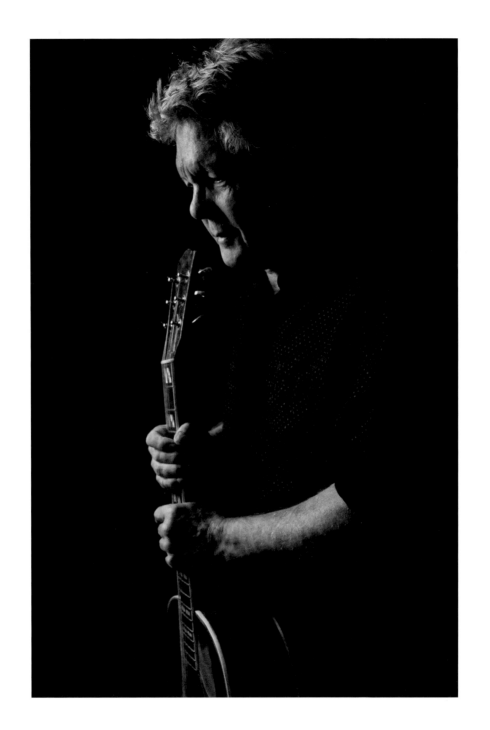

STEVE FORBERT
Nashville, Tennessee

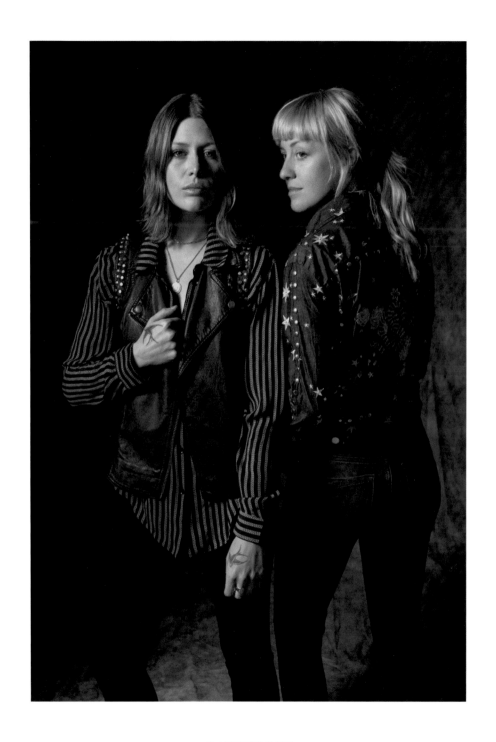

LARKIN POE

Memphis, Tennessee

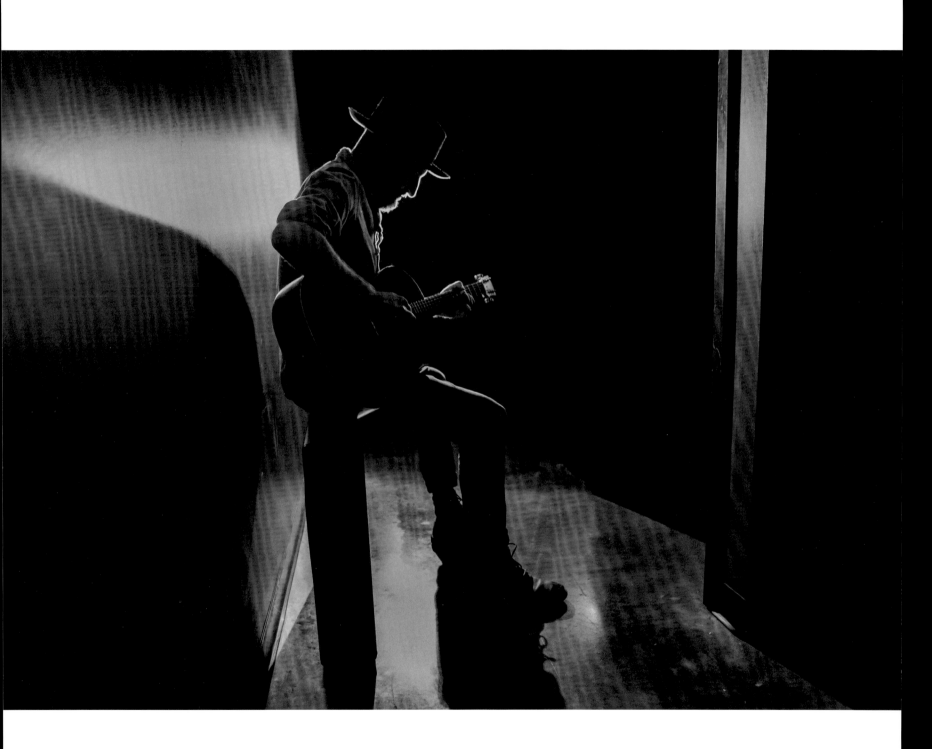

SETH WALKER
Nashville, Tennessee

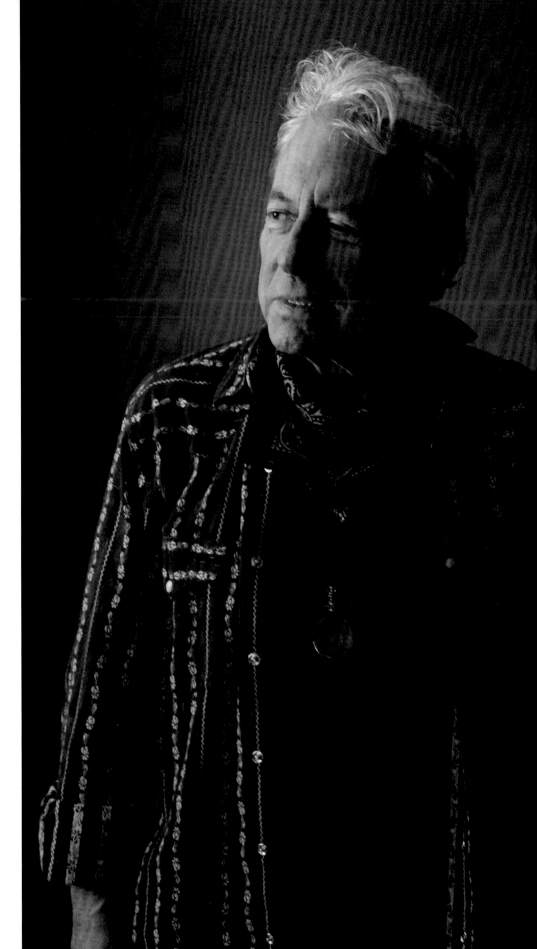

THE FLATLANDERS
Nashville, Tennessee

174

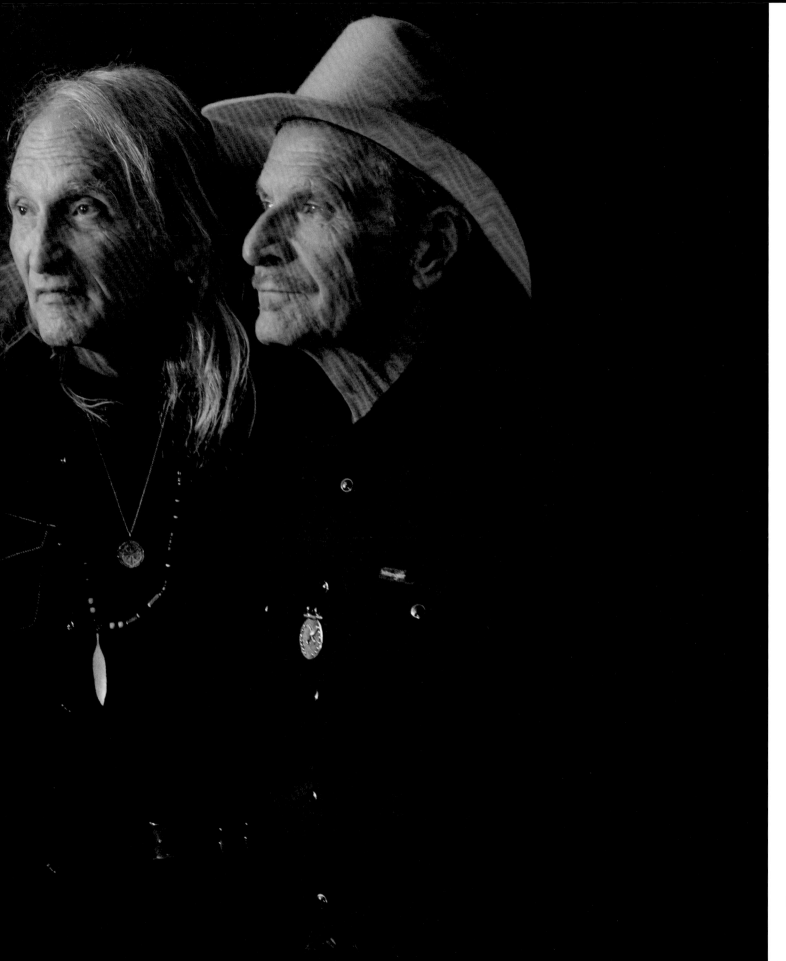

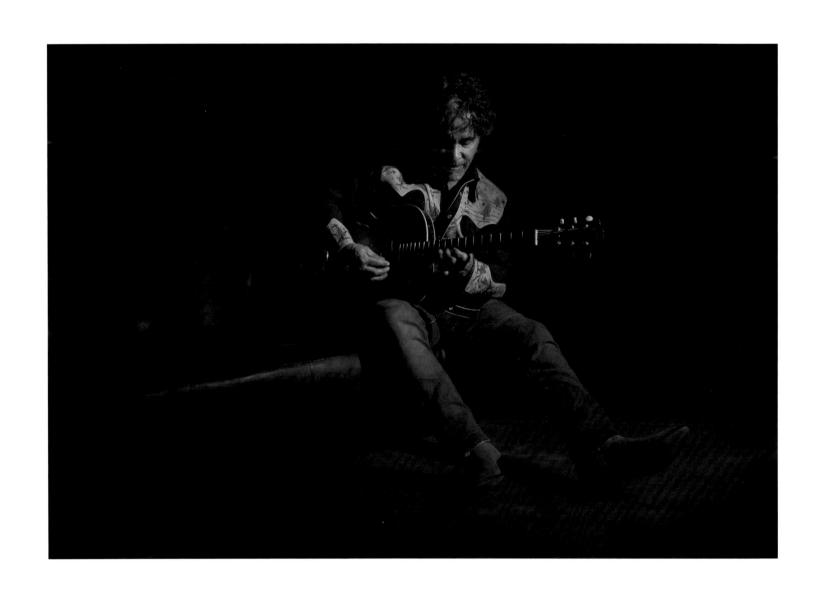

JOHN OATES
Nashville, Tennessee

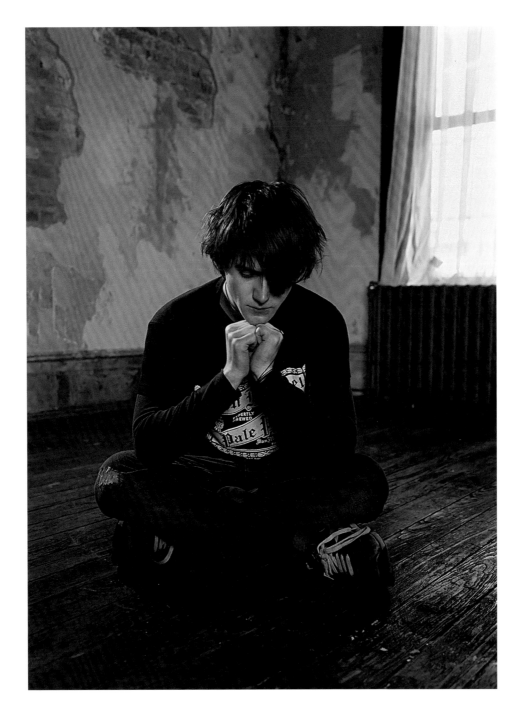

CONOR OBERST

New York, New York

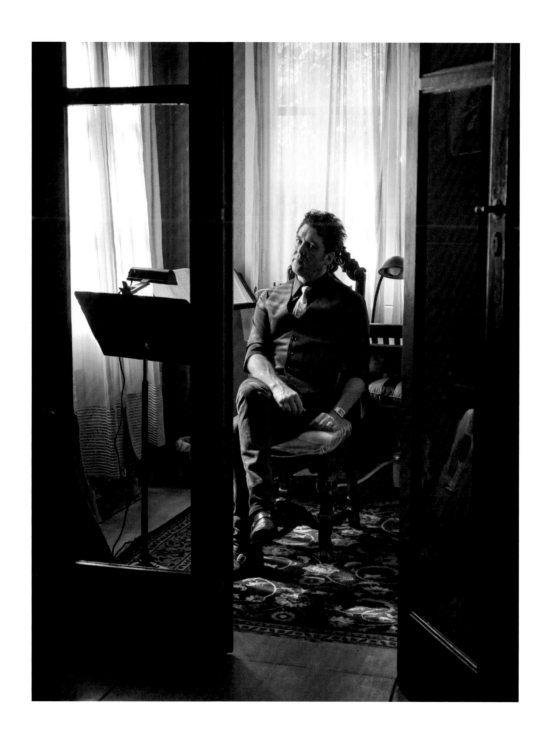

JOE HENRY
Los Angeles, California

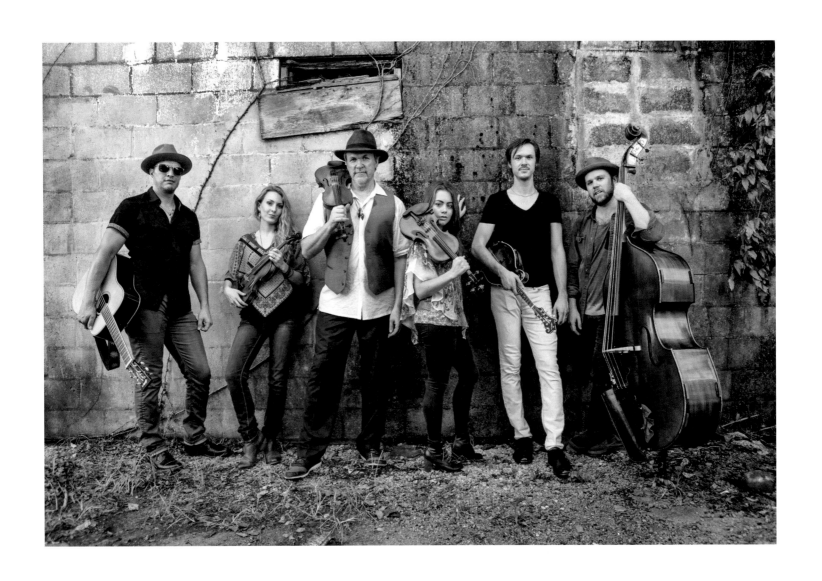

THE O'CONNOR BAND

Nashville, Tennessee

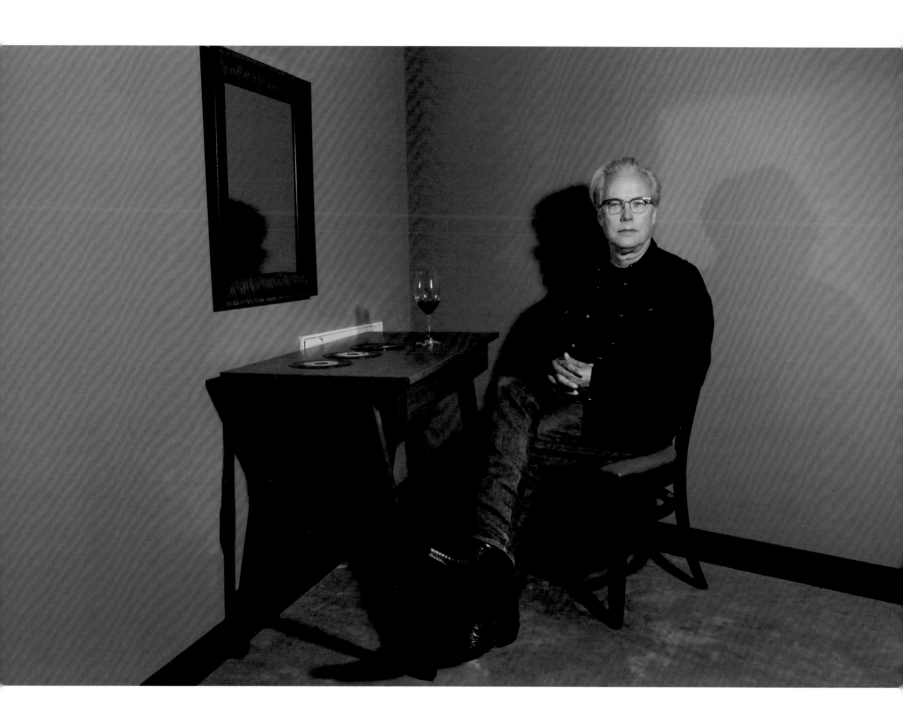

RADNEY FOSTER

Nashville, Tennessee

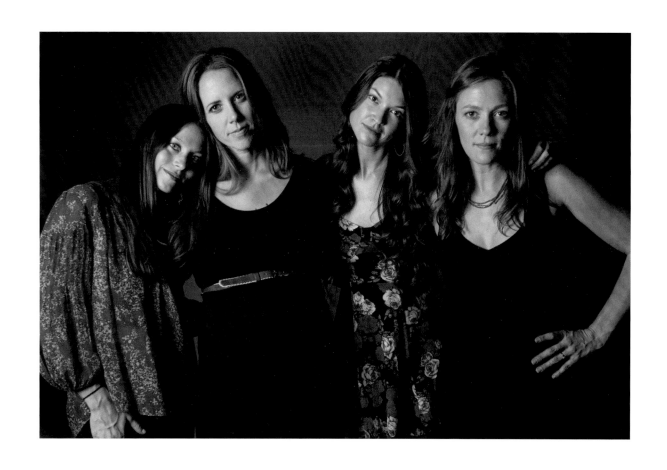

THE TRISHAS

Nashville, Tennessee

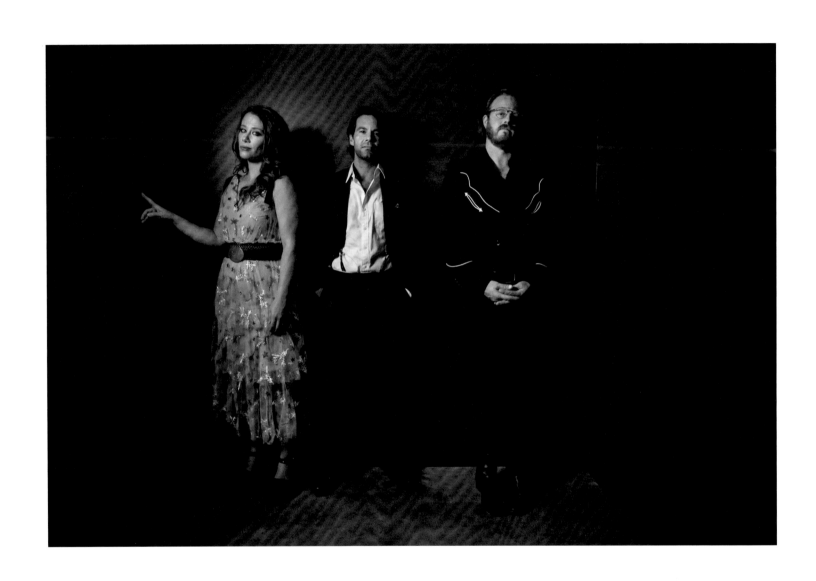

THE LONE BELLOW

Nashville, Tennessee

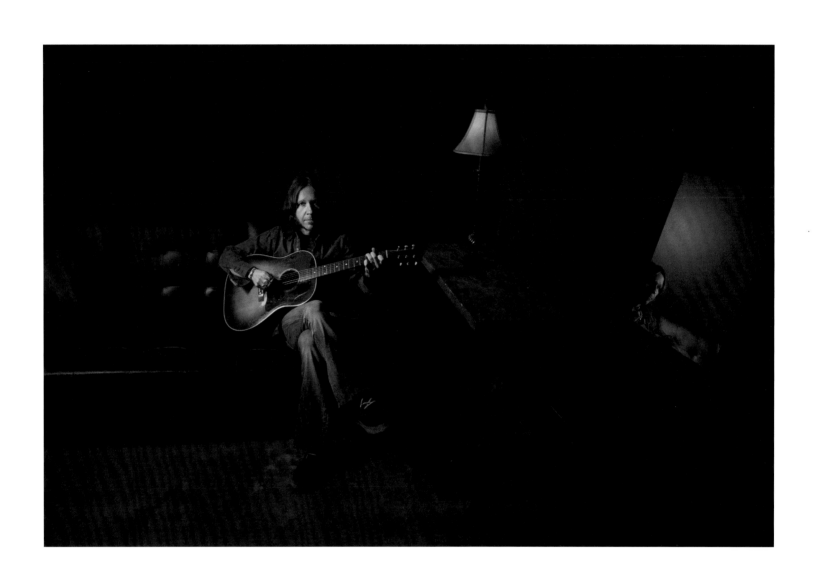

CHARLIE STARR
Nashville, Tennessee

DANNY BURNS
Nashville, Tennessee

184

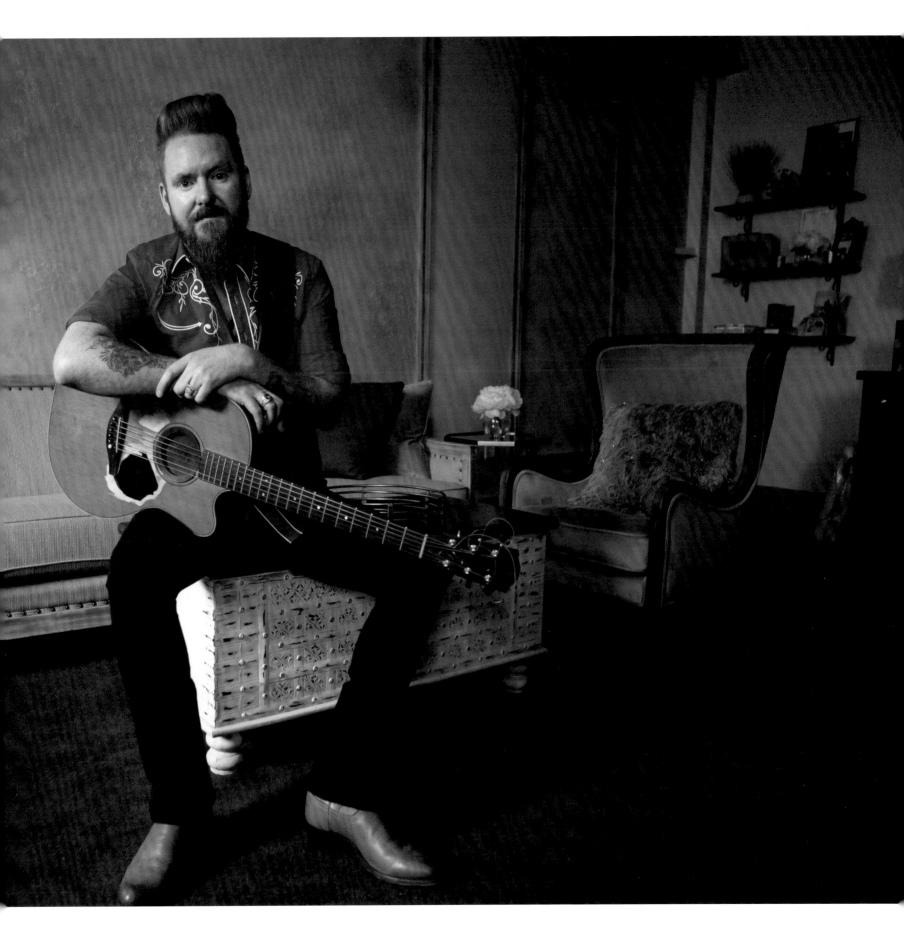

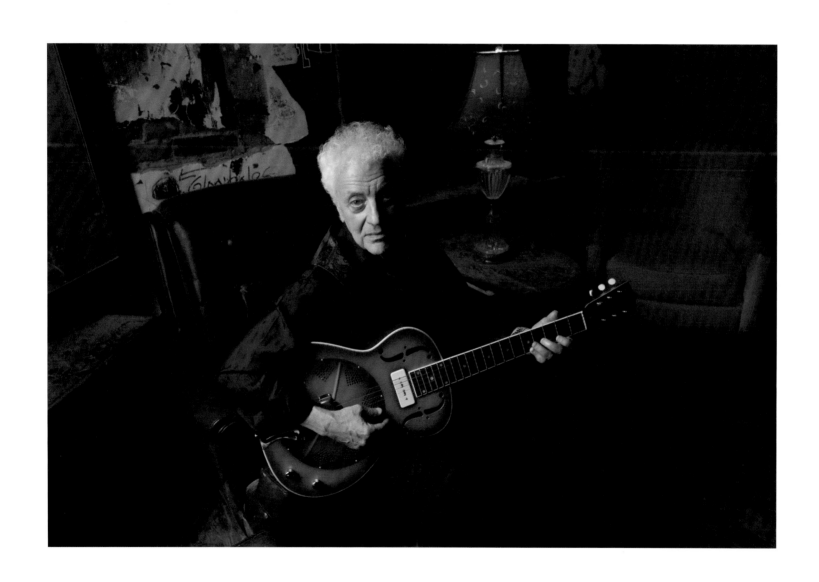

DOUG MACLEOD

Memphis, Tennessee

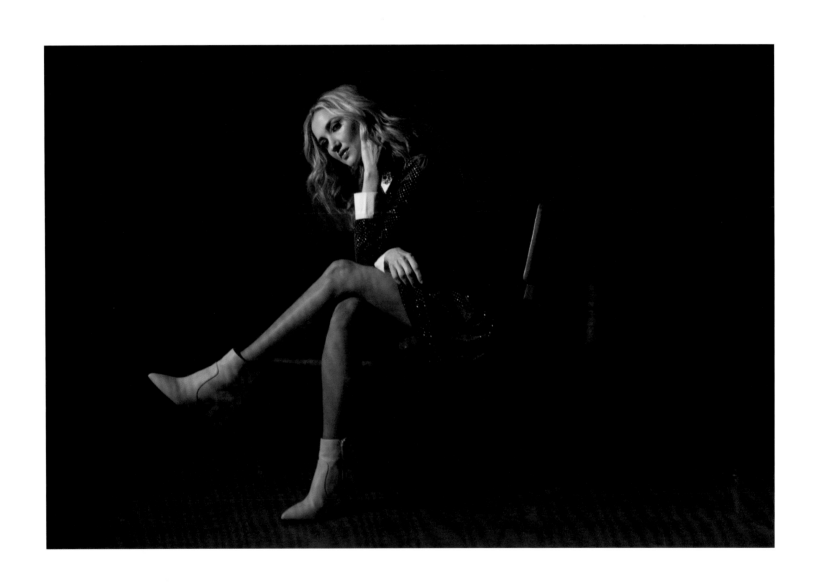

SARAH DARLING
Nashville, Tennessee

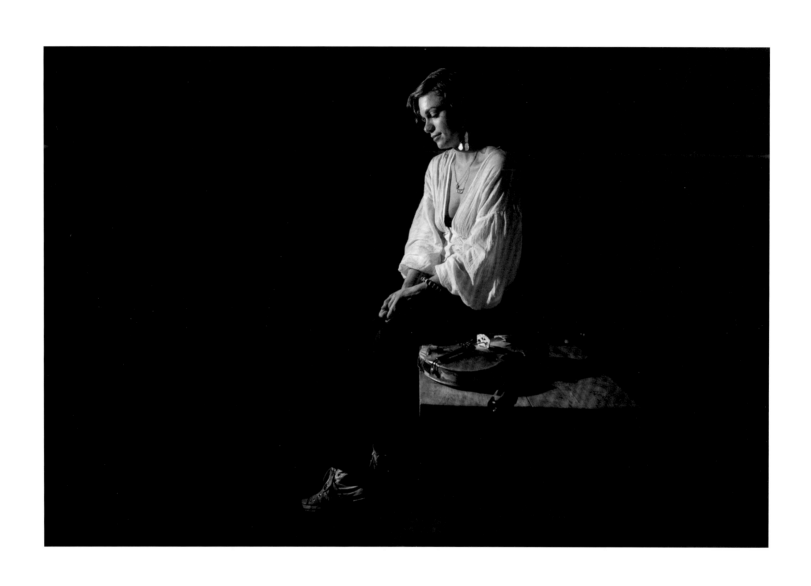

LILLIE MAE
Nashville, Tennessee

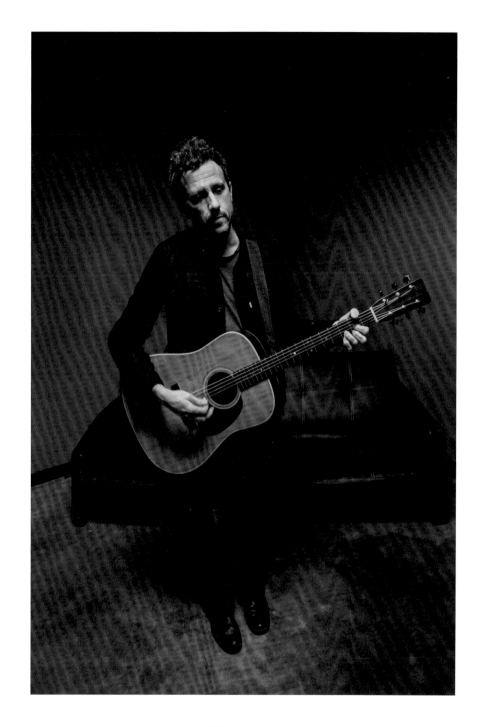

WILL HOGE

Nashville, Tennessee

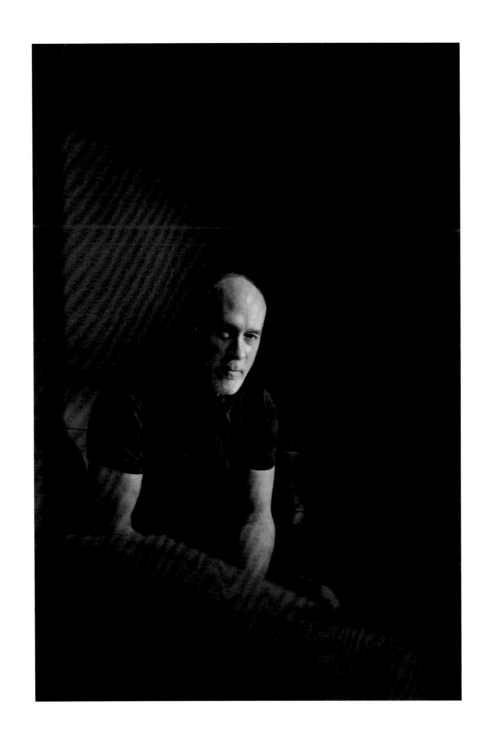

MARC COHN
Nashville, Tennessee

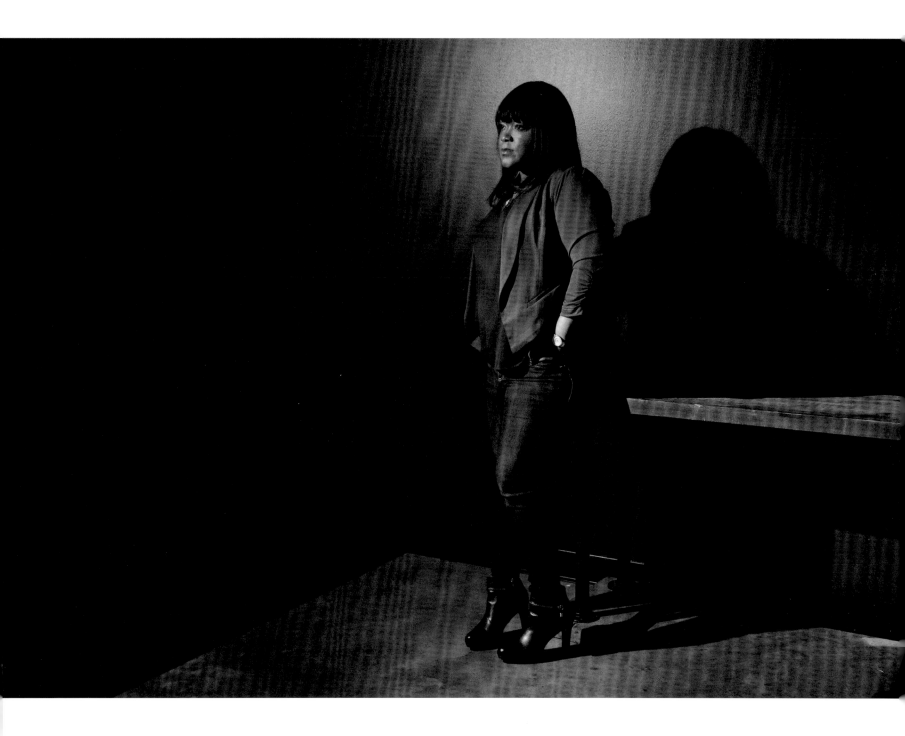

SHEMEKIA COPELAND
Nashville, Tennessee

JOHN PAUL WHITE
Nashville, Tennessee

192

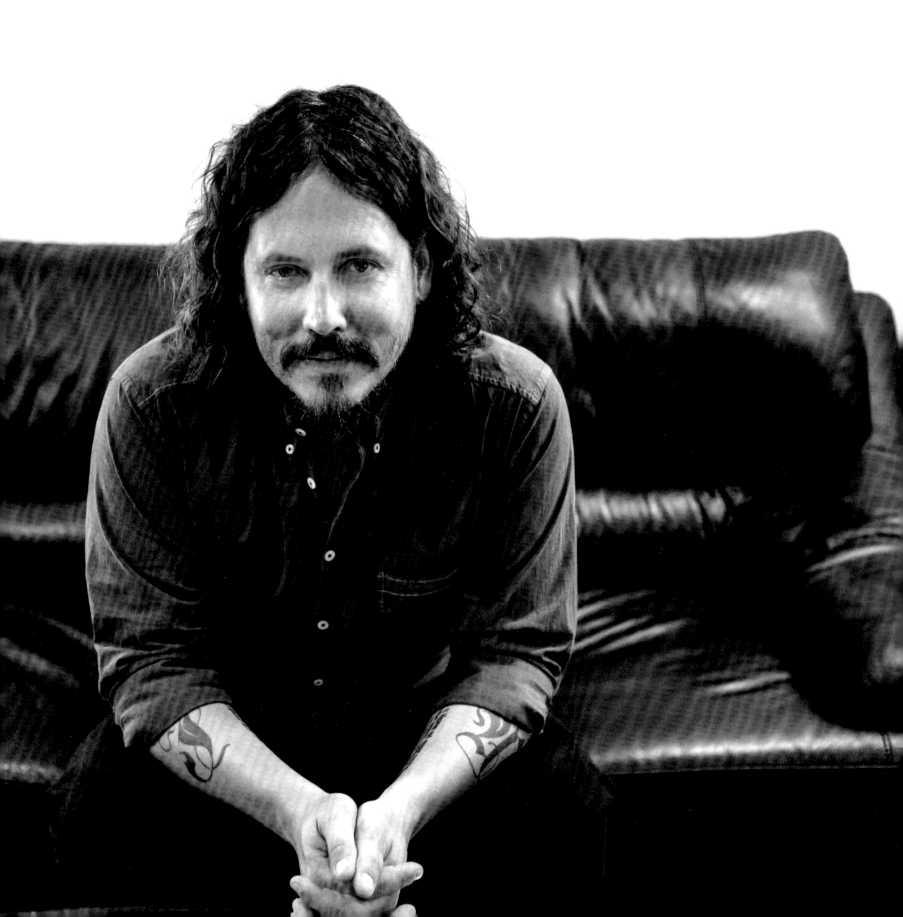

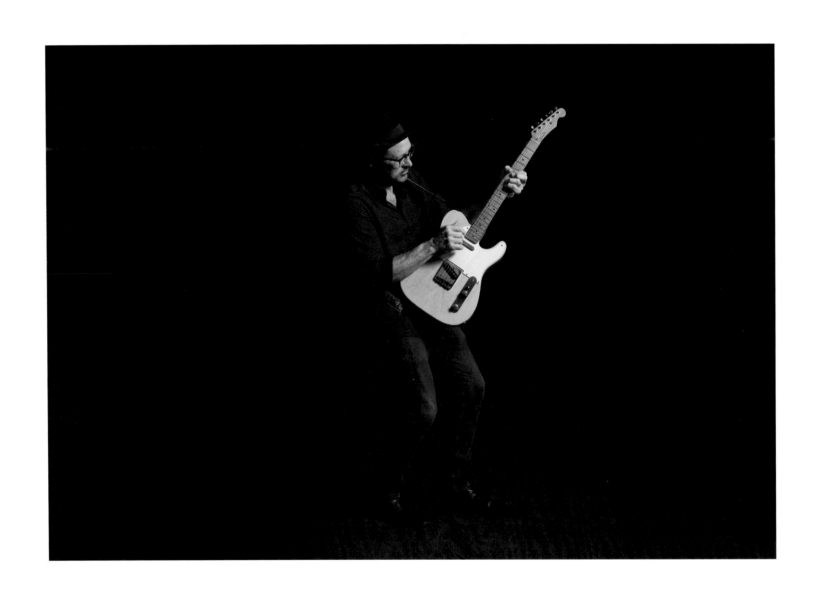

WILL KIMBROUGH

Nashville, Tennessee

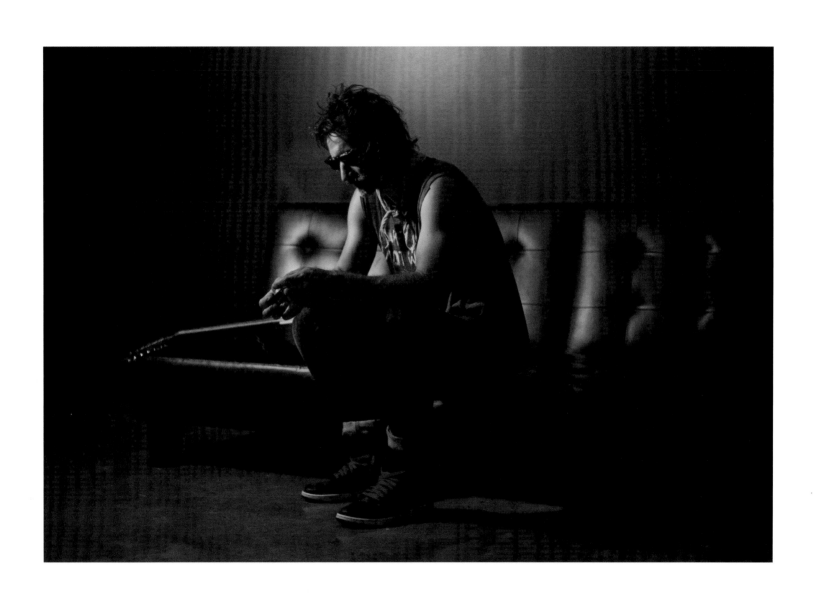

GRIFFIN HOUSE
Nashville, Tennessee

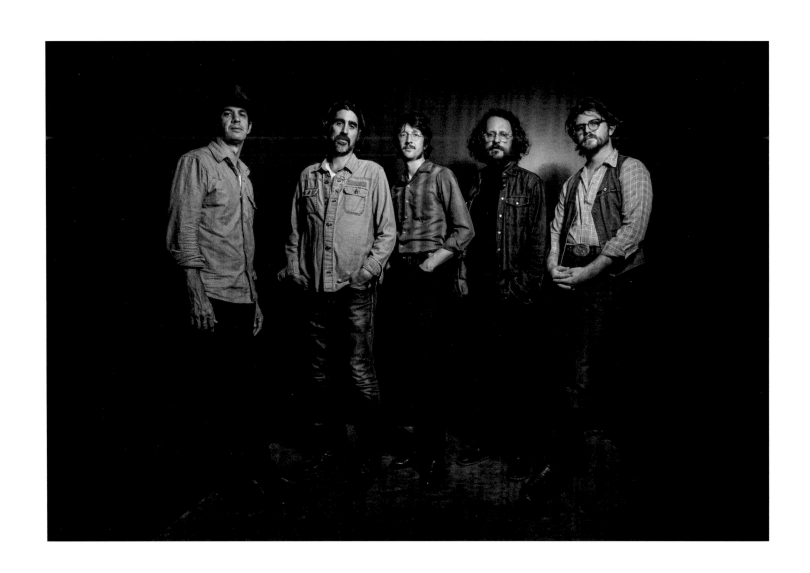

THE BAND OF HEATHENS
Nashville, Tennessee

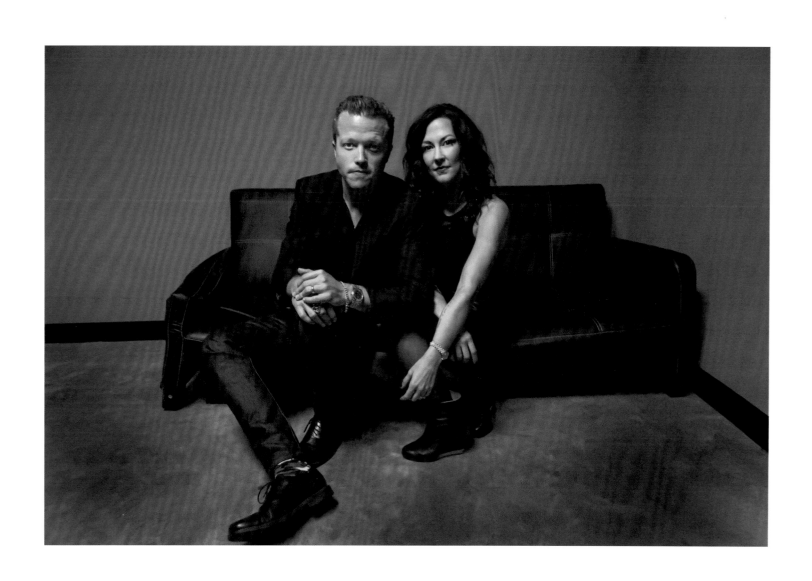

JASON ISBELL AND AMANDA SHIRES
Nashville, Tennessee

FATS KAPLIN
Nashville, Tennessee

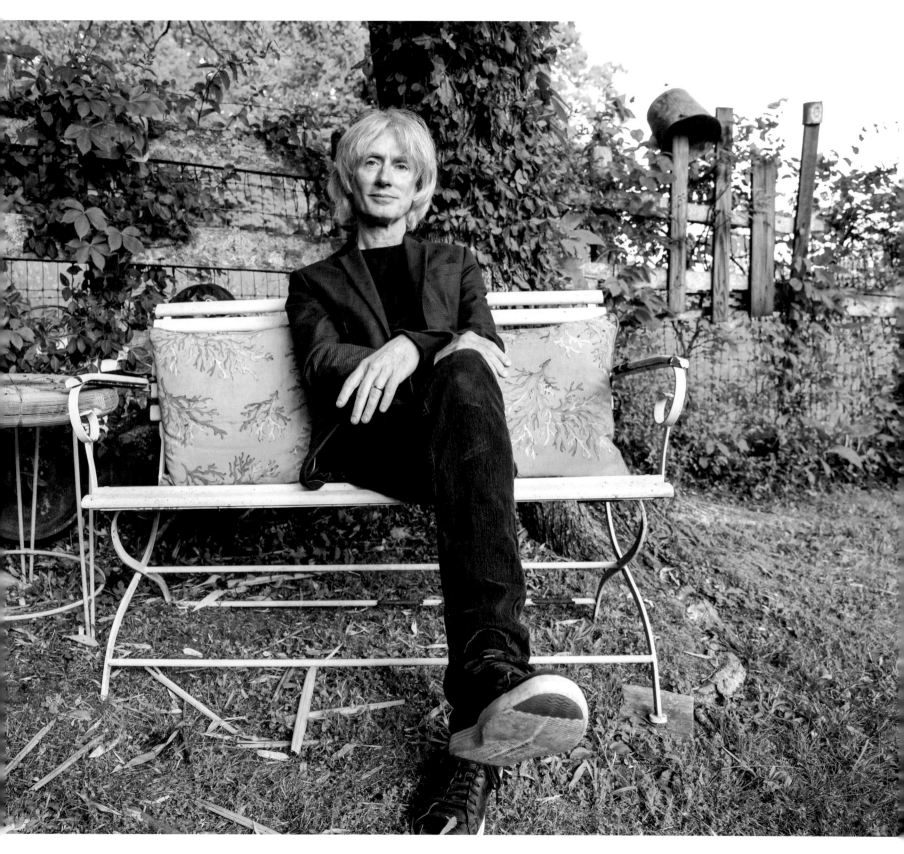

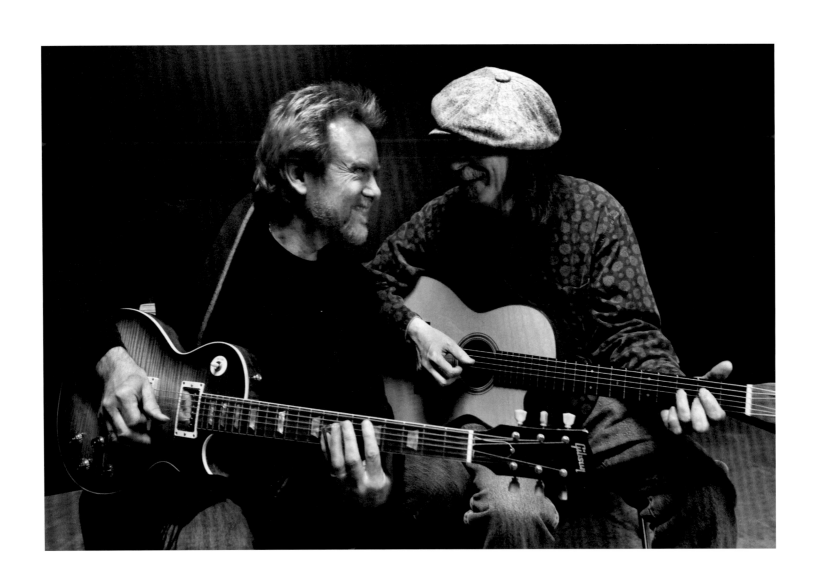

LEE ROY PARNELL AND JACK PEARSON
Nashville, Tennessee

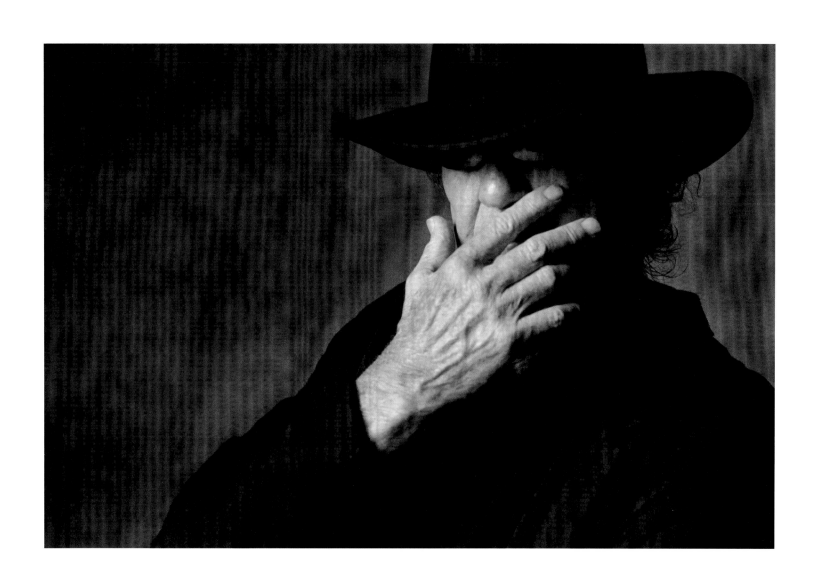

TONY JOE WHITE
Memphis, Tennessee

RICHIE FURAY

Nashville, Tennessee

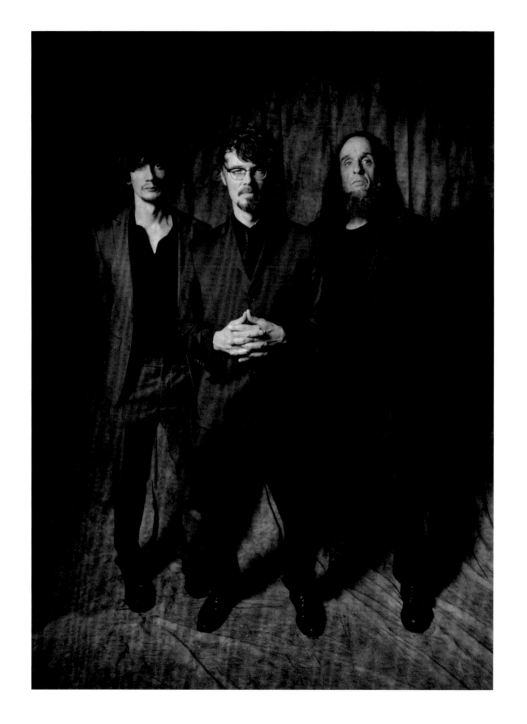

NORTH MISSISSIPPI ALLSTARS
Memphis, Tennessee

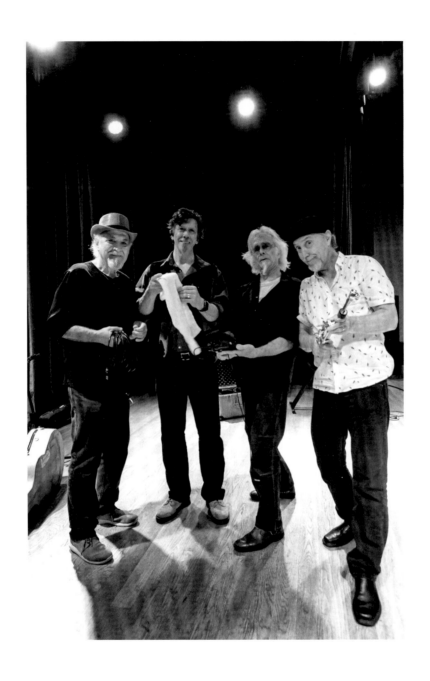

THE SUBDUDES

Nashville, Tennessee

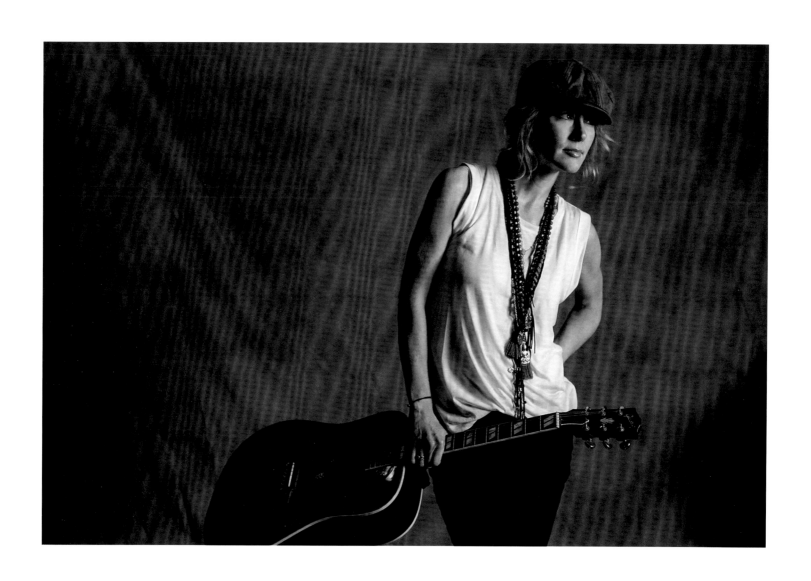

ALLISON MOORER

Nashville, Tennessee

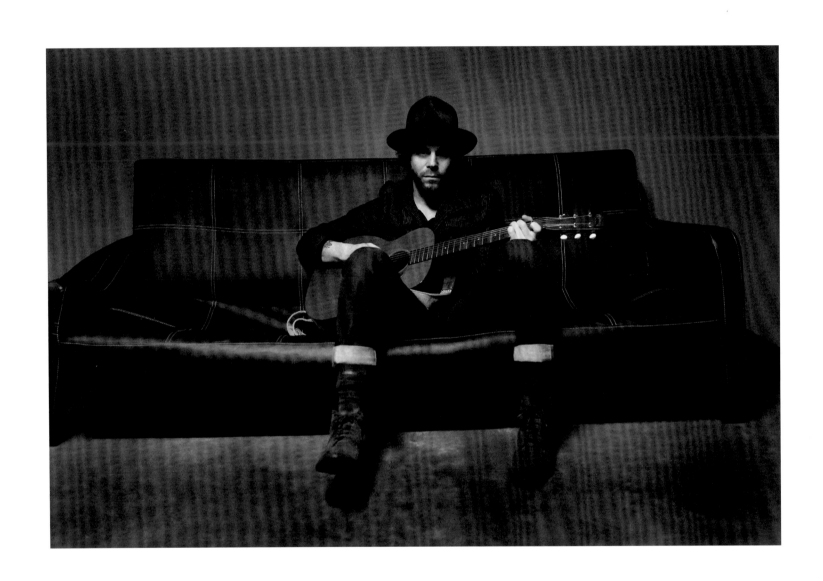

LANGHORNE SLIM
Nashville, Tennessee

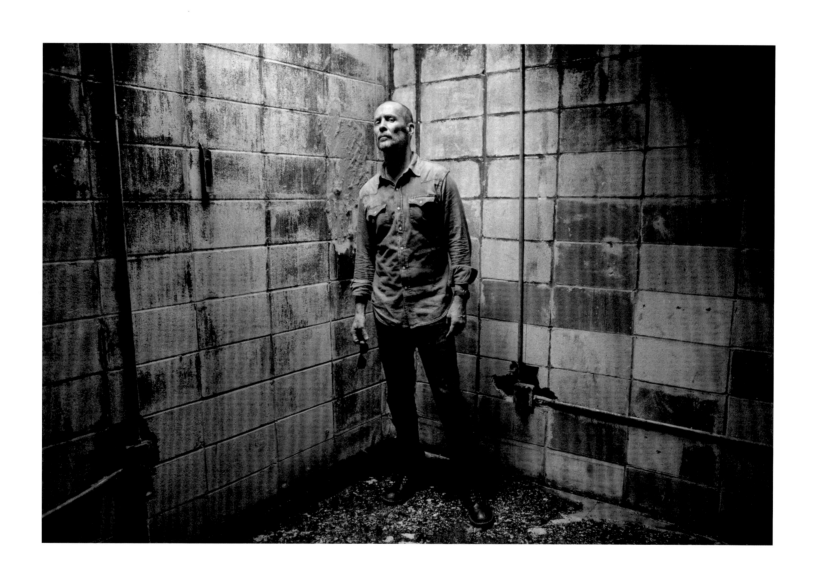

PAUL THORN
Nashville, Tennessee

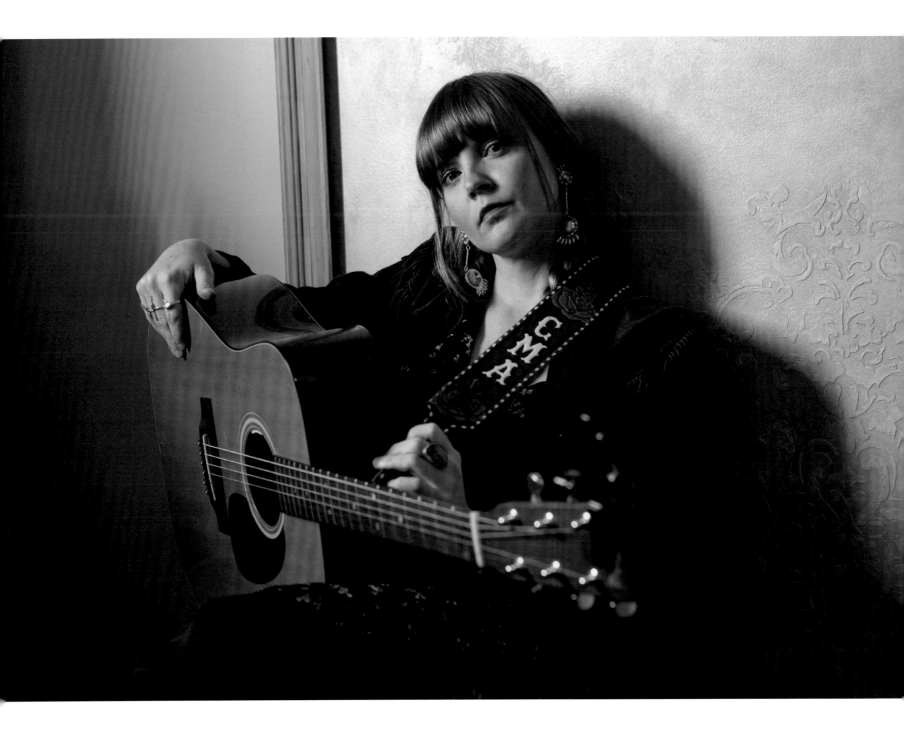

COURTNEY MARIE ANDREWS

Nashville, Tennessee

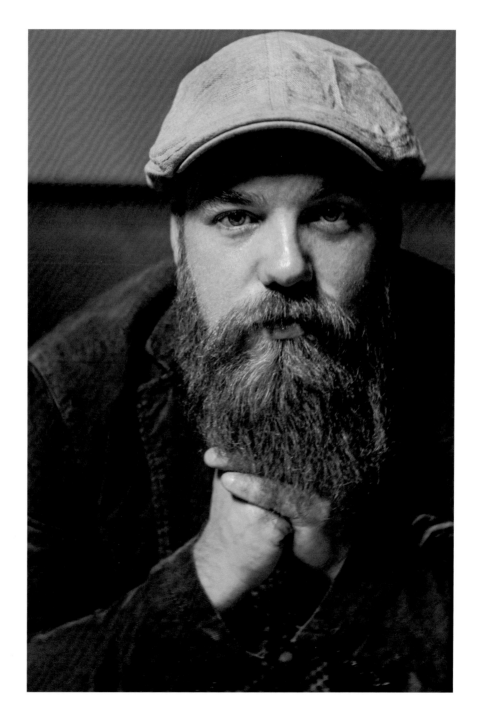

MARC BROUSSARD
Nashville, Tennessee

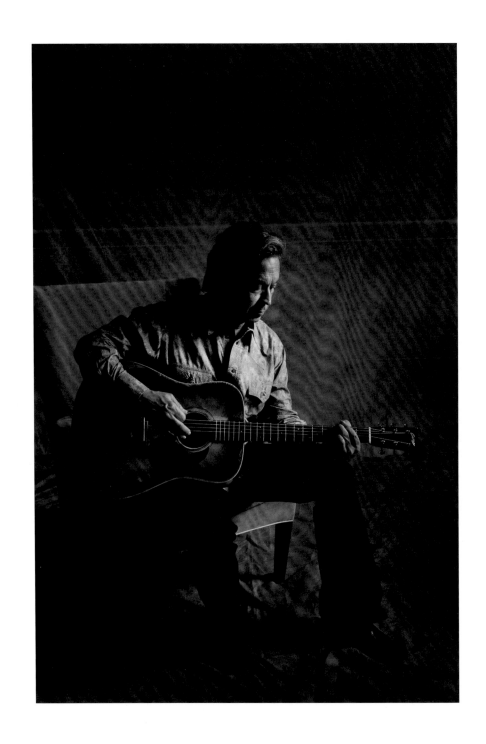

JIM LAUDERDALE
Nashville, Tennessee

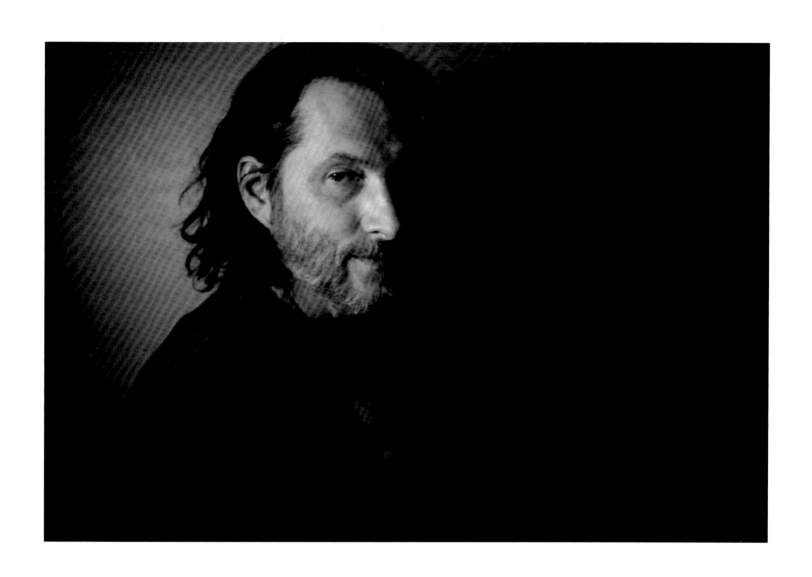

MATTHEW PERRYMAN JONES

Nashville, Tennessee

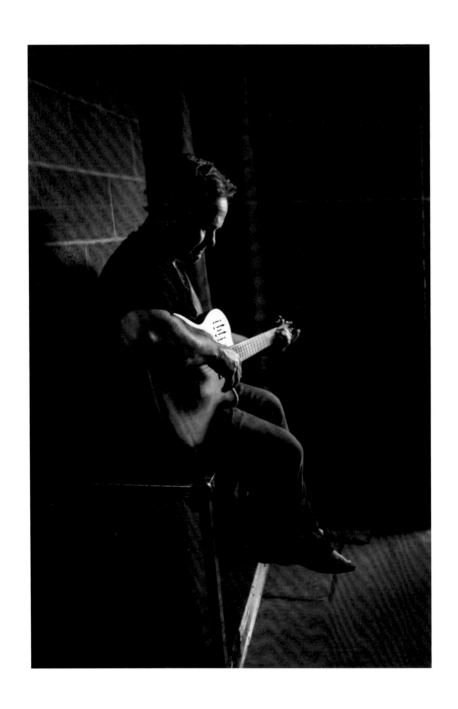

MARTIN SEXTON

Nashville, Tennessee

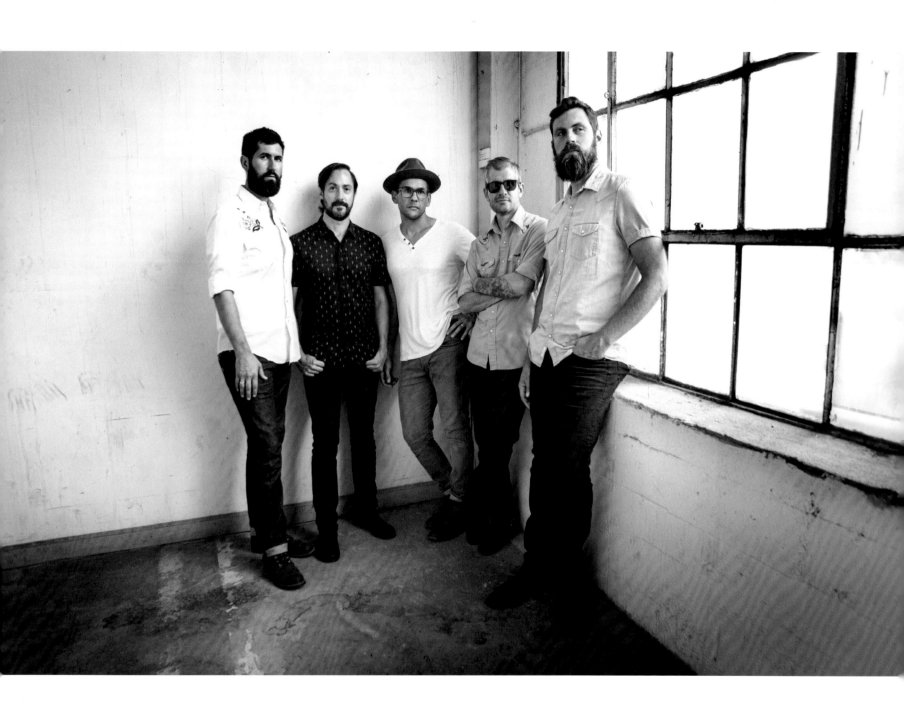

THE STEEL WHEELS

Black Mountain, North Carolina

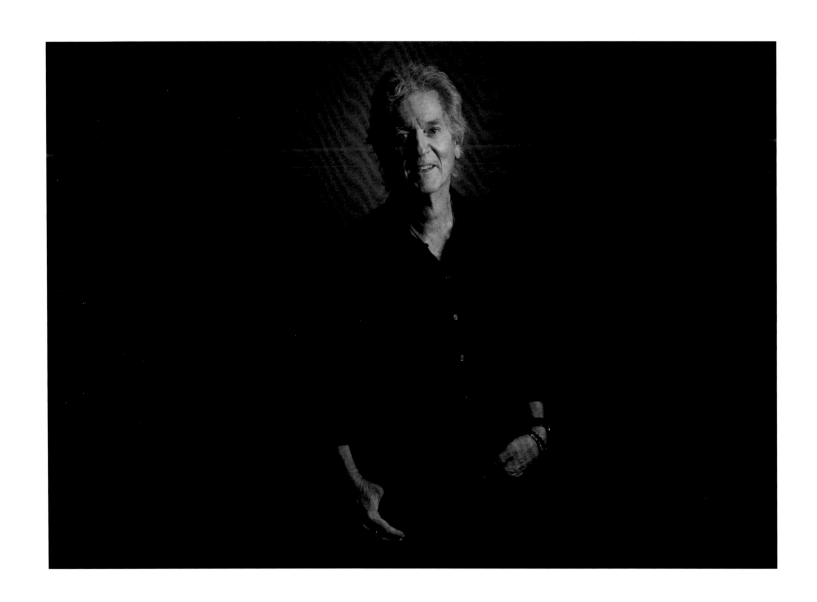

RODNEY CROWELL

Nashville, Tennessee

STEPHEN STILLS AND JUDY COLLINS
New York, New York

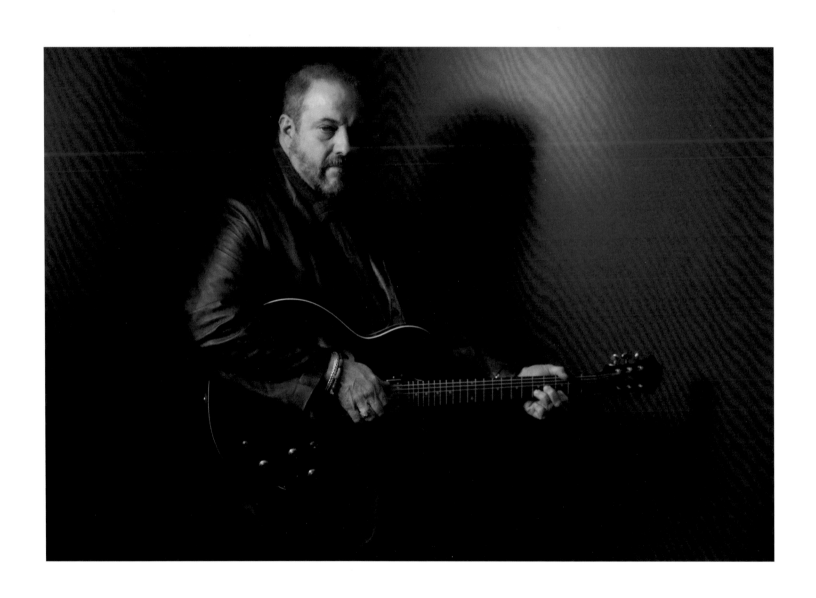

RAUL MALO

Nashville, Tennessee

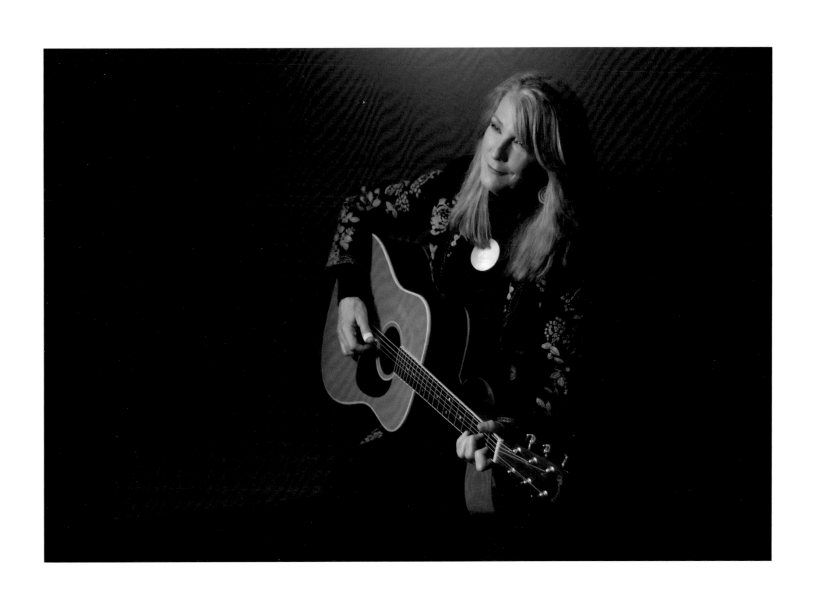

KATHY MATTEA

Nashville, Tennessee

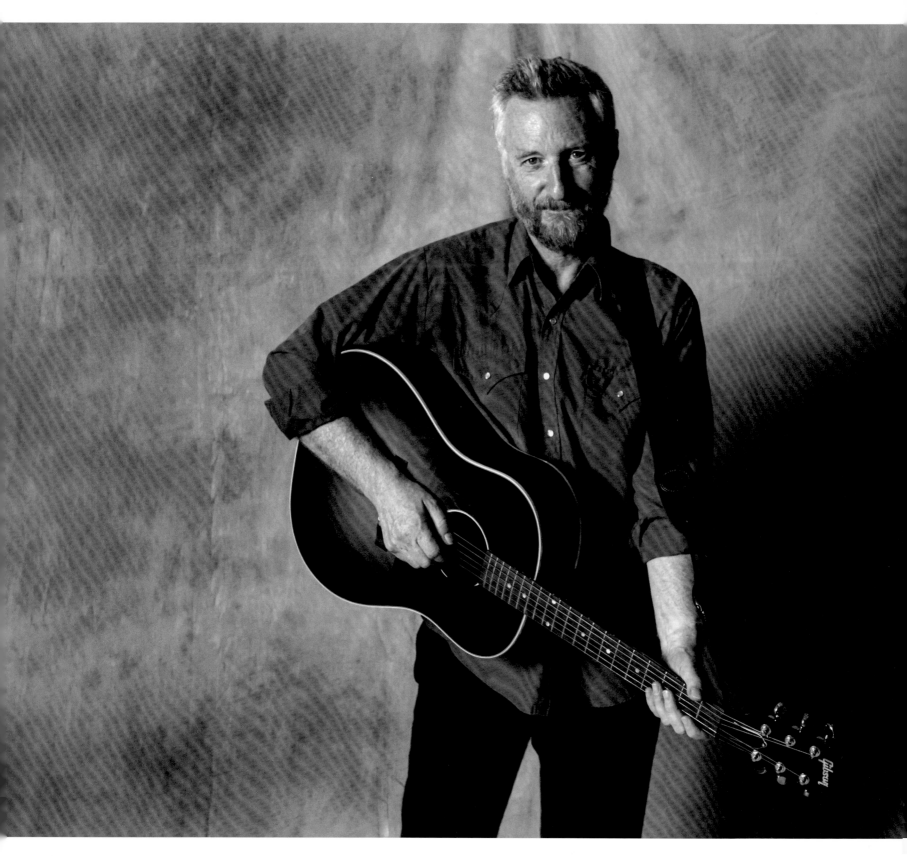

BILLY BRAGG
Nashville, Tennessee

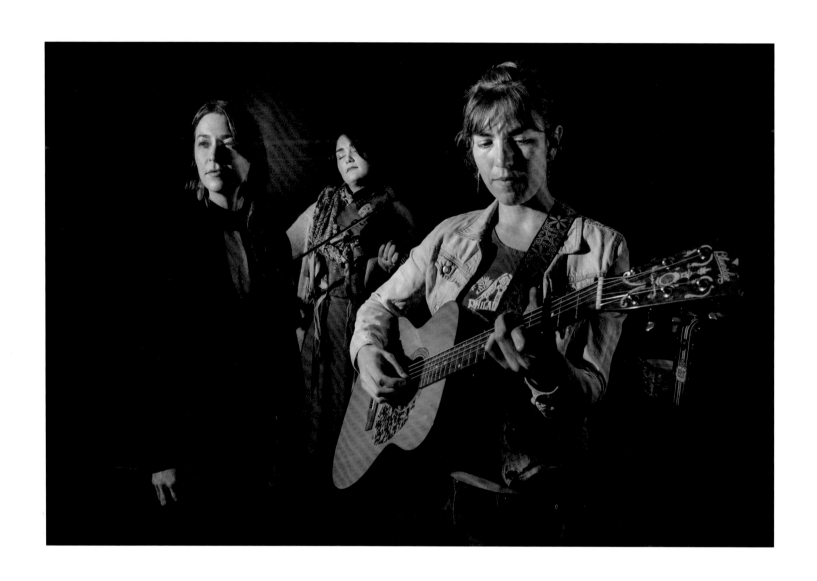

LINDSAY LOU, PHOEBE HUNT, MAYA DE VITRY

Nashville, Tennessee

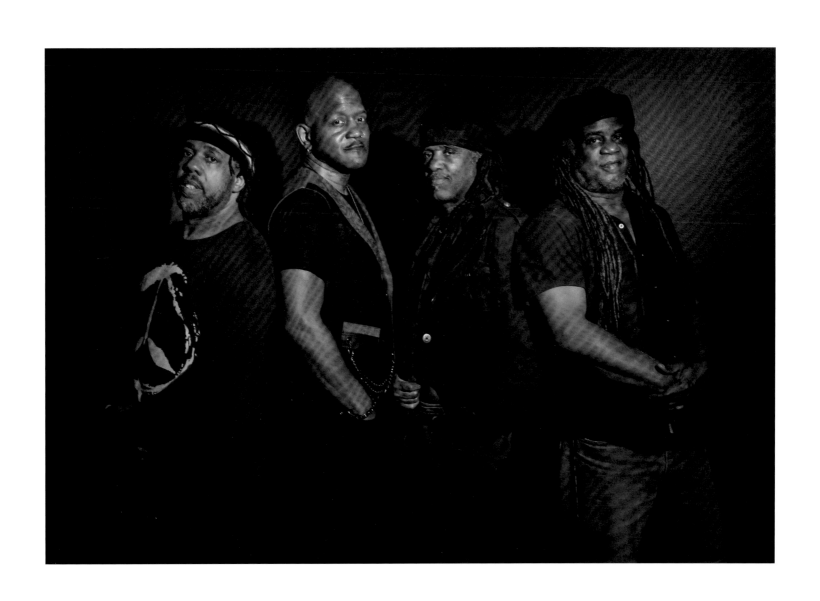

THE WOOTEN BROTHERS
Victor, Joseph, Roy "Future Man," and Regi
Nashville, Tennessee

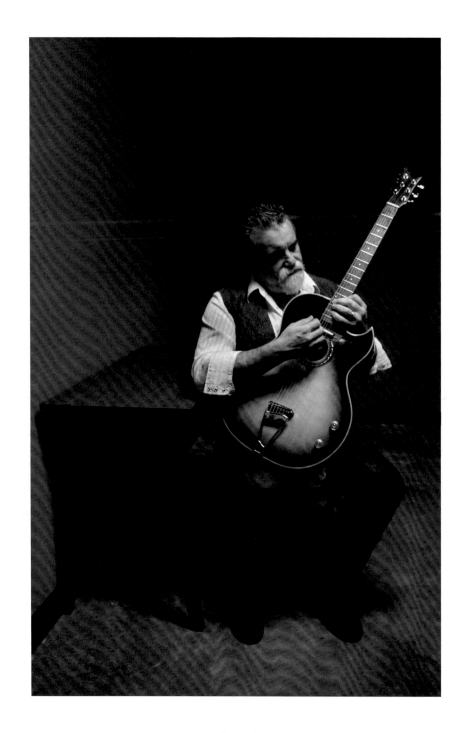

DARRELL SCOTT

Nashville, Tennessee

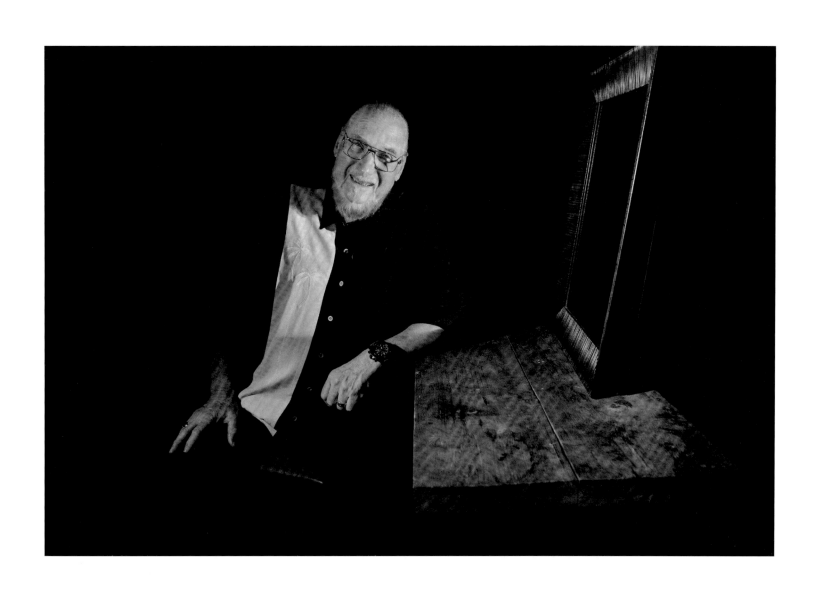

STEVE CROPPER

Nashville, Tennessee

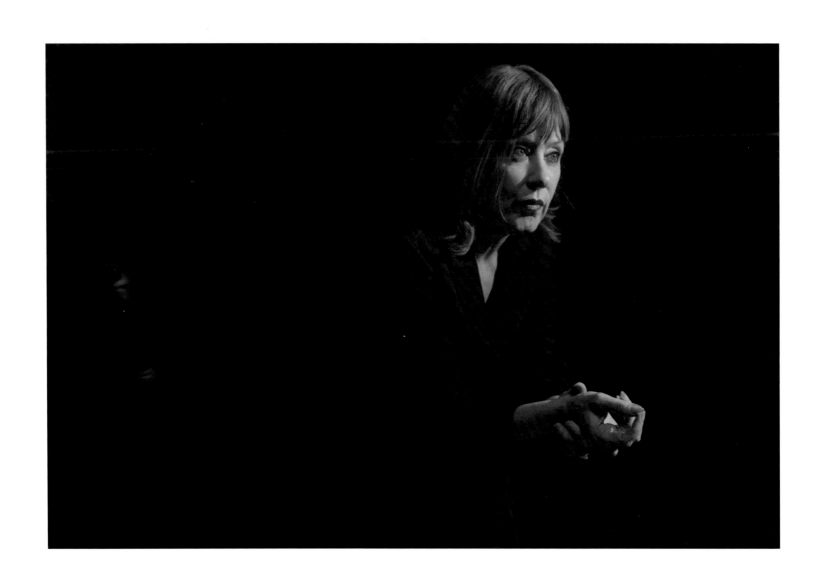

SUZANNE VEGA

Nashville, Tennessee

OPPOSITE:

STEVEN VAN ZANDT

Memphis, Tennessee

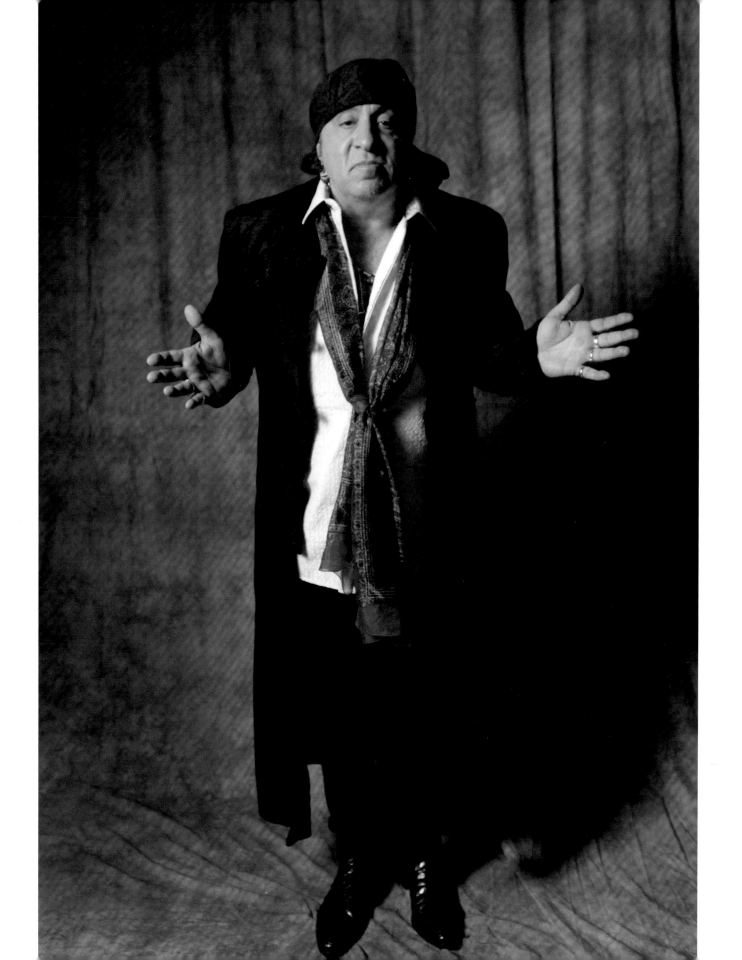

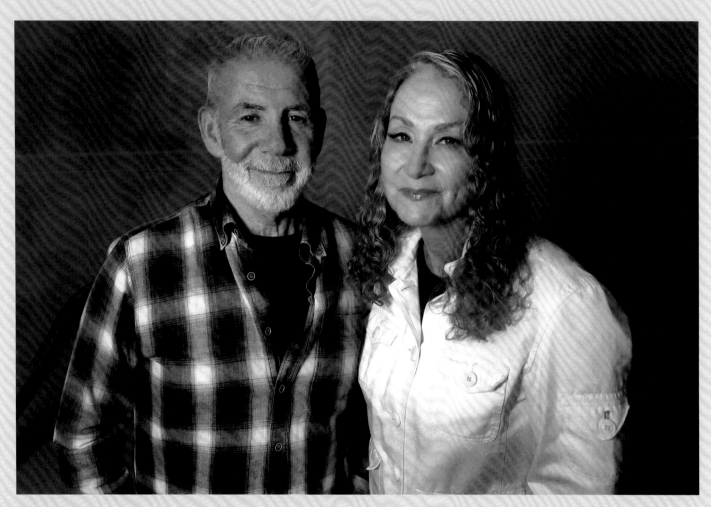

Jeff Fasano with Joan Osborne

ACKNOWLEDGMENTS

A huge thank you to those who were instrumental in my life and in creating this book.

My father, Thomas Fasano

Alexandra Boos

Phillip E. Collins

Robert Baker

Ron Baker

Maria Rangel

Merlin David

Karen Wells Verlander

Edd Hurt

Mary Gauthier

Jed Hilly

Danna Strong

Liza Saturday

Mike Simon

Dolly Chandler

City Winery Nashville

M Music & Musicians

Paste Magazine

Folk Alliance International

International Bluegrass
Music Association

Americana Music Association

The Blues Foundation

Michael Weintrob

*And to all the artists who allowed me to capture their image through my lens,
I dedicate this book with thankfulness and gratitude.*